D-65'S LIGHTROOM WORKBOOK
WORKFLOW, NOT WORKSLOW IN LIGHTROOM 3

Library of Congress Control Number: 1426896491

ISBN 13: 978-0-615-37844-2

ISBN 10: 0615378447
 0615378447

DIGITAL
WORK *flow*
not
workslow)

www.D-65.com

This book is dedicated to our daughters,
Paige, Karalyn and Luci
who give us inspiration and love
and to the entire Spritzer / Resnick family.

CONTENTS

| ACKNOWLEDGEMENTS

There are so many folks who helped make this project a reality. First we must thank all of our readers and workshop participants who looked forward to another edition.

The photographic inspirations come from mentors and friends Jay Maisel, Susan Meiselas and Eric Meola.

None of this would have been possible without the support of a core group of friends and colleagues of the Pixel Mafia and especially the close support and friendship of some of the most intelligent digital minds in the world, Seth's fellow partners in Pixel Genius; Jeff Schewe, Martin Evening, Andrew Rodney, Mac Holbert and the late Mike Skurski and Bruce Fraser.

There is of course the entire Adobe family as well. Never have we worked with a company where one truly feels like family. There are so many brilliant minds and wonderful people including Tom Hogarty, Kevin Connor, Melissa Gaul, Eric Chan, Mark Hamburg, Thomas Knoll, Troy Gaul, Zalman Stern, Peter Merrill, Dustin Bruzenak, Julie Kmoch, Brian Kruse, Andrew Rahn, Eric Scouten, Jon Steinmentz, Kevin Tieskoetter, Max Wendt, Ben Zibble, Jingyuan Bai, Ying Liu, Qiang Zhu, David Franzen, Michelle Qi, Heather Dolan, Kelly Castro, Benjamin Warde, Becky Sowada, Bill Stotzner, Dan Tull, Jeff Van de Walker, Dan Gerber, Shoji Kumagai, Craig Marble, Donna Powell, Tomoko Shinji, Nobuyuki Takimoto, Phil Clevenger, Phil Lu, Julieanne Kost, and Bryan O'Neil Hughes.

Extra thanks to Chittra Mittha, Kathy Waite and Allison Goffman. A very special thanks to Ann and Richard Katz who acted as our technical editors on this project; Kevin McVea from Strategic Content Imaging; Rob van Tuin, our web designer and Angela Paniza, our book designer.

We could never have done this without the loving support of each other and the support from our family.

Seth and Jamie

| FOREWORD

It is strange how monumental changes seem to take place just at the turn of every century.

In the spring of 2003 I bought my first digital camera. No more film to load, the ability to shoot at high ISO's and change the color temperature at will...11 plus megapixels. What more could anyone ask for?

Well, as it turned out, a lot. Buying that first digital camera was a huge psychological move for me, and I soon began to suspect that all was not right in the digital universe. I began to hear about something called "RAW," and bought my first compact flash card —1GB. And then, I met Seth Resnick and Jamie Spritzer.

A friend, Sean Callahan—the founder of *American Photo*—had recommended that I go to a lecture Seth was giving to a class that Sean taught. It was still in the days when people asked you if you were shooting film or digital, and Seth's presentation was peppered with references to which images were on film, and which had been shot with digital.

I had gone to Seth's talk with a lot of doubts, but I came away a true believer—in digital, but more importantly, in Seth. As he showed his series of pictures documenting the treatment of Renee, a five-year old girl burned by hot grease in a kitchen accident, and his voice broke, I started to realize that there was a reason that Sean had urged me to go to Seth's lecture. We had a few things in common--we both went to Syracuse University, and had taken classes with color guru Tom Richards. But despite showing some absolutely great images, one thing stood out for me in Seth's lecture, and it was a technical one. At one point he mentioned that he had "calibrated" the projector.

Huh? *He calibrated his projector...who was he kidding?*

And that was the beginning--the beginning of cursing this guy who I depend on at just about any hour to answer some arcane question I have about "color space," or "bit depth." Well, not really cursing. But I began to realize that in this brave new world of digital image making and digital processing and digital editing,

there was a common thread that kept showing up, and it was *THEM*. Seth and Jamie.

For all of its pluses, digital had one huge minus for me, and was that I could no longer lay my slides out on a lightbox. Hey, live with it. Get a grip, get a life. Read this book. We can no longer simply turn in an image. It needs to be archived, backed up, keyworded, assigned a color space. It needs GPS coordinates. It needs a catalog, it needs a library, it needs *Lightroom*, it needs... Seth and Jamie.

When I first downloaded my images from a compact flash card, there were problems. I hadn't formatted the card in the camera, and cards at that time were not very reliable. Losing a single image was, for me, catastrophic. Other things seemed to go wrong. The blacks didn't look right, and the highlights were burning out. There was noise in the shadows. And what about the images themselves--what folder were they in, where had I backed them up, and why couldn't I find them?

Lightroom 1.0 came out in January of 2006. Just before heading to New Delhi, a year later, to make images for what was then just a dream for a book on India, I had gone over the architecture and structure of *Lightroom* with Seth, and he showed immense patience and guided me through setting up its preferences. He's probably forgotten, but there was even a panicked call or two when something happened that I couldn't figure out.

I found myself late at night, keywording images in *Lightroom* while in a hotel room in Mumbai, realizing that at long last I had my "lightbox" back. Twenty thousand images were in my India "catalog," and with one click I pulled up just the ones that had the keywords *Jaipur, saris and women*. A few quick "Command-B's" and I had added them to a "Quick" collection. Within a few minutes I processed them and uploaded them to a blog I had set up to record my days as I travelled throughout India.

It was only when I got back from several months of traveling that I realized what the digital revolution and *Lightroom* were really all about. I had spent 93 days on the road without a single roll of film, and yet I could find any image from that trip in just a few seconds. All of the images were backed up, and my final selects had been color-coded and assigned ratings.

I've just come back from Iceland, where Seth oversaw a "Focus on Nature" workshop. Every time we got back on the bus, Seth would plug in his card reader and within a few minutes he had the images keyworded, as he sat there, quickly and efficiently processing his first selects. Later that week, he projected his favorites, and they were, to say the least, jaw dropping. Someone said of digital "it sees what I don't." I would go so far as to say it has made me a better photographer. The instant feedback, the freedom to experiment with color temperatures and ISO's, to shoot in what used to be "impossible" light, and the ability to extend the tonal range—all of these things have given us enormous freedom. Freedom to shoot what we cannot see, but also the freedom to make a mess of working with and cataloguing our images. Or, to read this book and use the power of *Lightroom* to...SAVE TIME and make money. Now there's a thought.

Seth and Jamie have laid the chapters out in a "quick read" style that follows *Lightroom*'s architecture from beginning to end. And you can fit their guidelines to your own style of shooting and your own way of organizing your digital image archive. It doesn't matter how expensive your camera is, or how many megapixels are on its sensor, because this book gives you the knowledge and the discipline to make the most of the tremendous possibilities of digital photography.

"Expose to the right." That's something that doesn't sit well with me, accustomed as I have been to underexposing Kodachrome, sometimes by as much as a full stop. But like many of us, I've learned the hard way that if I'm going to play in this digital world I've got to know the rules of the road. At the end of Seth's workshop in Iceland, an Indian doctor who was in the group pulled me aside and said "You know, if I had to work half a year to come to this workshop again, I would." I agree. But in the meantime, I'll re-read the latest version of this book. Again.

—Eric Meola, Photographer

INTRODUCTION

What is D-65?

No one ever accused a creative mind of being organized. The two don't usually go hand in hand. But when you're a photographer, being organized is invaluable. And if you're shooting digitally, it's crucial.

D-65 is a unique company dedicated to educating photographers. We work with the industry to offer new ways of thinking, while incorporating the latest technologies. Our services include digital workflow workshops, webinars, one-on-one training and tech support, and consulting for photographers, studios, agencies, and corporate art departments. D-65 provides quality professionalism, while understanding the needs of photographers and creative individuals.

This book is based on the D-65 workshops which are a dynamic resource for photographers of any level. The 4-day intensive workshop equips photographers with the tools to manage their workflow efficiently, effectively, and effortlessly.

Utilizing the 5 modules of *Lightroom* 3 this book will teach you detailed workflow, digital asset management, processing and image delivery. You'll become an expert in keeping every image you shoot organized and archived and you will have the skills to create your own successful workflow in *Lightroom* 3.

This book is all encompassing and vital for professional photographers, art directors, photo editors, image heavy bloggers, and the advanced amateur.

If you read our first book, The *Photoshop Lightroom* Workbook, Workflow not Workslow in *Lightroom* 2, you will already know why we love *Lightroom*. If you haven't read our first book, or been to one of our workshops or webinars, *Lightroom* is a one-stop solution for digital workflow. It utilizes the power behind Adobe Camera Raw, combining image processing and a digital asset management system under one roof. The aim of *Lightroom* is to be simple and to streamline workflow.

The software is very well suited to the professional photographer or the amateur photographer. It is not designed to replace *Photoshop* or *Bridge*, but rather to work alongside those applications. It was built from the ground up, and optimized to accomplish its tasks with speed and efficiency.

There are many new features and improvements in *Lightroom* 3. In each chapter, we will highlight them and provide in-depth details.

REQUIREMENTS TO RUN *LIGHTROOM*

Lightroom is an image processing application and as such, it should be no surprise that the performance is greatly enhanced with sufficient RAM and processing power. The minimum specifications are listed below, but please keep in mind that these are bare minimum requirements.

Macintosh

- Macintosh OS 10.5 or higher (*Lightroom* will not run on any version earlier than 10.5)

- Intel Mac processor only

- RAM: 2 GB

Windows

- Processor: Intel® Pentium 4

- OS: Microsoft® Windows® 7, Windows Vista® Home Premium, Business, Ultimate, or Enterprise (certified for 32-bit and 64-bit editions) or Microsoft® Windows® XP with Service Pack 2

- RAM: 2 GB

64-BIT INSTALLATION

Mac: *Lightroom* 3 is a 64-bit application by default. *Lightroom* 3 can be used as a 32-bit application by selecting 'Adobe

Lightroom 3' in the Application folder, choosing Get Info (CMD I) and checking the 'Open in 32 Bit Mode' option.

Windows: The *Lightroom* installer contains both a 32-bit and 64-bit version of the application. By default, the 64-bit version will be installed only on Windows Vista and Windows 7 64-bit operating systems. All other operating systems will install the 32-bit version by default.

TIP: The Lightroom 3 catalog upgrade process does not erase or remove your previous Lightroom catalogs. The upgrade process will modify previews of an upgraded catalog. Returning to a previous version of Lightroom will require that the previews be re-rendered. This can be a lengthy process for those with hundreds of thousands of images.

| UPGRADING FROM *LIGHTROOM* 2.6 TO 3.0

If you were working in *Lightroom* 2.6, you will need to upgrade your *Lightroom* Catalog. If you have a single catalog in the default location, *Lightroom* 3.0 will automatically open that file and upgrade it (see Figures 1A and 1B below).

If you have multiple catalogs, you will need to upgrade each one manually. The time this process will take is dependent on the size of your existing catalogs. This operation CANNOT be cancelled. Do not force quit this operation or *Lightroom* will become corrupted. Any catalog that is updated in 3.0 will no longer be able to open in 2.6. During the upgrade process, *Lightroom* will automatically check the integrity of the new catalog.

Lightroom Catalog Upgrade

Please upgrade the catalog file "Lightroom_Catalog" for use with Lightroom 3.

Lightroom will create a new catalog file in the destination indicated below. The previews will also be moved to this location and converted for use in Lightroom 3.

Upgrade Destination: /Volumes/Lightroom3_Librar...log/Lightroom_Catalog-2.lrcat (Change...)

(Choose a Different Catalog) (Quit) (Upgrade)

FIG 1A

Updating Catalog

Lr

Catalog Upgrade in Progress

Upgrading Previews

Cancel

FIG 1B

If you upgrade an existing catalog, you will notice that the original catalog and previews remain and a new catalog and previews are created. Note that this can cause some confusion because the new catalog will be designated with the number 2 after it. We felt the new catalog should have a number 3 after it so that the user knows it is for *Lightroom* 3, but the engineers simply designate the new catalog with the same name -2.

Lightroom_Catalog-2.lrcat

Lightroom_Catalog-2
Previews.lrdata

FIG 1C

Lightroom_Catalog.lrcat

Lightroom_Catalog
Previews.lrdata

Optimization is one benefit of *Lightroom* 3 and you may notice that the same information from your 2.6 catalog is considerably smaller in 3.0. Notice that in Figure 1D the original catalog was 1.14 GB and the upgraded catalog is 1.07 GB

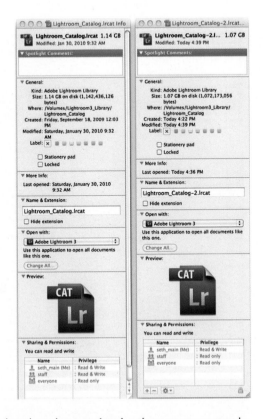

FIG 1D

Again, please note that there is **no going back** once you upgrade. The preview.lrdata in our catalog for version 2.6 was 225.73 GB and after upgrading, the 2.6 preview.lrdata file was 559.3 MB and are no longer usable (Figure 1E). For this reason it would be a very wise idea to make sure you have a complete backup of your 2.6 catalog before you upgrade, just as a precaution in case something goes wrong during the upgrade process.

FIG 1E

All keyboard shortcuts and screen shots in this tutorial are Macintosh. If you are using the Windows version see chart below.

Windows:	Mac:
Alt	Option/Alt
Control	Command
Right Click	Control Click
Enter	Return

BEFORE YOU SHOOT

Before we get into the fundamentals of *Lightroom,* it is important to get a grasp on some of the key elements of shooting digital. When you learn math, it is vital to understand how to add and subtract before you learn how to multiply. This same principle applies to digital. Digital workflow begins even before the camera shutter clicks. In order to truly perfect your digital workflow, you need to understand all of the concepts that govern the world of digital.

| MEMORY CARDS

Flash memory cards are an overlooked but a very important part of digital workflow. After all, the flash memory card is the modern day equivalent of your film. In the same way that you didn't use just any film, even though they were all color or black and white, all memory cards are not created equal. Some of the important criteria are speed, data verification, technical support, warranty, and size. SanDisk, Toshiba and Samsung are among the largest flash memory chip suppliers. Toshiba is actually a partner with SanDisk.

There is also a second component within a memory card known as the controller. SanDisk and Lexar produce the majority of the controllers. Technically, it is the combination of the controller and the flash memory that ultimately determines the efficiency and the performance of the card.

If the memory card physically holds data, it is a miniature hard drive. These are known as microdrives, originally perfected by IBM. They are still available from Hitachi and Seagate. While these were very popular early on, they have pretty much been replaced by compact flash cards or flash memory. Memory cards enable your ones and zeros (digital data) to be stored in a cell known as a memory cell, as opposed to the rotating platter of a hard drive. Flash memory cards are more durable than the older microdrives in part because microdrives contain moving parts and are susceptible to jarring and rough handling.

| MEMORY CARD SPEED

The speed itself is dependent on more than just the card. The architecture of the camera is also a factor. A card that is super fast in one camera could be slow in another camera. This all depends on how the controller interchanges data with the specific camera.

| CHOOSING THE RIGHT SIZE MEMORY CARD

Flash memory cards have been increasing in size, and are now available up to 32 GB. D-65 still advocates using 2-8 gig cards.

Why? The memory card is likely to be the first place you can encounter a problem. Any glitch or failure with the memory card can wreck a shoot. For this reason, D-65 chooses to match the memory card to the RAW file size produced by the camera.

Don't fall into the trap of believing that more storage on a card is better. You would never shoot a film-based job on only one really long roll of film just in case the lab ran into problems. For this reason, D-65 recommends using multiple cards per job. You can size the card specifically for a camera. While a 32 gig card may seem like a great convenience, you are putting all of your "digital eggs" in one basket. The key is not to have too many images on one card in case of failure.

| HOW LONG WILL MY MEMORY CARD LAST?

All cards have a lifespan, as is the case with all digital products. While the manufacturers are reluctant to post specific numbers, all cards will eventually die, as the cells in the card start to expire. Do not assume that a card will last for 300,000 erase and write cycles. It is a good idea to introduce new cards on regular intervals using your existing cards as backup. D-65 buys new cards generally when the card size jumps to the next level. We don't buy the largest, but we do go up in size.

| ALWAYS FORMAT THE MEMORY CARD IN YOUR CAMERA... EVERY TIME

You must format your memory card in the camera. Do not just remove or delete the images using the computer or camera software. This may lead to data loss. Why?

All cards run with their own operating system and have their own native file structure. These media typically need to be formatted to a FAT16 file structure while many computers use a FAT32 file structure. If you manipulate the images on a card using a FAT32 computer, this information will be written to the card/microdrive. So, you will have a FAT16 device with FAT32 information. Not a desired result, and such an easy problem to avoid.

To avoid data loss:

- **A lways format compact flash cards in your camera.**

- **Reformat the card every time you remove it from the camera.**

- **Do not take the card out of your camera, check the images on a computer and then put the card back in the camera and continue shooting.**

- **Never fill a memory card.** If there is not enough space to write the last file, the entire card may get corrupted. Leave a few shots (3 or 4) at the end of each card. This greatly reduces the risk of card failure.

EDITING IN CAMERA

While it is generally safe to delete files as you shoot in the camera, there is an exception to this rule that can lead to data loss.

Do not delete files at the end of the card to create extra space for more shooting.

The data is very vulnerable when the cards are close to filled. It is almost a guarantee that you will encounter data loss if you delete files at the end of the card. It is acceptable to do a rough edit while you are shooting, using the LCD on the camera back. Do not be overzealous with your editing; remember the limitations of the LCD display. However, it is a good idea to delete obvious "out takes" in camera to reduce editing time later.

SHOOTING AT THE OPTIMUM ISO

Every digital camera has an optimum ISO setting. The best capture quality will be obtained using that ISO. In fact, the only camera setting that will significantly impact the quality of the RAW capture is the ISO. The nomenclature on the menus of cameras tends to confuse photographers. We all ask the questions, "Should I shoot on Adobe RGB, turn on noise reduction? Sharpening?" The reality is that none of these apply

when shooting in RAW mode. The only settings that apply when shooting RAW are shutter speed, f-stop and ISO.

When shooting film, photographers typically pick a higher ISO when they need speed or when the light is reduced. In the world of digital capture, D-65 suggests shooting at the optimum ISO whenever possible because there is a direct correlation between digital noise and higher ISO.

The higher the ISO, the more potential there is to generate noise.

Noise is a level of electronic error usually resulting from amplification of the signal from the sensor. While there are various ways to mask noise, the best solution is to try to prevent it before it occurs. Up until recently, D-65 was adamant to try to shoot at the optimum ISO for the camera. Although camera manufacturers claimed excellent results at higher ISOs, we found that most cameras produced less than optimal quality at ISO 400 or above.

Recently, because of better insulators in micro components and all around better technology, both Nikon and Canon have changed our way of thinking with the high end cameras. We have seen spectacular results at ISOs above 3000. As time goes on, ISO may become less and less of an issue.

In general, a camera with a maximum ISO sensitivity of 800 will gather light twice as fast at that sensitivity as it would at 400. If you can make a shot at 1/100th of a second at 400 ISO with a particular setup in the camera, the camera will take the same shot at 1/200th of a second with the same setup at 800 ISO. There is, however, a penalty of increased noise at higher ISO sensitivities.

You should always set the ISO no higher than is necessary to produce the best quality image.

There is only one place to eliminate noise, and that is at the sensor level. Reducing noise after capture is a mask or band-aid; it is not truly eliminating the problem. There is really great noise reduction in *Lightroom* 3, but if it is not enough, D-65 recommends a great product called Noiseware (www.imagenomic.com).

| WHITE BALANCE

The white balance indicates the color of the light in which an image was captured. Our eyes automatically adjust to changes in white balance by making the brightest area of the scene white. As you recall, shooting film under fluorescent lighting looked green, while to the human eye, it never appeared green. While no camera is capable of the white balancing accomplished in the human brain, digital cameras do an admirable job.

Digital cameras have sensors with red, green and blue filters. There are twice as many green filters as red and blue filters in digital cameras because our eyes are most sensitive to green wavelengths. Digital is trying to mimic the way your eyes see.

Unlike film, a digital camera gives you full control over white balance. Obtaining a specific white balance value can be accomplished in many ways. Some cameras allow you to set custom white balance values. While it is true that you can always adjust the white balance of a RAW file after the fact, having to do this will slow down your workflow. Achieving the correct white balance in camera will speed up your workflow.

Many cameras have an AWB mode. In our minds, this stands for Average White Band, and not Average White Balance. The photographer, not a computer chip, should take control and determine the desired color temperature. For example, many of us like to shoot at sunrise and sunset. The light at these times, known as golden light or National Geographic light, is exceedingly warm. Setting your camera to AWB at this time will correct this light to look more like light at high noon.

Below we have an example of the same image shot with two different white balance settings. The scene is a vendor selling squid in an outdoor market. It is a cloudy day, and there are fluorescent tubes and a red incandescent light bulb hanging over the squid, along with a green and white awning. It is the type of image that in the days of film would be nearly impossible to correct. In Figure 1.1, the camera is set to daylight. In Figure 1.2, we have done an in-camera custom white balance to achieve the correct white balance that we wanted.

FIG 1.1
As Shot

FIG 1.2
Custom White Balance
Done in Camera

X-Rite ColorChecker
If custom white balance isn't an option for you, another way
to obtain an accurate white balance is to place an X-Rite
ColorChecker (www.xrite.com) in the scene.

To do this, place the X-Rite ColorChecker in the frame and
capture the image. When you process the file in *Lightroom,* use
the White Balance tool in the Develop Module and click on the
second patch from the left in the bottom row. The white balance
will be corrected instantly.

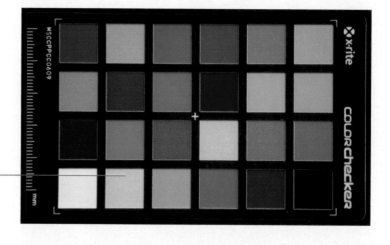

Click on this patch
for white balance
in a frame

FIG 1.3

To use the custom white balance in the camera, focus on an area of the image that has white with detail (such as the underbelly of the squid in the upper left-hand corner of the image in Figure 1.2). While white with detail will not give the exact same reading as an X-Rite ColorChecker, it will be very close in most situations.

Color balance is very subjective. We all see color differently. It is technically determined in our brain. No two people see the exact same shade of red in a red ball. If you were shooting clothing for a clothing manufacturer, then we would always recommend using an X-Rite ColorChecker. The manufacturer will want the yellow sweater to look exactly or as close to the real thing as possible. Going to a beach at sunset and shooting a portrait for an editorial piece is another story. You would likely want the warm light on your subject, which is not "technically" white balanced at all.

In the days of film, we used an 81A filter on the lens or a sun CTO filter on the strobes to warm up the scene and make it look like afternoon sunlight. Many editors hired us specifically for this look, while other editors didn't like the look of our warm portraits at all, thinking the skin tones were too orange. Neither look is right or wrong; it is just personal preference.

UNDERSTANDING HISTOGRAMS

One similarity between film and digital is that whether you are shooting with a digital camera or on film, getting correct

exposure is essential for getting great results. Your creativity and composition may be great, but unless it is exposed correctly, you have nothing at all. With film it is pretty easy to simply look at transparency and judge whether it was exposed correctly or not.

Some photographers and photo editors assume that exposure is not a problem with digital, because you see your results immediately. Although this is a great advantage, it doesn't actually solve all the problems. Once you start looking at and understanding the technical merits of a digital file, the world that you thought you knew changes very quickly.

Figure 1.4 (A) below contains only pure black and pure white. The histogram for this image, Figure 1.4 (B) looks like a pair of goalposts.

FIG 1.4 (A)
As Shot

FIG 1.4 (B)
Histogram showing pure black and pure white

While many folks would complain that the histogram above is a "poor" histogram, it is actually a perfect histogram for this particular image. This is a very important concept to understand. An image cannot be judged on its histogram alone, as illustrated above.

There is no such thing as a "perfect" histogram.

Every image has a histogram that represents the tonal values in that particular image. Judging an image solely on the histogram is a mistake that many people, photo editors and stock agencies make. You must evaluate the image and a histogram together.

Figure 1.5 (A) contains values from black (0) to white (255) and the histogram Figure 1.5 (B) clearly shows that. However, the histogram shown in Figure 1.5 (A) is not technically superior to the histogram shown in Figure 1.4 (A). They each represent the tonal values of their associated image.

In *Lightroom*, the left side of the histogram represents 0% luminance while the right side represents 100% luminance. Luminance is an indicator that describes the amount of light that passes through or is emitted from an object. It is an indicator of how bright something is.

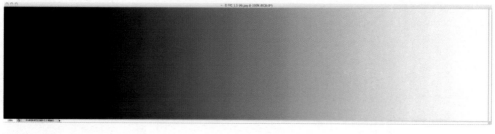

FIG 1.5 (A)

FIG 1.5 (B)
Image and histogram
showing values from
black (0) to white (255).

Now that you've grasped these concepts, things start getting more complicated!

We will try to keep this simple and in *English*. There is a conflict of sorts with digital, depending on whether you come from a school of photography based on aesthetics or based on technical value. Let us explain.

We grew up shooting transparency film and when we wanted certain colors to saturate, we underexposed them. Our mentor was and still is Jay Maisel and Jay typically hit an electric shade of red known for its vibrancy that was about 2 stops underexposed. Many of Jay's strong saturated colors were achieved with underexposure of as much as two or even three stops. He shot for years on a film that many came to love, known as Kodachrome. Today with a digital camera, you can still underexpose and the color will look similar to that of film but the quality of the file will be poor. *Why?*

The basic digital camera of today has a dynamic range of about six stops. The majority of cameras offer capture in 12 bits, meaning technically that they can capture 2^{12} power or 4096 tonal values. If you divided the 4096 tonal values between the potential of six stops and if each stop is looked at as a zone, it would be logical to assume that each stop has an equal amount of data. That logical assumption would be wrong and accounts for one of the biggest misunderstandings when it comes to exposing for digital.

Most digital cameras today use a sensor that simply counts photons. They produce a charge that's directly proportional to the amount of light that strikes them. The cameras for the most part use a series of array filters. The red-filtered elements produce a grayscale value proportional to the amount of red light reaching the sensor; the green-filtered elements produce a grayscale value proportional to the amount of green light reaching the sensor; and the blue-filtered elements produce a grayscale value proportional to the amount of blue light reaching the sensor.

A RAW digital file is truly a linear file. Ironically, data is captured in a linear progression very much the same way as traditional f-stops work with film. F 2.8 allows twice the light as F 4.0 and 4.0 is twice 5.6 and so on. So without getting too geeky here, one half of the data of a 12-bit capture (4096 levels) or 2048 levels is in the brightest stop (highlights), 1024 in the next stop, 512 in the next stop and so on until one gets to the shadows which contain only 64 levels. The darkest stop of the digital file has the least amount of data and thus shows the greatest amount of digital problems, mainly noise, which looks like static on a television screen.

THE DARKEST TONES	THE DARK TONES	THE DARK MIDDLE TONES	THE LIGHT MIDDLE TONES	THE BRIGHT TONES	THE BRIGHTEST TONES
FIVE STOPS DOWN	FOUR STOPS DOWN	THREE STOPS DOWN	TWO STOPS DOWN	ONE STOP DOWN	**2048** LEVELS AVAILABLE
64 LEVELS AVAILABLE	**128** LEVELS AVAILABLE	**256** LEVELS AVAILABLE	**512** LEVELS AVAILABLE	**1024** LEVELS AVAILABLE	

FIG 1.6
One half of the data of a 12-bit capture (4096 levels) or 2048 levels is in the brightest stop (highlights), 1024 in the next stop, 512 in the next stop and so on until the shadows that contain only 64 levels.

Since the most information in a digital capture is in the first brightest stop, the very act of underexposure reduces the quality of a digital file.

From a pure technical position, you should expose digital capture so that the most data is present. As a general rule, this means that a properly exposed digital file is slightly overexposed.

Let's think about film for a moment. When shooting transparencies, we typically underexposed to increase saturation and color. The problem here is that if we simply underexpose in camera, we will lose valuable data in our RAW files. Essentially, digital exposure is exactly the *opposite* of transparency film. In digital capture we want to make a judgment call on the overexposure side rather than the underexposure side. It is during processing that we can achieve our rich, saturated color, rather than during exposure where we would sacrifice the quality of the file.

D-65 is not saying to *always* slightly overexpose in digital. With film, the "correct exposure" is the correct exposure. However, many times that "correct exposure" is a slight underexposure in order to achieve the desired saturation and color. We don't however always underexpose film. Similarly, we don't always overexpose digital files.

WARNING: USING THE HISTOGRAM DISPLAYED ON THE BACK OF YOUR CAMERA

Not to further confuse the issue, but there is also a lesson here for the photographer. Many cameras have a histogram display on the back of the LCD on the cameras that warn when a highlight is about to be blown out and many photographers adhere strictly to the histogram. However, the LCD preview and the histogram on the back of the camera do not represent any real information regarding how your RAW capture will look. The camera does an "on the fly" conversion to sRGB.

The histogram is a luminance histogram of the sRGB preview, not a true representation of your file. As a general rule for some of the most widely used professional cameras, the overexposure warning is off by at least one stop. This prevents you from blowing out the highlight, but it typically also eliminates the brightest stop with the most information. The camera manufacturers set the threshold for this display too low, which will lead you to underexpose your image.

If you look at Figure 1.6, and realize that the histogram in the back of the camera is blinking at level 1024, instead of 2048 (one stop early), and if you are like most photographers, you are worried by the blinking histogram. So you back off one more

stop. You are now at level 512. You have successfully eliminated two-thirds of the information in this image. The blinking light is useful in that it really means you have at least one stop to the right before you are blowing out any highlights. One amazing quality about *Lightroom* is the ability to recover almost two stops of blown-out highlight detail captured by the sensor, but not visible in the camera LCD.

Beware of the camera's histogram and LCD!

| EXPOSING FOR DIGITAL

Determining exposure for digital capture is quite different than exposing for film. Digital camera sensors have a wider dynamic range and are much more sensitive to light than many films. You can use less created or strobe light with digital than you would with film. Lighting digital capture the same way you would light film will generally result in an image that looks overly lit.

Another common exposure problem is that people will base their exposure on a gray card and as a result shoot at that ambient light value. A light meter reading taken off a subject of known reflectance like an 18% gray surface is only giving you a base exposure.

With digital, it is vital to actually expose for the color as well as the ambient light. Colors change and vibrate depending on the exposure. Our best suggestion is to shoot at the same ISO value so that your brain gets used to the colors produced under similar light conditions. Ideally, shoot on manual so that you learn the light instead of letting the camera make the decision for you.

D-65 determines what color in a scene we want to accentuate. Our exposure is based on that particular color. For example, an image with bright, vibrant yellow and very dark blue will have a different exposure value depending on whether you are accentuating the yellow or the blue, regardless of the ambient light which is constant throughout the frame.

The key to getting a digital file that is technically good is essentially to shoot in a RAW mode and overexpose slightly and then bring it down during the processing phase. In the end you

can still end up with a red that looks like the Jay Maisel Red and in fact with a good RAW processor, you can actually achieve a better quality image with more detail and even more vibrant colors and saturation, but getting there is essentially the opposite of what we did when exposing film.

One thing that a photo editor must keep in mind is that if a photographer delivers a RAW file and it is exposed correctly for the greatest amount of data, the file will most likely be overexposed. A photo editor may naturally think that the photographer should learn how to expose if his own knowledge is based on working with film but the slightly overexposed digital file is actually the best one.

I 16 vs. 8: IS THERE A BIT OF DIFFERENCE?

Understanding the difference between 8-bit and 16-bit is a critical part of digital. *Lightroom* and *Photoshop* are all about 16-bit corrections and yet commercial printing is all about 8-bit. Why do you need to care about bits, especially if you end up printing in 8-bit and know that 16-bit images are twice as big as 8-bit ones?

Let's start with some basics: in digital imaging the number zero is the complete absence of color while the number 255 is represents the maximum level of a color. 8-bit RGB images use 0 to 255 to represent each channel of red, green and blue. Therefore, (255,0,0) is equal to red and (0,255,0) is equal to pure green, while (0,0,0) equals black and (255,255,255) equals white. Zero through 255 gives 256 total distinct values that each of these three channels can have. If you multiply 256 times 256 times 256, you get 16.7 million different combinations for an 8-bit image.

Now with 16-bit, we get 65,536 values for each channel instead of only 256. So 65,536 x 65,536 x 65,536 gives us 281 *trillion* total possible colors. It's confusing if we make it so technical, huh?

So let's put all this in simple English and use fruits to describe 8-bit to 16-bit. Fruit and *Lightroom* go hand and hand and will actually make total sense.

Before we explain it is important to understand that altering pixel data is a destructive process. Quite simply, everything we do in

Photoshop hurts pixels. In fact the best way of using *Photoshop* is the method that produces the least amount of destruction.

To make this easy we are going to use the concept of fruit. In this case 256 (8-bit) will be represented by apples and 65,536 (16-bit) will be represented by strawberries. Imagine that instead of pixels we had fruit deriving the images in Figures 1.7 and Figure 1.8). Apples represent 8-bit and strawberries represent 16 bit. Conceptually we are making rows of fruit instead of pixels, so we have 256 apples making up the image in the 8-bit model and 65,536 strawberries making up the 16-bit model.

Knowing that *Photoshop* is destructive, if we went ahead and did a levels adjustment on the 8-bit model we would have a hole, or in pixel terms a gap in data, in the image the size of one apple. If we did the same adjustment on the 16-bit model, we would have a hole, or gap in data, the size of one strawberry. We could do many more adjustments on the 16-bit model, with each adjustment causing another strawberry-sized hole before we had a hole the size of one apple.

FIG 1.7

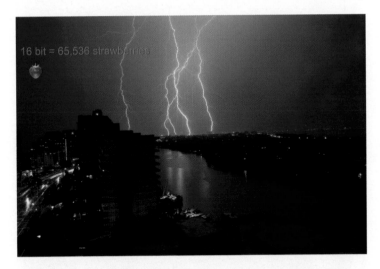

FIG 1.8

So as we edit in 16-bit mode, we will still lose data, but much less than we would in 8-bit. (It takes a lot of strawberries to make a hole the size of one apple.)

Can you see the difference between 16-bit and 8-bit? Yes and no. First, let's look at the histogram of the image with no changes, Figure 1.9.

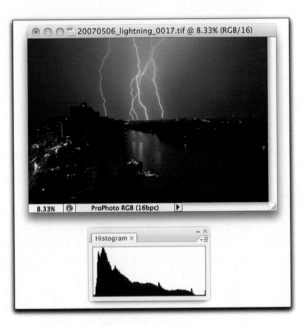

FIG 1.9

In the histograms in Figure 1.10 and Figure 1.11 choosing auto contrast, auto levels and a curves adjustment on both a 16-bit (FIG 1.10) and 8-bit (FIG 1.11) file will show a drastically different histogram. The histogram with the 8-bit file clearly shows gaps of data (apples vs. strawberries).

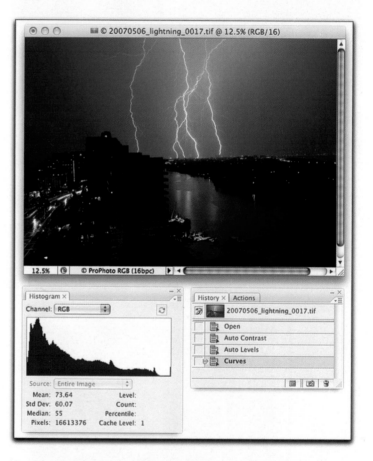

FIG 1.10
Histogram of image with adjustments done in 16-bit.

However, if someone were to show you a printed image, it may be very tough to decide whether it was 16-bit or 8-bit. There is one good example that is many times a tell-tale sign. In places like Miami where we have a nice blue sky, the sky in a print should go from a nice light blue to a much darker blue at higher altitude. In a print, you may notice that the sky goes from light blue and then there is a line or what looks like banding going to a darker blue. Typically what you are seeing is an image where the adjustments were done in 8-bit instead of 16-bit. The stripes or banding are

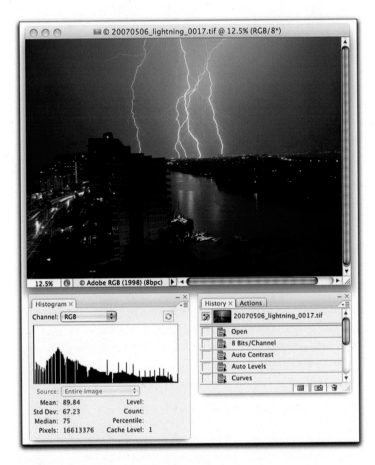

FIG 1.11
Histogram of image
with adjustments done
in 8-bit.

missing gradations of tone, so instead of a nice even light to dark
blue it appears as light blue and then a much darker blue.

So the bottom line is to work in 16-bit whenever possible.

FILTERS

While many photographers use all kinds of filters with film-based
cameras, it is generally not a good idea to use them with
digital. Why?

The glass in a lens is not flat and the lens is composed of many
different elements and element groups. This glass has a meniscus
curve. A meniscus curve is similar to the shape of a kneecap.

Light will pass through the glass lens with a meniscus curve, hit the sensor and then bounce straight out through the lens.

Putting a filter, like a skylight filter which is generally a screw mount, can wreak havoc. The glass on the filter is most likely not a meniscus curve and light will pass through the filter, hit the sensor, and then reflect back on the sensor instead of passing through the filter. Skylight and UV filters are also altering the wavelength of light that hits your sensor.

The conversion of photons to pixels by the sensor is based on calculations from pure, natural light. In simple English, changing the light with a UV filter will effect contrast in the final image because the sensor has no way of knowing there is a UV filter on top of the lens. A polarizing filter is the only filter that is acceptable for digital, because achieving the effects of a polarizer in *Lightroom* or *Photoshop* is nearly impossible.

So how do you protect your lens? Use the lens cap! Jay Maisel uses Velcro strips to keep the lens cap attached to each lens. Otherwise you may find them in your washing machine after they fall out of your back pocket.

YOUR PHYSICAL WORK ENVIRONMENT

A frequently overlooked but important part of digital workflow is the room that houses your computer. Your physical working environment must be considered part of your color management system. Following are some suggestions for maximizing the impact of your workspace.

- **Control ambient light when correcting color.** While many people work only in totally dark rooms while correcting colors, it is difficult to work in total darkness for long time periods. In reality, total darkness isn't practical and too much ambient light competes with the light emitted from the monitor. So you will need to find a balance that works for you in your environment.

- **Use a monitor hood.** Shield the monitor from ambient light by using a hood on its top and sides. These two areas should be shielded to a distance of 12". The inside of the monitor hood should be a matte black color. These hoods can be purchased

from stores catering to the graphics design trade or made using directions found on the Internet.

- **Configure a neutral computer desktop.** Your computer desktop should be as neutral a color as possible. A solid gray is optimum. Your desktop should not be configured to display an image of your child or favorite travel destination.

- **Neutral walls reduce color cast.** The visible walls around your monitor should be a neutral color; gray is ideal.

- **Keep CPUs and monitors away from sources of direct heat or cold.**

I WORKING BACKUPS

The most popular means of storing data is on hard drives. It is not a matter of if they will die, or fail. It is only a matter of *when* they will die. All data must be backed up regularly. For workflow, D-65 suggests a secondary hard drive to use as a backup, and to perform backups of your current work on a regular basis.

TIP FOR CANON CAMERA USERS:

Some camera manufacturers allow you to put information into a metadata field. By placing the proper copyright information into this field, you are embedding your name and copyright into the field so that every time you press the shutter the copyright and owner information is embedded into the files created by that camera.

For Canon cameras: connect the camera to the computer with a Firewire or USB cable. Using the Canon software, you can add and store your copyright information in the camera. This is an incredible asset and saves you a step during file processing.

FIG 1.12

| SUMMARY

- Not all memory cards are created equal, and bigger isn't necessarily better. Choose the correct memory card for your camera and for your needs. Don't forget to format your memory card every time you take it out of the camera.

- Only edit in camera when your memory card is not close to being full.

- The best image quality will be obtained when shooting at the optimum ISO for your camera. Noise is inherent at higher ISOs.

- The only filter acceptable for digital is a polarizer.

- Achieving the correct white balance may be subjective.

- X-Rite ColorCheckers can give a photographer the technically correct white balance.

- Your work environment is a critical component to your overall workflow and image quality.

- The histogram of an image shows the range of tone within an image. There is no such thing as a good or bad histogram. It simply reflects the tonal range of the image.

- Digital is linear capture, meaning we are capturing degrees of brightness. Twice the light or brightness equals twice the data or information.

- With digital capture, it is better to make a judgment call to overexpose, rather than underexpose.

- The histogram on the back of the camera is an sRGB histogram representing luminance only, and is typically off by one stop.

- It is essential to have a backup for digital imaging.

UNDERSTANDING FILE FORMATS AND SHOOTING RAW

| SHOOTING IN RAW MODE

RAW is the digital capture format that provides photographers with the ultimate flexibility and allows them to produce the optimum file for delivery to clients and reproduction. The RAW format provides the most data, which is the basis for generating the best final image. This format contains all of the actual data captured by the camera's CCD or CMOS sensor. Finally and most importantly, capturing RAW format files gives you a true original: a digital negative. You can always return to your original and process it differently.

In the world of film-based shooting, once the film was processed, there were very limited options to fix a poorly processed or improperly exposed roll of film. However, with digital capture in RAW format, the photographer can manipulate the actual pixel data after the fact to achieve the desired results. This could be as simple as adjusting white balance or increasing contrast in the image, or as complex as manipulating individual color channels to improve hue and saturation. You do not have the ability to make these types of changes to JPEG or other file types without negatively impacting image quality.

Some photographers choose to capture JPEG format files because it is faster. Yes, shooting JPEG files is faster, but has some inherent problems. The JPEG format uses a lossy compression technique that results in pixel data being thrown away even during image captures. This loss of original pixel data lessens the quality of the image. The JPEG algorithm throws away approximately 3800 values of brightness from the image and uses destructive compression to shrink an image into a smaller size at the expense of quality. In fact, a JPEG has one third of its luminance data discarded. Unfortunately, the most commonly implemented capture format for digital cameras is JPEG. Although appropriate in limited circumstances, the difference in quality is very noticeable at higher ISOs where increased noise and hue problems are clearly visible. Most importantly, every time you capture in JPEG format, you have lost your ability to have a real original, and have restricted your color space.

The differences between capturing all the data, as in shooting RAW, or capturing just some of the data, as in shooting JPEG, are pretty dramatic. Figure 2.1 reveals an image that was shot in RAW and processed as a TIFF. Notice the intense and rich color. This is what we would want the image to look like if we were showing it to a client or a teacher.

Next, take a look at Figure 2.2 and notice the difference in color and tone. This image was shot in the highest JPEG mode in camera. The colors are severely muted. If you were to shoot both JPEG and RAW and you were going to send your teacher or client the JPEG files as an example of what you shot, you would see that they look very different from the version you shot as RAW. For this reason D-65 stresses that you shoot RAW and then if need be, convert to profile in *Photoshop or Lightroom* so that the

color of the final image even in a JPEG will look the same as in the master file.

FIG 2.1
An image that was shot in RAW and processed as a TIFF. Notice the intense and rich color.

FIG 2.2
This image was shot in the highest JPEG mode in camera. The colors are severely muted.

The differences between an image with all the data and a compressed file like a JPEG go far beyond just the color. Look at Figure 2.3 (A) and Figure 2.4 (A) and notice the jagged edges revealed in the JPEG file compared to the full size TIFF file. Also notice the histogram for each file. You can clearly see data loss in Figure 2.4 (C) which is the histogram from the JPEG file.

FIG 2.3 (A)

FIG 2.3 (B)

FIG 2.4 (A)

FIG 2.4 (B)
Section of the JPEG
file enlarged showing
the effects of JPEG
compression.

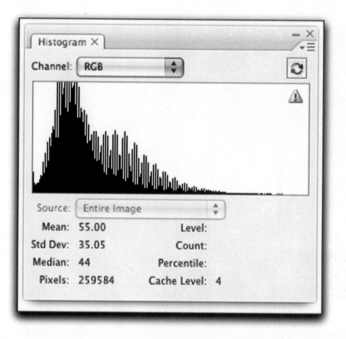

FIG 2.4 (C)

I THE IMPORTANCE OF DNG

Shooting digitally allows a photographer to combine editing with shooting—providing the power to see in real time and improve the image. Personally, we haven't shot any film in more than seven years, and doubt we will ever shoot film again. For what we do, digital is simply better.

But our intellectual property—and the intellectual property of all photographers—is at risk. Why? Almost every digital camera today creates a file, which is in a proprietary RAW format. A RAW file contains all of the data and information the chip in the camera is capable of capturing. Unlike JPEG, which is a lossy compression format that discards data and is only available as an 8-bit file, RAW preserves all of the color data and metadata. Using a RAW format, you can always go back and reprocess to different specifications without losing any quality.

In the old film-based world, when the film was processed, right or wrong, there was no going back. With the RAW format, however, the photographer is able to act as the "lab technician" and tweak the pixel data to achieve both tonal control and white balance.

You simply can't do this with JPEG or other compressed formats without a loss of image quality. Simply put, RAW is the format that is needed to produce the optimum file for delivery to clients and reproduction.

I THE MANY FACES OF RAW

Here, however, is the problem: there are many different and proprietary RAW formats. Each digital camera manufacturer has created one or more proprietary formats for RAW files; some manufacturers even change those proprietary formats between their individual camera models. We have NEF, TIF, CRW, and CR2—just to name a few RAW file extensions. And each camera company has created converters to change these RAW file formats into usable files such as JPEGs, PSDs, and TIFFs.

An additional factor is the evolution of operating systems. As these operating systems change—Mac 9.2 to OSX to Tiger, Panther, Leopard and Snow Leopard for instance—software that's compatible with those systems at the very minimum needs updating.

Suppose you have a 4-year-old camera that you used to photograph the greatest project of your life. Of course, you shot RAW because the RAW format is superior to all others. And you did everything right; you even backed up those files to all the media types several times. You now turn on your new computer and find that your camera manufacturer's converter has not been updated to the new operating system and won't run. Your greatest job can no longer be accessed. As operating systems change and as the world of digital capture grows, the potential for disaster increases.

Other problems can also arise. For instance:

• The photographic world is experiencing mergers and acquisitions as are many other sectors of our economy. Suppose your camera manufacturer merges with another company—as with Hasselblad and Imacon—or simply changes like Polaroid. Suppose they simply go out of business due to tough economic times. You may indeed own the copyright to your data files, but it could become a classic case of having no software to open them.

• Currently, to open RAW files, you can use the camera manufacturer's converter or a third-party software such as Adobe's *Lightroom, Capture One* by Phase One or Adobe's *Camera Raw*. From the perspective of digital photographers, the third-party manufacturers are typically the crème de la crème. Every time a new camera comes out, an engineer from the third-party manufacturer is required to reverse engineer the camera to try to adapt it to their software and then create an update for all their users. The lag time waiting for an update, however, can easily be six months. With all the new cameras coming out at such a rapid pace, it's possible that you could have the latest camera, but that your software of choice may not be updated.

As a photographer, you own the copyright to your work, which is granted at the moment of creation. You may own the copyright to your intellectual property, but if you can't access the intellectual property you create, you have nothing.

To me, the greatest concern for a digital photographer today is not how many times you archive, but whether or not you will be able to open your archive. Photographers are currently being held hostage because our ability to open these files is controlled by third parties. The need for a universal RAW format is imperative.

UNIVERSAL DNG?

With this in mind, Thomas Knoll—the guy who wrote the *Photoshop* program—and a group of other engineers from Adobe have produced a format designed to be universal—Digital Negative, or DNG.

Officially released in September 2004, DNG preserves all of the needed proprietary metadata and color information from the camera manufacturers, and also provides a universal means of archiving the data for all future generations. It does not replace the proprietary file, but rather creates a new file renamed as a DNG, so that you wind up with your original RAW file as well as a copy of the RAW as a DNG. The long term goal is that the camera manufacturers will utilize DNG as their RAW format, and do away with all the proprietary formats—so that all RAW files coming out of digital cameras are DNG.

Even *Capture One*, Adobe's biggest competitor for RAW processing, has announced that it would support DNG. This is a very positive step forward. We urge all photographers to embrace DNG as a means of preserving the very integrity of digital photography—it is absolutely a necessity in guaranteeing the long-term viability of our digital files.

The ability for us to create art is based on licensing and re-licensing our creations for future generations. If future generations can't even open our creations, digital photography itself is at a risk of demise. In the D-65 workflow, we always archive a DNG.

| FILE FORMATS

While there are many file formats including JPEG2000 and PDF, *Lightroom* supports the following file formats. What follows below is a basic description of each format.

- **RAW:** Raw formats contain unprocessed data from a digital camera's sensor. Most camera manufacturers save image data in a proprietary RAW format.

- **DNG:** Digital Negative (DNG) is a publicly available archival format for RAW files. By addressing the lack of an open standard for the RAW files created by individual camera models, DNG helps ensure that photographers will be able to access their files in the future. You can convert proprietary RAW files to DNG from within *Lightroom* and *Photoshop* and with the standalone free application *DNG Converter*.

- **TIFF:** Tagged Image File Format (TIFF, TIF) is used to exchange files between applications and computer platforms. TIFF is supported by virtually all paint, image-editing, and page-layout applications. However, most other applications, including older versions of *Photoshop (pre-Photoshop CS)*, do not support documents with file sizes greater than 2 GB. Most image editing applications will also recognize all the metadata contained in a TIFF file, making it the industry standard. The TIFF format provides greater compression and industry compatibility than *Photoshop* format (PSD) but has several save options and

takes longer to save than a PSD. In *Lightroom*, you can export TIFF image files with a bit depth of 8 bits or 16 bits per channel.

- **PSD:** *Photoshop* format (PSD) is the standard *Photoshop* file format. To import and work with a multi-layered PSD file in *Lightroom*, the file must have been saved in *Photoshop* with the Maximize PSD and PSD File Compatibility preference turned on. You'll find the option in the *Photoshop* file handling preferences. *Lightroom* saves PSD files with a bit depth of 8 bits or 16 bits per channel. Adobe applications all recognize PSD. Most other image editing applications will also recognize PSD, but in some cases those applications may not be able to read all of the metadata within the file.

- **JPEG:** Joint Photographic Experts Group format (JPEG, JPG) is commonly used to display photographs and other continuous-tone images in web photo galleries, slideshows, presentations, online services and on camera LCDs. JPEG is an 8-bit RGB image that compresses file size by selectively discarding data. When shooting the JPEG format in camera, there is a loss of about 20% of the data on capture. And every time a JPEG is saved, there is additional loss. Making changes to the JPEG file and saving it over and over again will eventually lead to a file that can no longer be opened in *Lightroom* or *Photoshop*, because each time you save a JPEG, random pixels are thrown away.

- **XMP:** Extensible Metadata Platform (XMP) is a type of metadata.

Metadata is a set of standardized information about a photograph, such as the author's name, resolution, color space, copyright, and keywords applied to it. Most digital cameras contain information about a file, such as height, width, file format, and the time and date the image was taken. You can use metadata to streamline your workflow and organize your files.

Lightroom supports the IIM standard of metadata originally developed by the International Press Telecommunications Council (IPTC). Wire services used this standard to identify transmitted text and images. IPTC includes entries for descriptions, categories, credits, and origins and its definitions are the basis for XMP.

XMP facilitates the exchange of metadata between Adobe applications and across publishing workflows. For example, you can save metadata from one file as a template, and then import the metadata into other files.

File information is stored using the Extensible Metadata Platform (XMP) standard. In the case of camera RAW files that have a proprietary file format, XMP isn't written into the original files. To avoid file corruption, XMP metadata is stored in a separate file called a sidecar file. For all other file formats supported by *Lightroom* (JPEG, TIFF, PSD, and DNG), XMP metadata is written directly into the files.

| NOTE: VIDEO

Lightroom 3 offers support for a variety of video files. It allows you to organize and manage video files but playback happens through an external player and there are no editing capabilities.

| SUMMARY

• There are six file formats that we discuss in *Lightroom:* RAW, DNG, TIFF, PSD, JPEG, and XMP.

• RAW and DNG are the only formats that contain all of the information the sensor is capable of capturing.

• There is currently no standard RAW format. This creates standardization and archiving issues.

• DNG is an open source solution to proprietary RAW formats. Digital needs to be as stable as film. Only a standard file format can assure this for the future.

COLOR SPACES FOR DIGITAL

| THE FOUR COLOR SPACES FOR DIGITAL

There are four major color spaces that we will discuss: sRGB, Adobe 98, ColorMatch and ProPhoto. First, think about color spaces as boxes of Crayola crayons. sRGB is the smallest box of crayons. It has 256 tones. The ColorMatch space can be thought of as a much bigger box than sRGB but not as big as Adobe 98. The large box that many people choose can be thought of as Adobe 98. It is like the big box of crayons with many shades of the same color. Finally, there is the ProPhoto color space, which is so big that there are more colors than you can fit into the box.

| UNDERSTANDING RAW DIGITAL CAPTURE

RAW files contain no color profile upon capture. Once you bring RAW files into an image processing software like *Lightroom,* a color space needs to be designated. ProPhoto is D-65's choice for processing RAW files. We also set up our Color Settings in *Photoshop* with ProPhoto as our working RGB. Why?

Digital cameras today have come a long way in a very short time. Today's sensors are capable of capturing a very wide tonal range. Unfortunately, the majority of photographers simply don't take advantage of the capabilities of their camera's sensor and inadvertently throw out very important color information without even realizing it.

Note that:

• Your camera captures a wider range of colors than you can see. The profile associated with the camera determines the colors available to be processed.

• Your camera captures a wider range of colors than your monitor can display. The profile associated with the monitor determines what colors presented to it are actually displayed.

• Your camera captures a wider range of colors than your printer can print. The profile associated with the printer determines which of the colors presented to it will be printed.

Let's start with how most cameras actually capture color or rather don't capture color. The camera sensor actually doesn't capture color at all. The sensor captures in grayscale only. It captures the intensity of the light in grayscale.

There are colored filters on the sensor so that a given pixel only sees light through a single colored filter of either red, green, or blue. Assuming you are shooting RAW, the job of the converter such as *Lightroom, Adobe Camera Raw* or *Capture One,* is to interpolate that data and render it as color.

If the pixel being interpolated was a "red" pixel, that value is assigned to red. If the pixel being interpolated is a "green" pixel, that value is assigned green, and if the pixel being interpolated

was a "blue" pixel, the value assigned is blue. With these three values, a color equivalent number can be calculated.

Every camera requires a profile or formula that can be used to translate the "zeros and ones" that become color equivalent numbers. Monitors and printers must recognize those numbers. This translation is essentially the goal of your working color space.

Okay, so in basic English, the color world we perceive with our eyes is captured by our cameras as light intensity in grayscale, translated into color by a special translator like *Lightroom*, and then passed on to our monitors, printers and all other devices.

I WORKING SPACE FOR DIGITAL

The majority of photographers use Adobe 98 as their working space. While delivery in Adobe 98 may be the so-called "standard" for delivery, it is not necessarily the ideal working space for digital photographers shooting RAW. Why?

ProPhoto can hold all the color the camera can capture, plus more. As cameras improve, they will capture even more colors. Every other color space including Adobe 98 will clip color from today's cameras. So the obvious question is, "What is clipping?"

In digital imaging, when a color falls outside the gamut or range, then we say that the color has been "clipped." If we did nothing about the color, then it would be left out of the final image. If we left these lost colors unattended, then our final image would come out looking flat, due to the missing hues.

One of the biggest complaints of digital photographers is the loss of reds. Well, when colors clip, red is the first to go. ProPhoto preserves the widest range of reds.

A monitor can display colors that cannot be printed. Paper, as well, can render colors the monitor cannot display. Why limit printed colors just because your monitor can't display them?

Epson and Canon printers can print colors that are outside the Adobe 98 space. Using a ProPhoto space will obtain a greater range of tones and colors. The bottom line is that **Adobe 98, or**

any color space except ProPhoto, does not preserve all the colors you get from the camera. Once the file is converted, the extra shades are gone forever.

We must also look towards the future. Most of today's monitors can't typically display all of the color in Adobe 98. Some of today's more expensive monitors and the monitors of tomorrow do and will display the full range of Adobe 98, if not more. For anyone using Adobe 98, you must ask yourself the question, "Why would you want to eliminate extra color and tone just because your monitor of today can't show it?"

| COLOR SPACE FOR THE WEB

The standard color space for the web for most monitors is sRGB. The reason for this is because when the standards were defined, sRGB was the largest space for any monitor. As monitors get better, there may be less of a need for sRGB.

| COLORMATCH COLOR SPACE

Another color space worth paying attention to is ColorMatch. ColorMatch was defined by the old Radius PressView monitors, which were an industry standard quite some time ago.

ColorMatch is very close to the gamut of CMYK (Cyan/Magenta/ Yellow/Black). Many photographers have difficulty converting to CMYK and complain about correct color when the client does the CMYK conversions from Adobe 98 for press. Since ColorMatch is very close to CMYK, it makes a lot of sense to deliver in ColorMatch if CMYK is out of the question.

Note: There is a problem delivering in Adobe 98 for most client/photographer relationships. Here's why:

In the old days, when we delivered film, the art director or pre-press house scanned the film and made a proof. Today, most art directors will receive a digital file in Adobe 98 from a photographer. This is where the problem starts.

Delivering in Adobe 98 is sort of like saying, "See all this color? Well, you can't have it." CMYK is a much smaller color space than Adobe 98. Delivery in Adobe 98 just about guarantees that the proof will *not* look like the image on the art director's monitor.

The blame then falls on the photographer shooting digital. If delivery occurred in ColorMatch, which is smaller than Adobe 98 and very similar to CMYK, the proof will look very much like what is on the art director's monitor. The digital photographer will definitely be hired again.

| USING COLOR SPACES AND PROFILES IN WORKFLOW

With this in mind, it makes sense for digital photographers shooting RAW to make their *Photoshop* Working Space ProPhoto, to process their RAW files as 16-bit ProPhoto, and to store their archive files as ProPhoto.

ProPhoto is perfect for the digital photographer, but it is not ready for prime time TV for the rest of the world. Because the majority of the world is in Adobe 98, you certainly don't want to deliver files to clients in ProPhoto. For client delivery, you may want to convert down to a color space the client can handle.

Most clients are used to Adobe 98. D-65's recommendation is to use the ProPhoto color space during RAW conversion, and then convert and deliver in Adobe 98 or ColorMatch. This will allow the photographer to gain greater tonal range and color and preserve it, achieving a better file. Converting the file to Adobe 98 or ColorMatch will preserve the greater tonal range and color while allowing the client to use the color space to which they are accustomed.

| WHY PROPHOTO?

• ProPhoto can hold all the color the camera can capture.

• As cameras improve, they will capture even more colors.

- When colors clip, red is the first to go. ProPhoto preserves the widest range of reds.

- A monitor can display colors that cannot be printed. Paper can render colors the monitor cannot display. Why limit printed colors just because your monitor can't display them?

- Epson and Canon printers can print colors that are outside the Adobe 98 space. Using a ProPhoto space will obtain a greater range of tones.

- The bottom line: Adobe 98 or any color space except ProPhoto does not preserve all the colors you get from the camera. Once the file is converted, the extra shades are gone forever.

I COLOR SPACES FOR CLIENT DELIVERY

Ideally, we would deliver images in CMYK using the International Color Consortium (ICC) profile supplied by the client or printer. Having the actual CMYK profile when we do our color conversions will produce the best results. However, much of the world disregards color profiles and/or doesn't understand color management. D-65 has a solution for these people, too.

If we are going to deliver RGB images, D-65 will deliver files in ColorMatch. ColorMatch most closely resembles what will be produced by CMYK output. Delivering files in Adobe 98 may look better on the screen, but may contain more colors than can be printed. So what you see is not going to be what your client will get in print.

For images being used on the web or in multimedia presentations, D-65 will deliver files in the sRGB color space. This limited space is the de facto standard for the web.

I DEMONSTRATION OF PROPHOTO

This is an image with a ProPhoto color space and a graph of the image in the color analysis program, *Chromix ColorThink*. See **Figures 3.1 (A), 3.1 (B), 3.2, 3.3.**

FIG 3.1 (A)
Image in the ProPhoto color space.

FIG 3.1 (B)
The image shown in
FIG 3.1(A) showing a
map of the image color

This graph displays our image plotted in Adobe 98. Notice how much of the image is out of gamut, or outside the map of Adobe 98. See the red out of gamut right here.

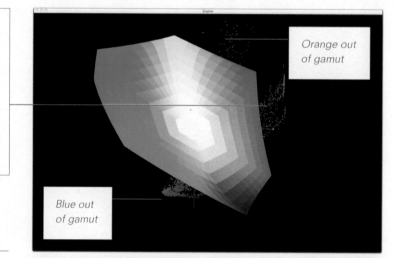

Orange out of gamut

Blue out of gamut

FIG 3.2

The graph displays the image mapped in ProPhoto and you will notice that ALL of the color is contained within the ProPhoto space.

FIG 3.3

| WHEN TO ASSIGN OR CONVERT PROFILES

One big problem with color management that always surfaces is how to handle files with different tagged color profiles or without any color profile at all.

- When opening a file, always assign a profile to an untagged (missing a profile) file. If a file comes in without a profile, use your working RGB.

- Convert from a source color profile to a destination color profile when you want to retain the color in a file, but need it in a different color space. For example, you would convert a ProPhoto file to sRGB when it is being used on the web. It will still look like the ProPhoto file, but will be tagged sRGB.

- A big misconception is that you can "go up" or increase the color space of a file. While *Photoshop* will allow you to convert from sRGB (a smaller space) to ProPhoto (a larger one), the effect will be one not of additional colors, but only more tones of the same colors.

Lightroom has really simplified many of the tough choices associated with color processing. For one, *Lightroom's* Develop Module uses a very wide color space, essentially ProPhoto RGB but using a gamma of 1.0 instead of 1.8. A gamma of 1.0 matches the native gamma of RAW camera files and ProPhoto is able to contain all of the colors that your camera is able to capture. Since ProPhoto is really a 16-bit space, *Lightroom* uses a native bit-depth of 16 bits per channel.

It makes sense to process your RAW files in ProPhoto and to store your archive file as ProPhoto. For client delivery, you will want to convert to the client-provided CMYK profile or, for a webpress, U.S. Web Coated (SWOP) v2 is a good default if you can't get the ICC profile from the printer. Use ColorMatch RGB for print or sRGB for the web. D-65 does not deliver images in the ProPhoto color space because most clients would not know how to handle it.

Images in *Lightroom* can be in any color space and will be color-managed provided the image has an embedded profile. If the image(s) you are working on do not have an imbedded profile, *Lightroom* will automatically assign sRGB without a warning dialog box.

| SUMMARY

- There are four important color spaces for digital photographers. They are from smallest to largest: sRGB, ColorMatch, Adobe 98 and ProPhoto.

- It makes sense to work in ProPhoto for digital imaging, but deliver in ColorMatch or convert to CMYK for print.

- If your images are going onto the web, sRGB is the correct color space.

- *Lightroom's* native color space is 16-bit ProPhoto.

- Assign a profile when an image is not tagged with one.

- Convert to profile when going from a larger color space to a smaller color space.

- While Adobe 98 may be the so-called standard, it isn't necessarily the best color space for digital photographers capturing in RAW.

LIGHTROOM'S ARCHITECTURE

The basic architecture of *Lightroom* brings a rather unique concept to software development. While *Lightroom* itself is one application, its construction is modular in nature. *Lightroom* is currently built with five modules: Library, Develop, Slideshow, Print and Web. *Lightroom's* modules are like five separate applications working in a nested-together fashion. Each module comes with its own set of tools, templates and panels. One of the neat things about the architecture of *Lightroom* is the possibility of third party developers constructing additional modules to enhance *Lightroom* even further in the future. (**Figure 4.1**).

FIG 4.1
Lightroom's Library Module

I MODULES

The modules are located on the top right corner of the *Lightroom* window. Clicking on the name of the module allows you to move between each module (**Figure 4.2**).

FIG 4.2
Lightroom's
Five Modules

I PANELS

On the left and right side of each screen are panels. Each panel contains functions specific to that module. Generally, the panel on the left side contains content and templates (**Figure 4.3**)

while the panels on the right contain the tools for each module
(**Figure 4.4**).

FIG 4.3
Slideshow Module
Left Side Panel

FIG 4.4
Slideshow Module
Right Side Panel

I TOOLBAR

The toolbar is located underneath the grid or loupe view of your
image(s). It contains controls specific to each module and can be
customized by the drop-down menu located at the right side of
the toolbar. Your screen size will depend on how many tools can
be seen on your toolbar. To view more tools, you can collapse
the side panels with the Tab Key. The Library Module Toolbar is
shown in **Figure 4.5**.

If you think your version of *Lightroom* doesn't have a Toolbar, try hitting the T key. The T key is the keyboard shortcut for showing and hiding the Toolbar.

FIG 4.5
Library Toolbar showing drop-down menu of available tools

I FILMSTRIP

The filmstrip at the bottom of the screen is a view of the current selection in the Library. The Filmstrip displays the photos you are working on as you move between modules. It displays selections from the currently selected Library folder, collection, keyword set, or contents of the Quick Collection.

One great little tip is that you can move forward or backward through your previously viewed images by using the Left or Right Arrows.

FIG 4.6
The *Lightroom* Filmstrip with Go Back Arrow highlighted

I *LIGHTROOM* KEYBOARD SHORTCUTS

There are some terrific basic keyboard shortcuts that will definitely speed up your workflow in *Lightroom*. We have outlined some below.

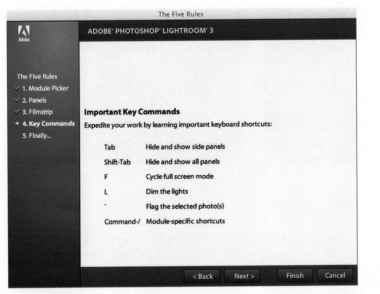

FIG 4.7
Some Important
Keyboard Shortcuts

- Tab will hide and show side panels (**Figure 4.8** and **Figure 4.9**)

FIG 4.8
Library Module Grid View with Panels showing

FIG 4.9
Library Module Loupe View E Key

- The G key is Grid View (**Figure 4.10**) and the E key is Loupe View (**Figure 4.11**)

FIG 4.10
Library Module Grid View G key

FIG 4.11
Library Module Loupe View E Key

• Shift-Tab cycles to full screen (**Figure 4.12** and **Figure 4.13**)

FIG 4.12
Normal view in Library Loupe

FIG 4.13
Shift Tab brings Loupe View Full Screen

• Pressing the F key will switch to full screen mode and pressing it again will switch to absolute full screen mode, hiding the system bar and hiding the Dock (**Figures 4.14 – 4.16**).

Sometimes people get fooled, because in absolute full screen mode they can't get to their desktop and they think that *Lightroom* has taken over their system and f....' them. **This is a good way to remember what the F key does.**

FIG 4.14
Pressing the F key will change this view to full screen mode

FIG 4.15
Pressing the F key changed this view to full screen mode (System bar and Dock are showing)

FIG 4.16
Pressing the F key again switches this view to absolute full screen mode (System bar and Dock are hiding)

• *Lightroom* can "turn out the lights," meaning that it can dim the technical sections of the screen so that you can view the image more clearly. Pressing the L key once will dim the lights darkening the interface. Pressing the L key again will turn the screen black and pressing it again will take you back to the default (see **Figures 4.17** thru **4.19**). Under *Lightroom* Preferences you can set the shade of gray and the opacity used in dimming.

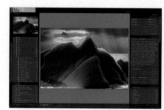

FIG 4.17
Lights On

FIG 4.18
Lights Dim

FIG 4.19
Lights Out

| ADDITIONAL LIBRARY KEYBOARD SHORTCUTS IN *LIGHTROOM*

• Using Control–Plus (+) and Control–Minus (-) will reduce and increase the size of the thumbnails in the grid

• The spacebar toggles between Fit and user set zoom views in loupe mode

• The spacebar in the grid view will change the view to loupe

• The D Key takes you from the Library Module Grid View into the Develop Module

• Command–Option–Up Arrow will take you to the previous module

• Command–F will activate search

• Command–K will activate the keyword entry field

• Command–Right Slash (/) takes you to the keyboard shortcuts for each module – this is GREAT!

I CREATING CUSTOM WORKSPACES
 IN *LIGHTROOM*

You can create custom workspaces allowing you to display only the panels you want, when you want to see them, to maximize your image size or screen real estate (**Figure 4.20**).

FIG 4.20
Control-Clicking on a panel allows you to custom configure the panel to show or hide

You can manually extend panels, making the sliders larger or smaller. To do this, mouse down on the edge of the panel, and a crosshatch will appear. Drag the cross hatch to the right or left to expand your image size (**Figure 4.21**). This is particularly useful in the Develop module because it allows you to extend the length of the sliders, which provides more accuracy and finesse. Note the extended panels on the right in **Figure 4.22**.

Mouse down and drag to extend a panel.

FIG 4.21

FIG 4.22

I CREATING A FULL SCREEN WORKSPACE

D-65 likes to use the F key and the Tab key to create a full screen workspace. We sometimes find it annoying, however, that the panels on the right and left roll over when you don't want them to roll over. An option that we find useful to correct this annoyance is to press down the Control key (or right-click with a mouse) and at the same time, click on the Panel Group Icon (designated by the little gray triangle pointing to the left and right of the panels). Choose Manual or Auto Hide. Both allow you to show the panels instead of having them roll over. You can also synchronize the behavior with the opposite panel (**Figures 4.23** and **4.24**).

FIG 4.23
Control-Clicking on the Panel Group Icon to set panels to open and close using Manual

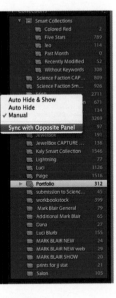

FIG 4.24

- **Auto Hide and Show:** Displays the panel as you move your mouse to the edge of the application window. Hides the panel as you move the mouse away from the panel–this is the default.

- **Auto Hide:** Hides the panel as you move the mouse away from the panel, but to open the panel, you must use the Tab key or click on the little grey triangle.

- **Manual:** You must open the panel manually by using the Tab key or clicking on the little grey triangle.

- **Sync with Opposite Panel:** This synchronizes both panels so that you do not have to configure each panel separately.

| *LIGHTROOM* PRESETS

Lightroom comes with preconfigured presets, and the user can also create their own presets. Presets are settings that can be created and saved to accomplish various tasks in each module of *Lightroom*. Creating and using presets is an excellent way of speeding up your workflow.

Where Presets are Stored in *Lightroom*

If you have created any presets in *Lightroom* and would like to move them to another computer, they are stored in: User Library>Application Support>Adobe>*Lightroom*.

FIG 4.25
Path for *Lightroom*
Preset Folder

Preset Locations for *Lightroom* in Windows

Presets are stored on Windows machines in: Documents and Settings>[username]>Application Data>Adobe>*Lightroom*.

On Windows Vista and Windows 7 the path is: Users>[username]/AppData>Roaming>Adobe>*Lightroom*.

For easy access, you can get to this folder by going to the Edit>Preferences>Presets and choosing Show *Lightroom* Presets folder.

FIG 4.26
Easy access to
Lightroom's presets

Moving Presets from One Computer to Another

It is easy to create a preset on one computer and use it on
another computer. Copy the preset that you would like to move
to another computer and place it within the corresponding folder
on your second machine. Make sure never to delete any of the
folders that hold the presets. You can also select a preset, right-
click and export that preset. That preset can then be imported
onto another computer.

Help Available from Every Module

Help and Keyboard shortcuts for each and every module are
available under the Help menu while you are in that module.

FIG 4.27
Help and Shortcuts for
each module

I SUMMARY

Lightroom is comprised of five modules, each designed
for a specific task. The functionality of each module is
controlled by a toolbar, panels and templates. There
are many useful keyboard shortcuts and presets to
boost workflow.

SETTING UP *LIGHTROOM*

All software comes with pre-configured default preferences. Many of us just assume that the defaults are appropriate and start using the software. The defaults may be fine for some, but disastrous for others. In order to truly streamline your workflow, it makes sense to configure your preferences and options so that they best suit your needs and to do so before you start using the software. With this in mind, this chapter will cover all of *Lightroom's* preferences, catalog settings and a few other configurable options so that your *Lightroom* will really fly and your workflow will be more efficient.

I *LIGHTROOM'S* PREFERENCES

Now, let's setup *Lightroom's* preferences. Go to the *Lightroom* main menu bar to *Lightroom*>Preferences. We will go through each of the preferences panes.

FIG 5.1
To set up *Lightroom's* preferences, go to the *Lightroom* main menu bar to *Lightroom*>Preferences.

I GENERAL PREFERENCES

By default, *Lightroom* will load your most recent catalog. D-65 suggests keeping all your photos in one catalog. However, you may want to create more than one catalog if you cannot hold all of your images in one location, or if you'd like to organize your system differently. You can choose to load another *Lightroom* catalog at any time from this general preferences menu. You can also choose another catalog by holding down the option key when starting *Lightroom*.

| General | Presets | External Editing | File Handling | Interface |

Settings: ☑ Show splash screen during startup
☑ Automatically check for updates

Default Catalog

When starting up use this catalog: /Volumes/Lightroom3_Library/Lightroom_Catalog/Lightro... ⬍

Import Options

☑ Show import dialog when a memory card is detected

☑ Ignore camera-generated folder names when naming folders

☐ Treat JPEG files next to raw files as separate photos

Completion Sounds

When finished importing photos play: No Sound ⬍

When finished exporting photos play: No Sound ⬍

Prompts

(Reset all warning dialogs)

Catalog Settings

Some settings are catalog-specific and are changed in Catalog Settings. (Go to Catalog Settings)

FIG 5.2
D-65's suggested setup for *Lightroom's* General Preferences

I PRESETS PREFERENCES

Default Develop Settings. D-65 chooses not to apply auto tone or auto mix. While we may use auto at times, we prefer to start out with our images "as shot," and manually decide how to process them. The reason we do choose "Make defaults specific to camera serial number and ISO setting" is that we might choose to apply a develop preset on import, which is camera- and ISO-specific. If this camera model or ISO should change, with these checked, the develop preset would not be applied.

Location. If you have more than one catalog, you might want to choose to "Store presets with catalog." We like to have our presets available all the time, no matter what catalog we choose or if we create a new catalog. Therefore, D-65 does not check "Store presets with catalog."

Lightroom Defaults. Restoring any of the presets listed will restore them to the way *Lightroom* is configured out of the box. This is useful if you have deleted or made changes to some of the default presets in *Lightroom*. A great way to move custom

presets from one computer to another is by clicking the "Show *Lightroom* Presets Folder."

FIG 5.3
D-65's suggested setup for *Lightroom's* Presets Preferences

I EXTERNAL EDITING PREFERENCES

Edit in Adobe *Photoshop* CS5: One of the totally cool features of Lightroom is the ability to open a file from *Lightroom* directly into *Photoshop*. This can be done using *Lightroom's* Photo Menu>Edit in Adobe *Photoshop* CS5, or keyboard shortcut, Command-E. You can then save that same file directly back into *Lightroom* next to or stacked with the original. You even have the ability to pick a second application for editing. For example, maybe you have a plug-in that only works in *Photoshop* CS4. You can pick *Photoshop* CS4 as your second application. You will then have the choice to open a file in *Lightroom* directly into CS5 or CS4 from *Lightroom's* Photo Menu.

Why would you use the external editing feature? Suppose you shot a skyline of seven frames and they are all in Lightroom. You want to use CS5's stitching capability to create a panoramic. You would select all the images in *Lightroom,* choose Command-E

to open them in CS5, and create your panoramic in CS5. When you close the file, it automatically creates a new panoramic file in *Lightroom*. Without this feature, you would have had to export each file individually from *Lightroom* and then open each file in *Photoshop*, and import the new panoramic file back into *Lightroom*. The external editing feature is a huge timesaver because you are basically able to bypass the import dialog altogether.

The File Format preference is for the files you are going to create in *Photoshop* or your designated external editing application. D-65 chooses a 16-bit ProPhoto RGB PSD or TIFF, because these are the types of files we create for working in *Photoshop*.

TIFF maybe more compatible with keeping up with changes in metadata in all applications. This is recommended for best preserving metadata in Lightroom. The first thing any application is going to update is to a TIFF standard.

Additional External Editor: OK, so why would you want a second editor? One reason a second editor may be desirable is if you want to use *Photoshop* plug-ins. Historically, all plug-ins needed to be rewritten for CS3 and many developers still have not updated some of the plug-ins even though we are up to CS5. If you wanted to use a plug-in that hasn't yet been updated, you may want to choose CS2, CS3, or CS4 as a second editor. If you work on images in several applications, you even have the ability to create a preset for additional editors, specifying the file type, color space, and bit depth per each application preset.

Edit Externally File Naming: We do not apply an export naming convention because we rename during our *Lightroom* workflow, and we like to keep those same names for our exported files.

FIG 5.4
D-65's suggested setup for *Lightroom's* External Editing Preferences

I FILE HANDLING PREFERENCES

Import DNG Creation: If you choose to import as a DNG, instead of copying or moving the camera proprietary RAW file, we suggest the preferences listed in **Figure 5.5**. We choose to import the proprietary RAW file and export a DNG. This way, our proprietary RAW file will match the DNG file. We do this because although we love DNG and believe that it will be here to stay, it is still not universally adopted. Our concern is that if we imported as DNG and DNG was not adopted, that we might have to go back and re-tweak all of our proprietary RAW files. We don't ever want to even think about that scenario. Our hope is that one day DNG will be adopted universally and we would simply be able to import our DNG files and toss our proprietary RAW files.

Some folks like to embed the original proprietary file in the DNG. We do not do this because it takes much longer to embed the file and it would take equally long to extract the file if needed. If DNG isn't adopted, we would have to extract original proprietary RAW files from every file. Ouch.

Reading Metadata: If you are using other applications or have used applications in the past that separate keywords with a period or slash character, then you should check "Treat "." as a keyword separator," and "Treat "/" as a keyword separator." *Lightroom* uses commas (",") to separate keywords. This preference makes it very easy to import and utilize keywords applied to images even if the keywords are not separated by commas and were generated in another application.

File Name Generation: D-65 uses underscores in our file naming convention. Other software applications use all kinds of characters, including spaces, which are known as illegal characters in filenames. Use of illegal characters in filenames can cause applications to have difficulty reading the filename or substitute randomly generated characters in their place. Spaces are particularly notorious for causing problems between computers.

To ensure cross-platform compatibility, *Lightroom* provides some very cool options. Even if your filename contains illegal characters or spaces, *Lightroom* will substitute legal characters for the illegal ones. D-65 chooses to "Replace illegal filename characters with underscore" when a file name has a space or an illegal character. Without this powerful feature, you would have to manually rename all your files that had illegal characters. Now it can be done automatically for you upon import!

Camera Raw Cache Settings: The *Camera Raw* Cache is used for caching RAW data for processing. Caching speeds up the Develop module.

Purging the cache. You may find that older camera profiles identified in the Calibrate panel may have displayed poor results at extreme ends of the temperature and tint ranges. There are new camera profiles for *Lightroom* and some of you may be using your own profiles created with X-Rite's Color Checker Passport (www.xritephoto.com/ph_product_overview.aspx?id=1257). Purging the *Camera Raw* Cache will clear any older profiles from the thumbnails. New thumbnails can then be generated using the latest version.

New in Lightroom 3 is the ability to increase the *Camera Raw* Cache up to 200 GB. Whether this is a true benefit or not is debatable, but we will try to explain and then you can make your

NEW

own judgment. The ACR Cache is really for an optimization process which will vary depending on the photographer's workflow.

The .lrdata files in the *Lightroom* Catalog are *Lightroom* Previews stored in a JPEG format. These JPEGs are either 1:1, Standard or Thumbnail and are a user option set in Catalog Settings as well as under Import in the Library Module. These previews are used to display images in all of the modules of *Lightroom* with the exception of the Develop Module.

Develop scans the previews to initially render on screen, but then it reads the actual RAW data. After the RAW data is analyzed, Develop performs initial processing, frees up the sliders so you can start working, and then completes processing the RAW data to render everything properly. So the big difference is that the Develop Module is using true RAW data, not just the .lrdata previews that the other modules use.

Now, here is where it gets a bit complicated. While *Lightroom* reads the RAW data, it also stores it in the *Camera Raw* Cache in a partially processed state, to save reading and reprocessing the full RAW data each time. That is particularly beneficial for speed, especially in Develop loading times, because part of the work has already been completed. If the data isn't in cache, as is the case with the same library but on a different computer (laptop for the road for example), it will just read the RAW data.

Once the cache reaches its limit, it becomes a temporary rolling cache, that is, the oldest images are removed to add the newest images. Images are added to the ACR Cache whenever the RAW data is read—for example, when building previews, updating previews, or loading into the Develop module.

○ ○ ○ Preferences

General | Presets | External Editing | File Handling | Interface

Import DNG Creation

File Extension: dng

Compatibility: Camera Raw 5.4 and later

JPEG Preview: Medium Size

☐ Embed Original Raw File

Reading Metadata

☑ Treat '.' as a keyword separator During import or when reading metadata Lightroom can recognize

☑ Treat '/' as a keyword separator dot, forward slash, and backslash separated keywords as keyword hierarchies instead of flat keywords. The vertical bar is automatically recognized as a hierarchy separator.

File Name Generation

Treat the following characters as illegal: / : \ * ? " < > | ¥ = + : , ^ []

Replace illegal file name characters with: Underscores (_)

When a file name has a space: Replace with an Underscore

Camera Raw Cache Settings

Location: /Users/seth_main/Library/Caches/Adobe Camera Raw (Choose...)

Maximum Size: 200.0 GB (Purge Cache)

FIG 5.5
D-65's suggested setup for *Lightroom's* File Handling Preferences

I INTERFACE PREFERENCES

Panels: Feel free to play with the Interface preferences until you find a look that you like. These preferences allow you to customize the visual look and feel of *Lightroom*. You can see what engineers do for kicks late at night by trying some of the different Panel End Markers. For fun, try Yin Yang or Atom. And you thought that engineering was all work and no play!

Lights Out: Controls the color of the background in Lights Out mode. You can also control the dim level. 80% is the default and D-65 stays with the defaults.

Background: The color surrounding your image in Loupe View. Medium Gray is the default, although many people like to change this to black. You can also add pinstripes as texture.

Keyword Entry: You have a choice of commas or spaces for separating keywords, as well as the choice of auto completing text in the keyword tags field.

FIG 5.6
D-65's suggested setup
for *Lightroom's* Interface
Handling Preferences

Filmstrip: You can choose "Show ratings and picks" as well as "Show badges." The other useful choices here are "Show photos in navigator on mouse-over" and "Show photo info tooltips." ***New in Lightroom 3*** is the ability to show stack counts in the Filmstrip (**Figure 5.7**).

FIG 5.7
Stack Count in Filmstrip

Tweaks: Some folks like the "Zoom clicked point to center" option. This option always centers the area that is zoomed. Choosing "Use typographic fractions" will display fractions in metadata fields using fraction characters, superscript or subscript.

I GENERAL CATALOG SETTINGS

Click on the General Preferences Window and click on "Go
to Catalog Settings" on the bottom (**Figure 5.8**). You can
also get to the Catalog Settings under *Lightroom's* Main
Menu>*Lightroom*>Catalog Settings (**Figure 5.9**).

FIG 5.8
Go to Catalog Settings

FIG 5.9
Go to Catalog Settings
from Menu

FIG 5.10
D-65's suggested set up for *Lightroom's* General Catalog Settings

Information: This shows what catalog you are working on, and information on that specific catalog, such as the size, when it was created, backed up and optimized.

Backup: D-65 chooses to "Back up catalog:" Never.

Depending upon the preference you choose for backup, you might see the dialog box in **Figure 5.11** when *Lightroom* starts or exits. The only time you will not get this window is if you choose to "Back up Catalog:" Never.

The choice to "Backup every time *Lightroom* exits" is a new and desirable option for LR3, but we think that a better option is to use software like *Super Duper* or *Retrospect* to back up both the catalog and the images, which we do twice a day. **Understand that using the backup in *Lightroom* will back up the catalog but not the images themselves.**

FIG 5.11
Back UP Catalog Dialog

I FILE HANDLING CATALOG SETTINGS

Preview Cache: Embedded previews, generated on the fly by the camera, are not correctly color-managed. These previews will not match *Lightroom's* interpretation of the proprietary RAW file. Previews rendered by *Lightroom* are fully color-managed.

Lightroom can create three types of Previews. It can create thumbnails, Standard and full 1:1 Previews. All of these previews are stored in the *Lightroom*_Catalog Previews.lrdata file. There is no right or wrong preview choice. The best choice depends on what works best with your workflow.

Previews are not the easiest thing in the world to understand, and in fact, just might be the most complicated concept in all of *Lightroom*. If you find it too complicated, many folks simply choose Standard and that should be fine for most needs. For those of you who zoom into 1:1 and don't like to wait, like us, you will probably want 1:1 previews.

Now, a more "geeky" explanation of preview technology for those those geeks out there. For every RAW file, *Lightroom* needs several previews of different pixel dimensions called by engineering, a preview pyramid. The reason for this is that as you zoom in, *Lightroom* must be able to deliver a high-quality image. The first preview is set by the size you set for standard previews. If the RAW file is large, like one from a Canon 5D or 1DSM11 (e.g., 20 MP) and the standard size is down around 1440, you will initially have fewer previews for each image in this pyramid. If you render 1:1 previews, *Lightroom* will have rendered all the other previews required for each in the pyramid of the zoom levels up to 1:1. This makes the file quite large.

Standard Preview Size: Designates the maximum dimensions for the rendered preview. Ideally, you would choose a size appropriate for your monitor and camera pixel size. You have four choices: 1024, 1440, 1680 and 2048. If all you want is standard sized, then choose a size equal to or slightly less than your screen resolution. *Lightroom* will also build smaller versions at the same time. These versions are used for the thumbnail, 1:2, 1:3 and 1:4 zoom levels.

FIG 5.12
D-65's suggested set up for *Lightroom's* File Handling Catalog Settings

The problem here is that many of you will use both a laptop and a desktop monitor. At some point in the future, it may be possible for *Lightroom* to build two different file sizes based on the size of the screen you are using. We use 30-inch monitors and as such we choose 2048 pixels.

Preview Quality: Designates the quality of the thumbnail. Low, medium and high, similar to the quality of the JPEG dialog box. You can see the image better with a high quality JPEG, although it will take up more space.

If you choose a Low resolution preview, it will take up very little space and will load very fast. However, should the file not be online, *Lightroom* will be unable to build very clear slideshows, web galleries or previews in the Library without them appearing jaggy.

Medium previews will work well for many people except that they display using the color space of Adobe 98 and if you need to zoom in to 1:1 to check focus, it will take a bit of time.

High Res 1:1 Previews have only one real downside, their size. 1:1 or full-size previews take up a large amount of hard disk space: ours consume almost 230 GB.

Some folks who like the benefits of the 1:1 previews build them on demand as an alternative to building them up front. They certainly take up a lot of space, and take time to build, but they allow for full-screen size images in the Library Module, Slideshow

Module, and Web Module, even when the images are not online. High Res previews will also look exactly the same in the Library Module as in the Develop Module. If the High Res previews are saved and stored, you can even scroll through full screen images in your Library with rapid succession and zero wait time for any rendering. D-65 chooses High for our workflow.

Automatically Discard 1:1 Previews: The choice to discard previews depends on your workflow. For example, a photographer who shoots a job, works on it, delivers it, and never needs to go back to that job again probably never has any use to keep these high resolution previews. A photographer who is routinely moving between shoots would more likely want to keep the high resolution previews for an extended or indefinite period of time. A wedding photographer who works furiously on a wedding for three weeks straight and then hopes he or she never has to deal with that wedding again may want the 1:1 Previews for the three weeks that they were working on the wedding and then toss them. A photographer who shoots stock and is constantly going through images from different dates may find it more beneficial to never toss the 1:1 previews.

D-65 would never want to toss the 1:1 preview, and wait for them to be regenerated the next time we are in that folder in our Library. Let's discuss a couple of basic considerations depending upon your philosophy:

Lightroom grabs the smallest thumbnail it can in order to keep up speed. With a low-res preview, *Lightroom* will load the thumbnails very quickly, but when you scroll through the images they will take time to generate. If you choose a higher quality to begin with, the import process will slow down, but when it is done, the previews are fully generated.

Lightroom will start by loading the embedded or sidecar thumbnail. Nikon image files (NEF) are particularly slow because many of them have full resolution previews.

D-65's workflow sacrifices the time and speed up front in order to get the highest quality thumbnail preloaded. Processing power and RAM may play a significant role in your choice. If you're fortunate enough to have a powerful computer with lots of RAM, you will find that you can gain both speed and quality.

Import Sequence Numbers: This is the default first number of your sequence of images on import.

| METADATA CATALOG SETTINGS

Editing: The menu choice "Offer suggestions from recently entered values" is something of which we have grown very fond. *Lightroom* tries to auto complete what you are writing for keywords and captions.

For all of you who own an iPhone, you know that when you first got your phone, texting drove you nuts because the phone was entering values and text that you didn't want. Once you and the iPhone got used to the auto-complete behavior, it was fantastic! This is exactly the way *Lightroom* behaves with this feature. "Clear All Suggestion Lists" cleans out and restores the default values.

"Include Develop settings in metadata inside JPEG, TIFF and PSD files" is great idea as it allows us to move between *Lightroom* and *Camera Raw* without having to export a new file. Go to *Lightroom*>Catalog Settings>Metadata and include a check in the box to "Include Develop settings in metadata inside JPEG, TIFF, and PSD files." This is a great option.

Lightroom handles JPEG, TIFF and PSD in a non-destructive fashion. When you make changes to these files in the Develop module, you are only changing a preview of the image on screen. It looks like you're changing the photo permanently, but you're not. Just like a RAW file, if you ever want to get back to the original JPEG, just click the Reset button in the Develop module and it's like nothing ever happened at all. The file can retain all the settings just like copyright information in File Info. By checking this box, the changes are written as metadata to the file, which is really quite cool.

FIG 5.13
D-65's suggested
set up for
Lightroom's Metadata
Catalog Settings

"Automatically write changes into XMP" is a subject of great debate. If you do not choose this, all changes to the XMP are written to the internal database only. This really allows *Lightroom* to fly. The problem with this is that if the database becomes corrupted, there is no way to extract this information. So in plain English, you might lose all the changes you have made to your images.

D65 advocates always saving an XMP file next to the original RAW file. We accomplish this by manually saving the metadata to the files, by choosing Save Metadata to File from the Metadata menu in the Library Module.

Automatically writing changes may sound great because you do not need to remember to save the XMP, but it is very taxing on the computer. Every time you make a change, the information is written to the internal database as well as to a sidecar XMP file. If the database ever crashes, you will not have lost any information.

Automatically writing XMP will also allow *Lightroom* and other programs like *Bridge* to work seamlessly by synchronizing the XMP settings. By doing this, the XMP files will always be located in the sidecar XMP with the RAW files.

To summarize, we feel it is safer to always write the XMP but *Lightroom* will take a speed hit to do it automatically. For those who want to write the XMP and not suffer a speed hit, uncheck "Automatically write changes to XMP" and when you are done working on images, either select the individual images or the entire folder of images and choose Command-S or *Lightroom*>Metadata>Save Metadata to File. This means rather than saving each and every step, you wait to the end of your working session or part way through it and then write the XMP files all at once (**Figure 5.14**).

If you are the kind of person that can remember to manually save the XMP, you should uncheck the box to automatically save XMP but if you are the kind of person who will probably not remember to save the XMP you may want to check the box.

We prefer to manually save the XMP.

FIG 5.14
Manually Saving
Metadata to File

EXIF: Exchangeable image file format (EXIF) is a specification for the image file format used by digital cameras. "Write date or time changes into proprietary RAW files," the last option in this dialog box, is one we don't check. We never want to change our proprietary RAW files. Choosing this option will write time or date changes directly to the file as opposed to writing them to the sidecar XMP file.

I *LIGHTROOM* OPTIONS

Lightroom also has many configurable options as well
as preferences.

I OPTIMIZE CATALOG

Catalog Optimization is much improved in *Lightroom* 3.0.
It also has a new location which can be accessed from
Lightroom>Library>File>Optimize Catalog. If your catalog is
running extremely slowly and you are seeing a lot of spinning
beach balls, or have any other problems, select Optimize
Catalog. Even if you don't have lots of problems it is a good idea
to optimize the Catalog on a regular basis.

FIG 5.15
Optimize Catalog

When you choose to Optimize Catalog, *Lightroom* will go
through a series of corrective and preventative steps akin to an
oil change for *Lightroom*.

FIG 5.16

Optimizing will indicate the last time you optimized the catalog.

Your catalog was last optimized 3/1/10 @ 8:18 AM. If it has been running slowly and you haven't optimized it recently, optimizing it again may improve performance.

Optimization may take several minutes. You will be unable to use Lightroom during this time.

Cancel Optimize

FIG 5.17

Optimizing can take quite some time depending on size of catalog.

Optimizing Catalog

This may take several minutes

Cancel

If optimization does find a problem, it will be corrected about 95% of the time. Should *Lightroom* be unable to repair the catalog, the application will be unable to launch the catalog. One of the most common problems causing a major *Lightroom* error is unplugging a drive containing a catalog or images before shutting down *Lightroom*. Because this is a common mistake and because it can produce a fatal *Lightroom* error, D-65 always suggests having a backup of your catalog. It's that 5% that falls under Murphy's Law, and will no doubt affect you if you do not have a backup.

FIG 5.18

One of the most common and potentially fatal conditions for *Lightroom* is disconnecting a drive containing images or a catalog before closing *Lightroom*.

Lightroom encountered an error when reading a catalog file and needs to quit.

Lightroom will attempt to diagnose the problem the next time it launches.

OK

The last time Lightroom ran, it shut down prematurely due to a problem reading the catalog. Lightroom must now check the catalog before proceeding.

OK

FIG 5.19
When a catalog is launched after a problem is discovered, Lightroom will diagnose and attempt to fix the problem. 95% of the time the problem can and will be fixed and the catalog will be faster and more efficient.

Unexpected error opening catalog.
The catalog could not be opened due to an unexpected error.

Try Again Quit Choose a Different Catalog

FIG 5.20
Catalog unable to be repaired.

I IDENTITY PLATE SETUP

Listed right under Preferences in *Lightroom's* Main Menu is the Identity Plate Setup.

| Lightroom | File | Edit | Library | Photo | Metadata | View | Window | Help |

About Adobe Photoshop Lightroom 3...

Preferences... ⌘,
Catalog Settings... ⌥⌘,
Identity Plate Setup...
Edit Watermarks...

Services ▶

Hide Lightroom ⌘H
Hide Others ⌥⌘H
Show All

Quit Lightroom ⌘Q

FIG 5.21
Location of the Identity Plate Setup

Think of the *Lightroom* Identity Plate literally as a vanity license plate. You can create Custom Identity Plates which can be placed at the top left section of the *Lightroom* interface and in specific modules like Slideshow, Print and Web. In a Web Gallery the identity plate can be a live link. So for D-65 the logo is not only a vanity plate but it will also bring folks directly to D-65.com from a web gallery. This can be your logo or any graphic. You

can save multiple identity plates. In our example below, we have saved an identity plate with the name D-65.

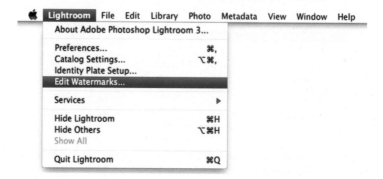

FIG 5.22
Identity Plate Editor
dialog box.

I EDIT WATERMARKS

A long asked-for feature is the Watermark Editor, which is new in *Lightroom* 3. The Watermark Editor allows you to customize and identify any information you want to apply as a watermark to your images. There is control over font, opacity, position, size and you can embed watermark graphics into your images. The Watermark Editor is available from the Library, Web, Print and Develop Modules as well as in the Export dialog box.

FIG 5.23
Selecting the
Watermark Editor from
the Library Module.

With the Watermark Editor, you can create a text-based watermark or utilize a graphic-based watermark created in another application like *Photoshop*. For a text based watermark, you simply enter the information for the watermark in the box

below the image. In our case we typed "© 2010 Seth Resnick All Rights Reserved."

Under Text Options you can choose the font, style, alignment and color. Under the Shadow dialog box you can control the Opacity, Offset, Radius and Angle of a Shadow on the created text. Watermark Effects provides options for opacity, size, and positioning which is controlled by Inset, Anchor and Rotate.

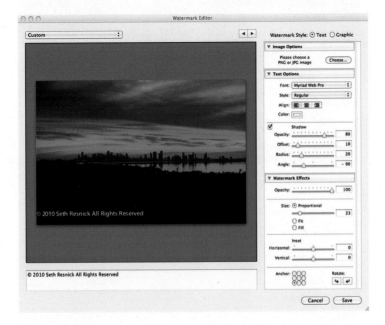

FIG 5.24
Options for the
Watermark Editor.

| 64-BIT PROCESSING IN *LIGHTROOM*

Currently, most commercial software is built as 32-bit code, not 64-bit code. *Lightroom* 3 ships with 64-bit potential. The 64-bit version of *Lightroom* will give a performance kick of about 8 to 12 percent compared with the 32-bit version. For one particular task—opening up a large file on a system with a lot of memory—the 64-bit version is 10 times faster because it doesn't have to write the data that won't fit in memory onto a relatively slow hard drive. 64-bit can utilize as much RAM as you have, leaving some available for the operating system.

The Mac version of *Lightroom* is both 32-bit and 64-bit. The Windows version is available as a 64-bit separate download. To enable 64-bit, find and select the Application, Get Info, and uncheck Open in 32-bit Mode. In our opinion, it is worthwhile because every little speed boost makes a difference.

Make sure that "Open in 32-Bit Mode" is NOT checked

FIG 5.25
Setting *Lightroom* 3 for 64-bit Mode

Lightroom running
in 64-bit mode

FIG 5.26
Lightroom running in
64-bit mode

I VIEW OPTIONS

One way to customize your Library is to display information over
your images for both Grid and Loupe Views. While these are
really options for the Library Module, we like to configure them in
advance of using the Library Module so it is appropriate to cover it
in this chapter on Preferences. The view options can be accessed
under the View Options in the View Menu of the Library Module.

Lightroom	File	Edit	Library	Photo	Metadata	View	Window	Help

Hide Toolbar	T
✓ Show Filter Bar	\
Toggle Loupe View	
Toggle Zoom View	Z
Zoom In	⌘=
Zoom Out	⌘−
Increase Grid Size	=
Decrease Grid Size	−
Sort	▶
Grid	G
✓ Loupe	E
Compare	C
Survey	N
Go to Develop	D
Crop	R
Spot Removal	Q
Adjustment Brush	K
Graduated Filter	M
Adjust White Balance	W
View Options...	⌘J
Grid View Style	▶
Loupe Info	▶
Enable Mirror Image Mode	

FIG 5.27
View Options Menu

Under Grid View in Library View Options (**Figure 5.28**), D-65 chooses Expanded Cells to display all of the available information on the thumbnails in the grid.

FIG 5.28
Library View Options

Under Options, we choose to uncheck "Show clickable items on mouse over only." With this checked, Rotation buttons and flags will only show when the pointer moves over the cell. Deselecting this option means that clickable items are always displayed.

"Tint grid cells with color labels" will display the color of a label (i.e., red) in the background of the cell. We find that this is incredibly hard on the eyes (**Figure 5.29**) and instead we uncheck this feature and check "Show Rating Footer, Include Color Label" (**Figure 5.30**).

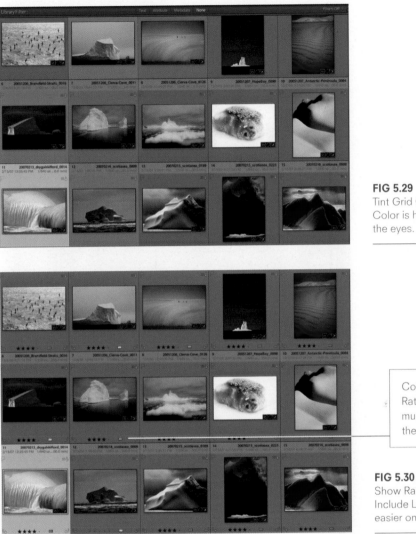

FIG 5.29
Tint Grid Cells with
Color is hard on
the eyes.

Color Label in
Rating Footer is
much easier on
the eyes.

FIG 5.30
Show Rating Footer,
Include Labels is much
easier on the eyes.

"Show image info tooltips" will include a description of an item,
like a badge, or a pick flag, when the pointer is over the item.

FIG 5.31
Image info tooltips

Under Cell Icons, "Flags" will display a Pick or Rejected icon in the upper-left corner of the thumbnail cell.

"Quick Collection Markers" shows the Quick Collection marker in the upper-right corner of the photo thumbnail. We turn this feature off and use the shortcut (B) to mark an image for a Quick Collection. We find it to easy to hit the marker by mistake.

"Thumbnail Badges" will reveal photos that have keywords, cropping applied, or image adjustments.

"Unsaved Metadata" is by default unchecked and we prefer to have it checked.

When you've added metadata to an image in *Lightroom* without saving the metadata to file, the "Metadata File Needs to Be Updated" icon will appear in the upper-right corner as a reminder.

Icon showing
unsaved metadata

Icon showing Quick
Collection Marker

Thumbnail badges
showing keywords,
cropping and
image adjustments

FIG 5.32
Cell Icons

"Compact Cell Extras" can be chosen to show the Index
Number, which is the order number of the photo in Grid and
Rotation. "Index Number" shows the order number of the photo
in Grid view. "Rotation" makes rotation buttons available. "Top
Label" shows your choice of information from a menu as does
"Bottom Label."

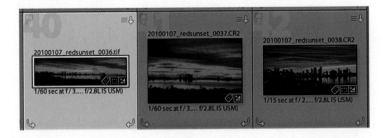

FIG 5.33
Compact Cell Extras

"Expanded Cell Extras" offers "Show Header with Labels" which
can display up to four items that you choose from the menus.
"Show Rating Footer" shows the footer items you select. We like
to choose "Include Color Label" and "Include Rotation Buttons."

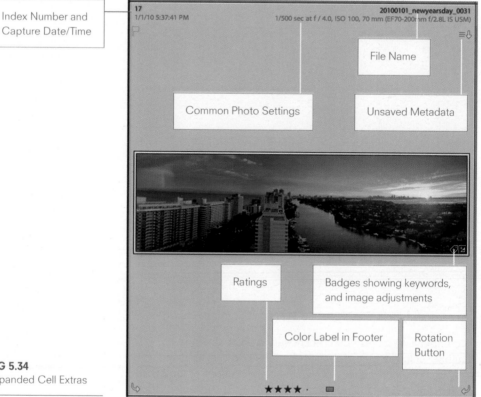

Index Number and
Capture Date/Time

17
1/1/10 5:37:41 PM

20100101_newyearsday_0031
1/500 sec at f / 4.0, ISO 100, 70 mm (EF70-200mm f/2.8L IS USM)

File Name

Common Photo Settings

Unsaved Metadata

Ratings

Badges showing keywords,
and image adjustments

Color Label in Footer

Rotation
Button

★★★★ ·

FIG 5.34
Expanded Cell Extras

Under Library View Options Loupe View (**Figure 5.35**), D-65
chooses to show File Name, Capture Date/Time and Common
Photo Settings. Whatever information is useful to you can be
configured for your workflow.

• Info 1 displays the Info 1 Overlay.

• Info 2 displays the Info 2 Overlay.

• Cycle Info display cycles through the two Info Overlay sets.

• The letter I will toggle between the displays.

FIG 5.35
Library View Options
Loupe View

FIG 5.36
Loupe View with File
Name, Capture Date/
Time and Common
Photo Settings. Using
the letter I you can
toggle between views.

I SUMMARY

- *Lightroom's* Preferences can be configured to streamline workflow.

- Using an External Editor in *Lightroom* allows for images to be worked on in another application and brought directly back into *Lightroom* without importing the images.

- The *Lightroom* Catalog also has settings to streamline workflow.

- If your *Lightroom* Catalog is running slowly, you can optimize and repair it.

- Choosing *Lightroom* preview quality really depends upon what your needs are as a photographer. D-65 chooses high quality previews all the time because it is the only preview that loads in the ProPhoto color space and allows for 1:1 previews.

- The Identity Plate in *Lightroom* is not only a vanity plate, but can also be used in slideshows and web galleries as a direct link to your website.

- The Watermark Editor allows you to customize and identify any information you want to apply as a watermark to your images.

- The 64-bit version of *Lightroom* will give a performance kick of about 8 to 12 percent compared with the 32-bit version.

- One way to enhance your Library is to customize the display information over your images for both Grid and Loupe Views.

CHAPTER 6 |
THE *LIGHTROOM* CATALOG

I DIGITAL ASSET MANAGEMENT

Lightroom is a true digital asset management system, and much more powerful than a simple or even advanced browser. An image browser allows you to simply browse folder structures and see thumbnails, while *Lightroom* stores information directly into a database. One of the key differences here is that with *Lightroom*, all of your information about your images is available even if the image collection is not online or connected to your computer. This means that you can take *Lightroom* on a laptop and still

see twenty years' worth of images and all the accompanying metadata, without physically having those images with you. You cannot do this with an image browser.

Let's make this really simple. Let's suppose that you have your images on an external hard drive. With Adobe *Bridge*, for example, in order to see those images, the hard drive has to be connected to your computer or the images will not be visible. With *Lightroom*, your external hard drive with the images can be a thousand miles away and you would still be able to see your images on your computer.

There are pros and cons to each of these approaches. The biggest pro for *Lightroom* is that the majority of the information about your images is available regardless of whether the images are with you or not (on- or off-line). The downside or the con to *Lightroom* is that in order to achieve the above, the images must be imported into *Lightroom's* database.

Looking at the biggest pro and con of *Bridge* in comparison to *Lightroom*, is that you do not have to import anything into *Bridge* to view it. You simply scroll through a hierarchy and can view your images. The downside is that anything you want to view must be connected to your computer or on your connected hard drive.

Lightroom will not replace *Bridge*. They are intended to complement each other. If you need to deal with files like PDFs and Quicktime movies, and you want to place files from one Adobe application into another, you will likely find that *Bridge* is good for your workflow needs. If you are a digital photographer and looking for a true digital asset management system, where you can even take your entire image collection on the road with you, then *Lightroom* is your answer.

I *LIGHTROOM* IS LIKE YOUR LOCAL PUBLIC LIBRARY

Let's explain the concept of the *Lightroom* Catalog using a visit to your local public library as an analogy (**Figure 6.1**). When you walk into your local public library, there are thousands of books, on many shelves and possibly on multiple floors. You've come to the library today to find one book. You can ask the librarian for

help, or you can go to the card catalog for all kinds of specific information about every book in the library.

It would be possible but illogical to walk through the aisles looking at every book to find the title you are seeking. Instead, you go to the card catalog and find the location of your book and simply walk directly to the right location. Similarly, it is not efficient to browse through a million thumbnails to find one image. So *Lightroom* uses a catalog (*Lightroom* Catalog.lrcat) as its card catalog for your images, the same as the card catalog in your public library.

Now, let's add to this concept. Your public library doesn't exist with only a card catalog. There is a physical building that holds all the books within it, along with the card catalog. In *Lightroom*, your images are also stored in a physical place. D-65 prefers this image library to be an external drive, or a secondary internal hard drive. This hard drive is your "public library" and all the images that reside in it are your "books." You may have thousands of images, just like a library has thousands of books. These images become your *Lightroom* Library. To find a specific image, you will use the power of *Lightroom's* Catalog, exactly like the card catalog at your local public library.

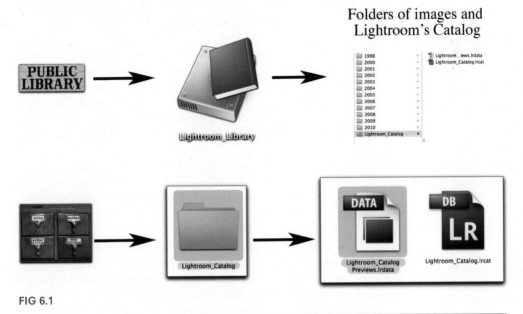

FIG 6.1

93

| THE *LIGHTROOM* CATALOG

So how does *Lightroom* work? To fully understand how *Lightroom* works, we will need to examine its structure. A lot of this is **new in Lightroom 3.0**, especially *Lightroom's* behavior with Previews, which we will delve into later. *Lightroom* has four basic components:

NEW

1. There is the application itself, Adobe *Lightroom*, which resides in your application folder.

2. There is also a *Lightroom* folder containing two very important files: the *Lightroom* Catalog.lrcat and the *Lightroom* Catalog Previews.lrdata. These two files are the heart of *Lightroom*. The default location for this *Lightroom* folder is in your User>Pictures folder.

 The *Lightroom* Catalog Previews.lrdata file contains the thumbnail previews for each of your image files. Specifically, it contains JPEG data that is used to create previews for the Library, the filmstrip and for output. There are several types of previews available to you, and we will cover them later.

 The *Lightroom* Catalog.lrcat file contains all of the database information related to your images.

3. There is one more folder which is stored in your User>Library>Application Support>Adobe>*Lightroom* folder which contains all of the presets that come with *Lightroom*, as well as any custom presets that you may create. The Windows path for this information is Documents and Settings>[Username]>Application Data>Adobe>*Lightroom*.

4. The Develop Module in *Lightroom* uses the Preview cache only momentarily while it loads the actual RAW file. The Develop Module needs the full file in order to apply settings to the pixel data.

 In order to optimize time spent switching between images in the Develop Module, Adobe *Camera Raw* stores some of the data it needs in a cache. This ACR Cache which is set as part of the preferences in *Lightroom* does not store previews, but stores processed image data that is used

to give a boost to the Develop Module whenever it need rendering changes. The default location for the ACR Cache is Users>Library>Caches>Adobe Camera Raw.

When you initially open *Lightroom* on a clean system, the user is not prompted to select a catalog. The catalog is automatically created in the User>Pictures folder. (**Figure 6.2**) If you already have *Lightroom* installed, you can option-click when starting *Lightroom* and select the location for your catalog. This is where your digital asset management system begins.

FIG 6.2
Default Catalog Location

| *LIGHTROOM'S* CATALOG LOCATION

Here is the critical concept. The default location for the catalog created by *Lightroom* and your images is in your User>Pictures folder. For an amateur or even a professional who does not have a large collection of images, this default location is fine. But keep in mind that with today's cameras, like a Canon 1DS Mark III, each file can be close to 100 MB.

As your computer's internal hard drive becomes more than 50 percent full, it rapidly loses efficiency. Potentially, your catalog could easily become larger than the space on your main hard drive. For this reason, we prefer not to use the default location, and instead use large dedicated drives (internal or external) to hold our *Lightroom* Library and *Lightroom* Catalog. D-65 is currently using a 1.5 terabyte 7200 RPM drive to hold the *Lightroom* catalog and the *Lightroom* library.

To set up your new *Lightroom* Library and Catalog, we suggest using two large dedicated hard drives. One is for holding your *Lightroom* Library and Catalog, and one as a backup holding the exact same information. We name the drives *Lightroom*_Library, and *Lightroom*_Library_BK. Regardless of how many hard drives we have, we always know which one holds our images and

catalog for *Lightroom*. Naming the hard drives in this way keeps things organized right from the start.

TIP: A simplified approach for the hobbyist or for the photographer who does not have thousands of images.

The number one problem we encounter with folks using *Lightroom* is that they end up with multiple catalogs on many drives and they can't find their images. This problem is so prevalent that we even did a video with Michael Reichman called, "Where the #$@! Are My Pictures?"

Why the problem?

If your *Lightroom* Catalog is on an external drive and is set to be your default catalog in the preferences, everything will work fine until one day when you start *Lightroom* and your drive with the catalog is not plugged in or online.

As soon as this happens *Lightroom* will start up from a new catalog in the User>Pictures folder and it will appear that you have lost all your images. We can't begin to tell you how many times people have called us to say that *Lightroom* has lost their images and 99% of the time this is the problem. **(Figure 6.3)**

FIG 6.3
Lightroom opened up without the hard drive that has the catalog connected.

So, if you are not a technically inclined person or if you don't have that many images, you may want to consider simply leaving your catalog at the default location in the User>Pictures folder. The benefit of this is that you will never misplace or "lose"

your catalog or your images. **If you are a power user or a professional with thousands of images, we strongly suggest that you maintain your catalog and images on a dedicated drive.**

We use an internal drive to store our *Lightroom* Catalog and our RAW files. There is nothing else on this drive. It is dedicated to *Lightroom* only. By using an internal drive, we are able to have the fastest possible connection. We maintain an exact duplicate of this drive on a second drive just for safety and we call this drive *Lightroom*_Library_BK. The "BK" stands for backup.

Lightroom_Library

Lightroom_Library_BK

FIG 6.4
*Lightroom*_Library hard drive and backup drive

I WHAT IS THE *LIGHTROOM* CATALOG?

In order for *Lightroom's* Catalog to "see" or recognize an image, the file itself must be physically imported into *Lightroom*. The *Lightroom*_Library hard drive contains all of those imported files. In *Lightroom*, you can only have one catalog loaded at a time. We choose to use a 1.5 terabyte drive, so that we can hold all of our imported files and the *Lightroom*_Catalog on one dedicated hard drive that is always loaded as *Lightroom's* default.

D-65's *Lightroom* Library contains mostly RAW files and some finals that needed further work in *Photoshop*. These can be RAWs or DNGs. We try holding our RAW files in the *Lightroom* Library, and only a few processed files for one specific reason. *Lightroom* may slow down if more than 150,000 files are in the Library. Eventually, the goal is for *Lightroom* to be able to hold at least one million files.

D-65 has taken all of its RAW files going back to 1998, and imported them into the *Lightroom* Library. Our dedicated 1.5 terabyte drive contains folders of RAW files, each designated with a job name (year, month, day, underscore job name). Also on

this 1.5 terabyte drive is our *Lightroom* Catalog folder. It is held within the Library. See **Figure 6.5** below.

Lightroom_Library window showing folders 1998–2010 with dates

FIG 6.5
External Drive holding all the folders of RAW files, along with the catalog

As you can see, D-65's catalog folder is very large. This is our primary reason for a large, dedicated drive holding all of our *Lightroom* files. Most folks do not have the space necessary on their primary drives for this amount of data.

Lightroom Catalog.lrcat (the catalog that stores information on your images in the Library)

FIG 6.6

Lightroom_Catalog.lrcat Info

Lightroom_Catalog.lrcat 1.16 GB
Modified: Today 3:12 PM

▼ Spotlight Comments:

▼ General:
 Kind: Adobe Lightroom Library
 Size: 1.16 GB on disk (1,159,463,198 bytes)

Lightroom
Previews.lrdata
(the file that holds
the preview data
assigned to
your photos)

FIG 6.7

I PROCEDURE TO CREATE A NEW CATALOG

1. From the *Lightroom* Library Module choose File>New
 Catalog or Start *Lightroom* while holding down the
 option key

2. The Select Catalog window will pop up with your
 catalog's location

3. Choose "Create New Catalog"

4. Choose the drive that you named *Lightroom*_Library

5. Under "Save As," type in *Lightroom*_Catalog

6. Choose Create

7. *Lightroom* will open with your new catalog loaded

FIG 6.8

The next time you start *Lightroom* with the option key down, you will see your new catalog listed. We suggest checking "Always load this catalog on startup" so that it will always load as your default catalog.

FIG 6.9

Create Folder with New Catalog
Save As: Lightroom_Catalog ▼
Where: Lightroom_Library ▲▼
Cancel Create

CATALOG TIPS:

• *If you ever lose your Library or Catalog, you have to physically choose the catalog file (.lrcat) within the Lightroom_Catalog folder.*

• *To create a new catalog, hold down the Option/Alt key on Windows or the Options Key on Mac when starting Lightroom.*

• *Lightroom's performance will decrease significantly if virus software is turned on.*

I USING MORE THAN ONE CATALOG IN *LIGHTROOM*

You can create more than one *Lightroom* Catalog in order to aid with organization and digital asset management. The downside is that you can only have one Library and one Catalog open at the same time.

There is no right or wrong answer as to how many catalogs you have in *Lightroom*. It is a matter of philosophy. George Jardine, a past Adobe *Lightroom* Evangelist, loves to have catalogs for every place he travels. For him, this makes total sense because he simply looks at the title of the catalog, and loads the catalog

he is trying to find. A photographer who shoots weddings, bar mitzvahs and social events may very well want a separate catalog for each type of event.

Since you can only view images from one catalog at a time, D-65 prefers to have one large catalog holding all the information on our images, and using extensive metadata and keywords to describe each image. In this way, we can drill down and find anything we want. For example, we will always have keywords or metadata describing the location we shot, so if we wanted to find all of our Miami Beach images, we would simply search the entire catalog for Miami Beach, and find those images. George Jardine would just load the one Miami Beach catalog. Two ways to do the same thing.

I SUMMARY

- *Lightroom* is a digital asset management system, not just a browser.

- *Lightroom* needs a catalog to find images. It is just like the card catalog at the Public Library. Inside the *Lightroom* Catalog are two very important files, catalog.lrcat and previews.lrdata.

- D-65 chooses to change the default location of the catalog because of its size.

- D-65 creates its own dedicated *Lightroom* Library that holds all RAW files and the *Lightroom* Catalog.

- You can create a new *Lightroom* Catalog.

- You can use just one catalog or more than one catalog, but only open one at a time.

Let's start by talking about *Lightroom's* first Module, the Library. The Library Module is "command central" for *Lightroom*. This is the heart of the digital asset management system. It is where you view, sort, search, manage, organize, rank, compare and browse through your images.

The *Lightroom* Library Module is a true database that catalogs all imported images so you can view previews and data whether the images are online or not. **All images must be imported into *Lightroom* to view them.** The import process imports the image

and also creates a metadata record in *Lightroom's* Catalog. This record contains all the data about the image including location, editing instructions and previews. The catalog can be thought of as the authoritative source of information for *Lightroom*.

It is important to understand the distinction between the *Lightroom* Library Module, and the *Lightroom* Library hard drive that we create to hold image files and the *Lightroom* Catalog. The *Lightroom* Library hard drive is simply a physical place that holds yours images and *Lightroom's* catalog much like a public library. We've discussed the importance of this *Lightroom* Library hard drive in Chapter 4. Now, let's talk about the features of the *Lightroom* Library Module.

The *Lightroom* Library Module is one of *Lightroom's* five modules and the module where all organization takes place.

There are many positive changes in *Lightroom* 3. Here are a few of the cool ones just for the *Lightroom* Library.

| LIBRARY MODULE IMPROVEMENTS IN LIGHTROOM 3

• Performance and Image Quality. The very core of the application was ripped apart by the development team and rebuilt to meet the needs of photographers with large image collections and increasing megapixels and consequent gigabytes of storage necessary or "major gigage"

• Improved performance throughout the Library for faster importing and loading of images

• Faster thumbnail scrolling

• Faster module switching

• The entire preview system has been overhauled so the thumbnail Grid won't be out of focus as you scroll (as in previous versions)

• Improved preview quality

- Ability to support CMYK files as well as RGB

- Optimize Catalog is now available directly from Library File Menu

- Find Missing Photos to locate offline or missing photos

- Find Previous Process Photos to locate photos first processed in an earlier version of *Lightroom*

- The ability to Match Total Exposures available from Develop Settings in Library

- Double-clicking on stack count badge now expands the stack with all photos selected

- Enhanced sorting with the addition of sort by aspect ratio

| THE LIBRARY FILTER

- Search Filters are no longer sticky, meaning that the last filter you performed will not be enabled the next time you open the filter panel

- Library Filter Source includes the ability to add favorites

| COLLECTIONS

- Thumbnail badge shows when photo is in a Collection

- Clicking on the badge will take you to the Collection

- Collections can be created within a Collection Set by Control- or right-clicking on the Collection Set

- Collection Set photos can be sorted by aspect ratio

- The name of a collection is displayed when a photo is added to a target collection

| SMART COLLECTIONS

• Adds new criteria for conditions like "is" and "is not" and Flash State Library

| HISTOGRAM

• Animation in the Library Histogram

| LIBRARY PAINTER TOOL

• Using the Option key will turn the Painter Tool into an Eraser Tool

| LIBRARY METADATA

• Show EXIF and IPTC Metadata

• Several new views available including IPTC Extension

• Edit a Metadata Preset in Library Menu

| PUBLISH SERVICES: Brand new feature for *Lightroom* 3 allows you to publish photos to popular sites such as Flickr directly from within the *Lightroom* Library.

• Real two-way synchronization, so that any comments made on your Flickr account will also appear in *Lightroom*

• While Flickr is the first Publish Service available, more will be added in the future

• There is an option to "Limit to KB size" which automatically adjusts the quality setting

• You can use Publish Services to Hard Drive which can be really handy for syncing photos to your iPhone or other computers

• If a file is republished, the new file replaces the existing file for Pro accounts without breaking the link to the page

• Publish will allow you to upload videos, too

• New badge on the thumbnails in Grid show photos that are in a standard or published collection

I **LIBRARY VIDEO:** Support for video files so photographers can import and manage both their still and video content.

• Videos can be rated, filtered, tagged, added to Collections, saved in Smart Collections, and managed

• The video camera icon identifies the videos and shows their length

• Double-clicking on the video, or clicking on the icon, will launch the video in your default video software.

I **TETHERED CAPTURE FROM THE FILE MENU**

• Tethered shooting captured by newer Canon and some Nikon DSLR cameras

I **THE LIBRARY MODULE WINDOW**

Figure 7.1 shows the *Lightroom* Library Window. The left side holds the Navigator, Catalog, Folders, Collections, and Publish Services panels as well as the Import and Export buttons. The right-hand panel holds Histogram, Quick Develop, Keywording, Keyword List, Metadata and Comments as well as the Sync Settings and Sync Metadata buttons. The Library Filter is located above the Grid, which resides in the middle of the main window and displays your images. At the bottom of the Grid is the Toolbar. The Filmstrip is located underneath the Toolbar.

When you import images into *Lightroom*, they will be organized in the Folders Panel, and appear in the center Grid View of the window.

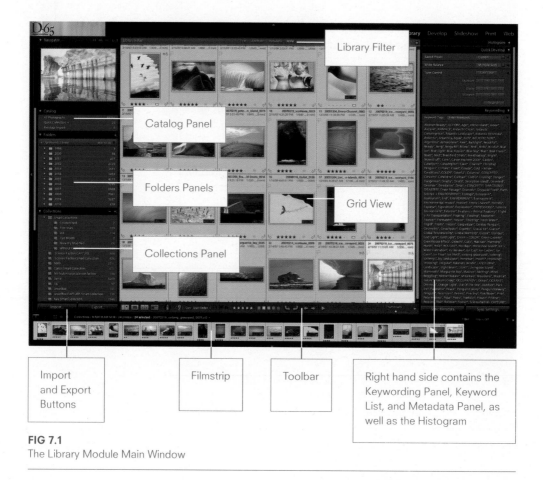

Library Filter

Catalog Panel

Folders Panels

Grid View

Collections Panel

| Import and Export Buttons | Filmstrip | Toolbar | Right hand side contains the Keywording Panel, Keyword List, and Metadata Panel, as well as the Histogram |

FIG 7.1
The Library Module Main Window

Now, we'll go over how all the panels in the Library Module function. We'll start with the left-hand panels.

I NAVIGATOR PANEL

The Navigator is located on the top left. This gives you a preview of the selected image. Clicking on the image in the Navigator will go to Loupe Mode to display the image in a large view.

There are four views plus a drop-down menu in the Navigator. The drop-down menu contains 8 additional magnification choices ranging from 1:4 to 11:1.

- Fit

- Fill

- 1:1

- 1:4 to 3:1

A great shortcut for the Navigator is to use Command + and Command - to zoom in and zoom out. The spacebar also can be used to zoom as well as the Z key.

Move through the image using the Navigator.

FIG 7.2
The Navigator Window

Using the Navigator in Workflow

The Navigator is great for checking critical focus or pixel defects. Clicking on any of these choices will enlarge the image accordingly. One very neat feature is that you can move through the image using the Navigator (similar to *Photoshop*). It works the best in the 1:1 or 4:1 ratio. Typically, you are going to want to see the entire image and then zoom in for a 1:1 view to check for sharpness. If you click on Fit and then click on 1:1, you will be able to cycle between those two views by using the space bar, or clicking on the image in Loupe View. **Figure 7.3** displays 1:1.

FIG 7.3
Cycle between two views by using the space bar or clicking on the image in Loupe View

The Catalog panel displays the number of photographs in your Library under All Photographs. When you highlight All Photographs, you will see all the images in your catalog displayed in the Grid. It also displays any Quick Collection you may have, as well as your previous import and previous export as a catalog or any missing files. Control-clicking on All Photographs will bring up the dialog Import Photos and Import From Catalog.

FIG 7.4
The Catalog Panel

▼ Catalog	
All Photographs	38861
Quick Collection +	0
Previous Import	56

What are Quick Collections?

A Quick Collection is a temporary gathering of images. There are several ways to create a Quick Collection. Our favorite way is to simply use the keyboard shortcut B key. Use the B key while you have an image or images selected will automatically add it to the Quick Collection. To remove images from a Quick Collection, hit the B key again.

The default way to create a Quick Collection is to click on the circle on the top right of the cell around the image when

browsing images. A dialog box will pop up and ask you if you'd like to add this image to a Quick Collection. Having the Quick Collection Marker turned on is controlled in View Options. We prefer to turn the marker off and use the B key instead (see View Options in Chapter 5).

A Quick Collection is not meant to be a permanent place to group images, just a temporary culling from a shoot to use in any module. You can only have one Quick Collection at a time. When you add an image to the Quick Collection, it does not move the image; it just adds a reference to the file's metadata. Think of a Quick Collection as a virtual shelf holding culled images temporarily.

Using Quick Collections in Workflow

Think about going through a group of folders to find your portfolio images. One way to do this is with a Quick Collection. As you browse through folders, you could add each potential portfolio image to a Quick Collection. When you have browsed all your folders, you may remove some images. Finally, when you have your selects for your portfolio, you may want to save the Quick Collection as a permanent Collection called Portfolio.

Quick Collections are great for making web galleries and slideshows of selected images that do exist within the same folder. It is great as a temporary culling of your images. The advantage of having a Quick Collection is that you are not moving those images out of the folder(s) in which they exist. You are only adding pointers in the metadata that identifies those files.

You can export from a Quick Collection, even though it is just a virtual collection. You can always convert a Quick Collection to a permanent collection by choosing File>Save Quick Collection. You can clear a Quick Collection by choosing Clear Quick Collection from the File Menu. Additionally, if you Control-Click on the Quick Collection you can Save the Quick Collection or Clear the Quick Collection.

The dark circle shows that this image is part of a Quick Collection

Click here to add to quick collection or just press the B key.

FIG 7.5
Quick Collection Marker

Target Collections

There is a + next to Quick Collection. The + sign signifies that Quick Collection is designated as your Target Collection. Any collection can be deemed a Target Collection. A target is simply the location that the image(s) will be referenced to when using the B key. By default, Quick Collection is your Target Collection. You can only have one Target Collection at a time. To change your Target Collection, control- or right-click on the new collection you want deemed as your target, and choose Set as Target Collection.

In **Figure 7.6**, we have set our Current Portfolio Collection as our Target Collection, so anytime we hit the B key on an image, we are adding a metadata reference of that image to our Current Portfolio Collection.

FIG 7.6
Setting a
Target Collection

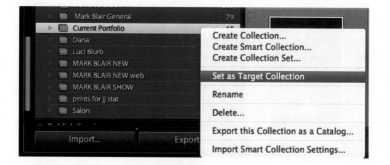

WORKFLOW TIPS FOR QUICK COLLECTIONS:

• *Command-B toggles you between the folder you are browsing and a Quick Collection you already have created*

• *D-65 prefers to use the B key to add/delete from the Quick Collection—it is too easy to accidentally click on the little circle when double-clicking on an image to go to Loupe View and inadvertently adding it to a Quick Collection—you can turn off the Quick Collection circle under View Options*

• *Control-Click on the Quick Collection to Save the Quick Collection or Clear the Quick Collection*

Previous Import in the Catalog Panel

Previous Import displays the number of images of your last import. This is the field that will be selected first by default after you import images into *Lightroom*. D-65 suggests moving off Previous Import and going directly to the folder of images you are working on. The main reason for this is some features that are available at the folder level are not available in Previous Import.

I THE FOLDERS PANEL

When you import images into *Lightroom,* the folders containing those images are displayed in the Folders Panel. The number of imported images within that folder is shown to the right of the folder name. The subfolders within the Folders Panel can also have subfolders for further organization. Simply click on the + icon next to Folders while you have a folder selected and it will prompt you to create a subfolder name.

FIG 7.7
Setting a
Target Collection

I THE VOLUME BROWSER

The Volume Browser (**Figure 7.8**) tells you where the images are and how much disk space is used/available (or photo count). Option/Alt clicking on the Volume Browser will select all the folders on that volume. Control-clicking on the volume browser (**Figure 7.9**) reveals available Disk Space, Photo Count, Get Info and Status.

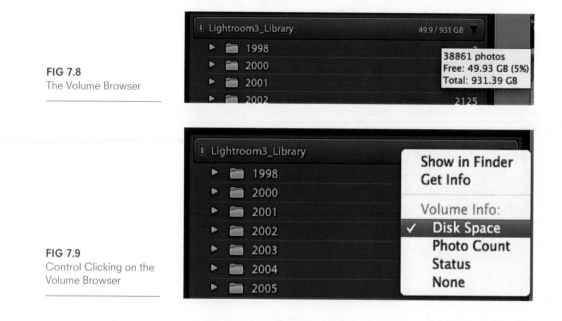

FIG 7.8
The Volume Browser

FIG 7.9
Control Clicking on the Volume Browser

Workflow in the Folders Panel

D-65 uses a specific file naming convention for all the imported folders of images, as well as for the images themselves. We import into a folder with a naming convention of Year, Month, Day, and Job Name. All of our image folders then line up in a hierarchical order based on year, month, and day, making it easy to browse through the jobs in a logical progression. The images inside those folders are also named using the same convention, with the addition of a sequence number. We will discuss this in more detail once we begin importing images.

The folders panel displays all the imported folders into *Lightroom*. Everything you import will show up in this panel in specific folders with the number of images included within each folder.

Click on the + icon to create a new folder or subfolder. Clicking on the – icon will remove a folder. You can also Add New Root Folder, display Folder Name Only, display Path from Volume and display Folder and Path

FIG 7.10
The Folders Panel

FIG 7.11
Click on the + icon to create folders

FIG 7.12
Control Click on a panel to display what panels will show or not show

You can move images within folders by dragging and dropping them. To move images, select the images you want to move in the Grid and drag them to the new folder location. Shift-select will select images in sequence and Command-select will select images out of sequence. You will see an icon, which looks like a stack of slides. The original location is shaded in light gray and the new location is shaded in light blue. Note that the light blue shading is only available with Intel Macs. **These are the actual images that are moving, not just reference files. The files will physically move on the hard drive where they reside as well.**

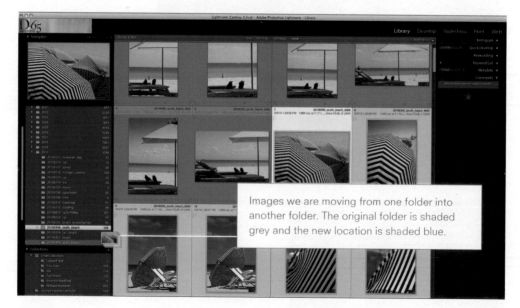

Images we are moving from one folder into another folder. The original folder is shaded grey and the new location is shaded blue.

FIG 7.13
Moving images between folders

More Folder Panel Options

To rename a folder, Control-click or right-click on the folder and choose Rename. The folder name will be changed in the Folders Panel, and also in the physical location where the folder resides. You will also notice that you can create subfolders, Show in Finder, Save Metadata, Synchronize, Update Folder Location, Export the Folder as a Catalog and Import into this Folder. Depending on where the folder is located, you can also add the parent folder or promote subfolders.

Synchronize Folders is useful as you have the option of adding files that have been added to the folder but not imported into the catalog, and removing files which have been deleted.

The Save Metadata option will update and save any changed metadata to either the catalog or to sidecar .XMP files as determined by your preferences. Lastly, Update Folder Location allows you to change the folder links without having to first remove the existing folder.

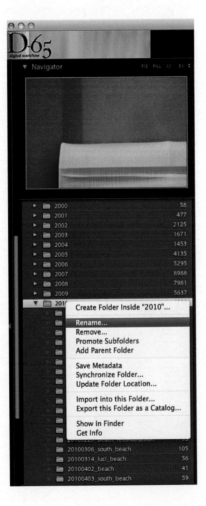

FIG 7.14
Options in the
Folders Panel

Lightroom as a DAM

Lightroom is a true digital asset management system (DAM) The catalog can display folders and images even if they are not currently physically present. In the example below, D-65 is on the road using a laptop computer. We have taken our *Lightroom_* Catalog folder with us but we have only taken a few folders of images from our *Lightroom* Library. We have taken these folders of images because we want to work on these files while we are on location. The folders in the light gray shade with the question mark (?) designate folders with images inside the folder that are not physically present on the external hard drive associated with our laptop's *Lightroom* Location Library. The folders shown in white are physically present on our external hard drive that we use as our *Lightroom* Location Library.

Shown in **Figure 7.15** are folders with question marks and a light shade of gray. These files are not physically present. However, *Lightroom* still has the power to browse these files, search for these files, and perform other database activities, with the exclusion of actual developing.

The folders with the question marks are not physically on the laptop or the *Lightroom* Location Library hard drive. They are still "at home or at the studio." The folders of images in white are on the mobile external hard drive that we take on location for our *Lightroom* Location Library.

FIG 7.15
Images online and offline in the catalog

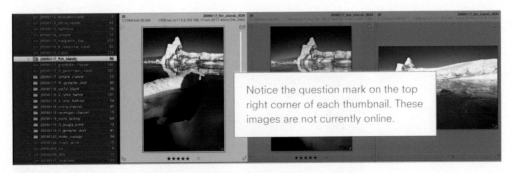

Notice the question mark on the top right corner of each thumbnail. These images are not currently online.

FIG 7.16
Images offline in the catalog marked with a question mark on the thumbnail

Using the Library Module in Workflow While "On the Road"

Because we have built high res 1:1 previews, we can even zoom in on these files without generating artifacts. This is one large plus for generating 1:1 previews. You can take the previews on the road without having the actual files and still make web galleries and slide shows and view the images at 100%. The only downside is that these previews do take up considerable space.

One welcome change *new in Lightroom 3* is that the entire preview system has been overhauled so the thumbnail Grid won't be out of focus as you scroll (as in previous versions) and there is improved preview quality. In **Figure 7.17**, we have a file that is offline, but has a high res preview. This allows us to zoom into 100%, and use the file for all purposes in *Lightroom* with the exception of the Develop Module, even without having the image physically with us. **Figure 7.18** is an example of an offline file which only has the low res preview generated. It reveals artifacts at 100%, rendering it useless for any purpose other than reference within *Lightroom*.

NEW

FIG 7.17
High res preview of an
offline image

FIG 7.18
Low res preview of an offline image

I THE COLLECTIONS PANEL

The last panel on the left side is called Collections, and it is located under the Folders panel. There are both Smart Collections and regular Collections. Regular Collections are manually compiled, similar to Quick Collections, but they are permanent and you can have as many Collections as you would like. Smart Collections are automatically compiled based on a set of criteria that the user assembles.

Why Use a Collection?

Here is the real power of *Lightroom*. You have an image in one folder. You want to place this image with a group of other images called Portfolio and you also want to use this for a stock submission for your agency and maybe even for a gallery show. In the old days, you would have to duplicate the file and place it in different folders. If you changed something in the file, you would then have to change it in all the files. Because *Lightroom* is entirely based on metadata, you can create Collections based on the metadata.

In the example that follows, we created a collection called Gallery Show and placed 25 images into that folder. Many of these images are also in collections called Jewelbox and Portfolio. The beauty of *Lightroom* is that the master file remains in its original location. We do not need to duplicate the file. Instead, *Lightroom* creates a reference file that will go into one or more collections. While you will see the image in thumbnail and full size when you view a collection, the actual image never moves from its original location. How cool is that? You can even make changes to an image and export from a collection.

You can also create sub-collections within a collection. It is a great way of organizing your images. Any collection can also be set to be a Target Collection (**Figure 7.19**). A Target Collection will automatically send an image to a collection deemed to be a Target by using the commands for a Quick Collection. For example, if we wanted to make the collection Gallery Show a target, we would select the folder and Control-Click on it, choosing Set As Target Collection.

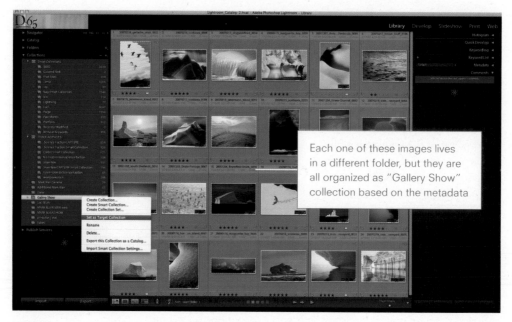

FIG 7.19
Example of a Collection

Smart Collections

Smart Collections are totally cool and they are automated so they work behind the scenes. They allow you to select criteria to automatically group your images into collections. For example, D-65 uses keywords to define images going to different stock agencies as well as color labels. We use both because the color labels are more visual in the Grid.

For the stock agency Science Faction we use the yellow label and we use a keyword called Science Faction. We like to keep track of all of our images at the many different agencies. In the past, we had to manually move them into their designated Collection which became tedious. Now we just build a Smart Collection that automatically moves any image with a yellow label and the keyword of Science Faction into its own special Smart Collection. The coolest part is that the next time we import images and they are keyworded with Science Faction and a yellow color label, they will automatically be grouped into the Science Faction Smart Collection.

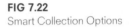

FIG 7.20
Smart Collection

Smart Collection Sets

Collections can be organized and refined by building Collection Sets. We have created a Collection Set called Stock Agencies and in that set we have specialized Smart Collections for each agency.

Create Collection Set

Name: STOCK AGENCIES

Set: Smart Collections

Cancel Create

FIG 7.21
Smart Collection Set

More on Smart Collections

Smart Collections can be edited as well. In fact they can be renamed, deleted and you can even import and export Smart Collections to another catalog.

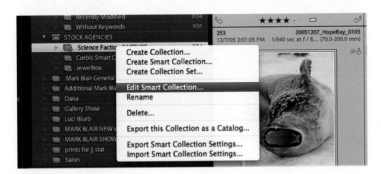

FIG 7.22
Smart Collection Options

WORKFLOW TIPS FOR COLLECTIONS AND SMART COLLECTIONS:

• Smart Collections can have very complex criteria. Hold down the Control key while clicking on the plus sign when

making decisions. The plus sign will turn into a # sign and give you the added ability to make conditional rules (Figure 7.23) which are very cool. So you have the ability to add almost any criteria to determine your search results

NEW

- **New in Lightroom 3** *is the ability to add extra criteria for conditions such as "is" and "is not" (Figure 7.23A) and Flash State*

- **New in Lightroom 3** *is a thumbnail badge to show when a photo is in a Collection (Figure 7.23B)—clicking on the badge will take you to that Collection*

- **New in Lightroom 3** *Collections can be created within a Collection Set by Control- or right-clicking on the collection set*

- **New in Lightroom 3** *Collection set photos can be sorted by aspect ratio*

- **New in Lightroom 3** *The name of a collection is displayed when a photo is added to a target collection*

FIG 7.23
Creating Smart
Collections with
Conditional Rules

FIG 7.23A
New in Lightroom 3
adds new criteria for
conditions like "is" and
"is not" and Flash State

FIG 7.23B
New in Lightroom 3
adds new thumbnail
badge to show when
photo is in a Collection.

| PUBLISH SERVICES

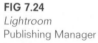

New in Lightroom 3 Publish Services is a brand new feature for *Lightroom* 3 and it allows you to publish photos to popular online photo management sites directly from within the *Lightroom* Library. Support for more sites will be added in time.

We will specifically look at the Flikr plug-in which was introduced with *Lightroom* Beta 2. Using the Flickr Set Up button within the Publish Collections panel will open the *Lightroom* Publishing Manager (**Figure 7.24**).

FIG 7.24
Lightroom
Publishing Manager

From here you can link your Flickr account (**Figure 7.25**) to *Lightroom* (**Figure 2.26**). If you do not have a Flickr account you will have to create one first.

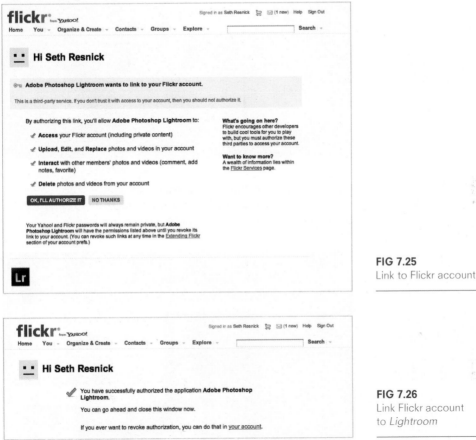

FIG 7.25
Link to Flickr account

FIG 7.26
Link Flickr account
to *Lightroom*

To publish your images to Flickr, simply drag them on to the Photostream Collection and then press the Publish button. *Lightroom* 3 will automatically begin the process of uploading the photos to Flickr. After they have been uploaded, control-click on the Photostream Collection and choose Go to Published Collection.

FIG 7.27
Publishing to Flickr
from *Lightroom*

Control-clicking on the Photostream collection also allows you to
create a Photoset, Set as Target Collection, Mark to Republish,
Show in Flickr and Import Smart Collection Settings.

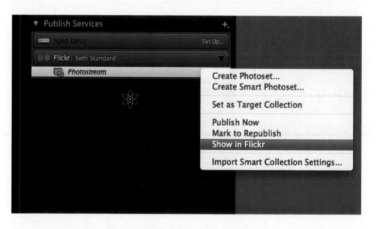

FIG 7.28
Photostream Options

On the right side of the Library you can click to add comments to
the Flickr images.

FIG 7.29
Publishing
Flickr Comments

Once published, *Lightroom* will show the images as Published Photos.

Flickr will show all keywords and caption information as well as a watermark created in *Lightroom*.

PUBLISHING SERVICES TIPS:

- *Synchronization runs both ways, so any comments made on your Flickr account will also appear back in Lightroom, which is pretty cool*

- *While Flickr is the first Publish Service available, more will be added in the future*

- *There is an option to limit to KB size which automatically adjusts quality setting*

- *Publish Services to Hard Drive can be really beneficial for syncing photos to your iPhone or other computers*

- *If a file is republished, the new file replaces the existing file for ProFlickr accounts without breaking the link to the page*

- *Publish will now allow you to upload videos*

- *New badge on the thumbnails in Grid shows photos that are in a Standard or Published collection*

I LIBRARY RIGHT SIDE PANELS

The right-hand panel of the Library displays a Histogram, Quick Develop, Keywording, Metadata and Comments for Publish Services.

I HISTOGRAM

NEW

The histogram in the Library is a representation of the tonal range of the selected image. We will be going over the histogram in great detail in the Develop Module. *New in Lightroom 3* is Animation in the Library Histogram.

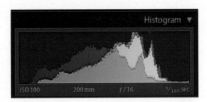

FIG 7.32
The Histogram Panel

I QUICK DEVELOP PANEL

The Quick Develop Panel expands when you click on the disclosure panel. The Quick Develop Panel provides you the ability to create color and tone adjustments to one or more images in the Library. The Quick Develop Panel also shows any Presets that you have created in the Develop Module and the Presets that come with *Lightroom*. The Control key toggles Clarify and Vibrance to Sharpening and Saturation. D-65 uses the Develop Module instead of this Quick Develop Panel because the Develop Module gives far greater control to make adjustments to our images. D-65 also applies an ISO/camera-specific preset on import. We will discuss this further in the the Develop Module chapter.

FIG 7.33
The Quick
Develop Panel

I KEYWORDING IN THE LIBRARY MODULE

Keywording really shows off the power of *Lightroom* as a digital asset management (DAM) system. The best way of using any DAM is to take advantage of the application's ability to find specific images. Proper keywording and fully filling out all metadata is not only advantageous, but essentially the only way of finding specific images in a very large collection. It is one thing to scroll through a few hundred images to find the one you want. It is an entirely different matter to scroll through 50,000 images to find the image you want.

I THE KEYWORD LIST PANEL

A keyword tag or "keyword" is metadata that categorizes and describes the key elements of a photo. According to one study, it may take more than 400 keywords to accurately describe an image without actually looking at the thumbnail. Building a Keyword Hierarchy can be a tedious and painful task, but it is essential to digital asset management.

Keywords help in identifying and searching for images in a catalog. Keyword tags are stored either in the image files or in XMP sidecar files or in *Lightroom* Catalog. The XMP can be read by any application that supports XMP metadata.

Keywording Images

To keyword your images, think globally first and then go for local. Think of keywording the same way you would classify an animal. A Spider Monkey would first be a Mammal then an Ape, then a monkey and finally a spider monkey. For example, to classify Miami Beach, you might want to make several keyword hierarchies. One Parent would be Continent with a child called North America. A second Parent might be called Countries, with a child keyword of United States. A third Parent might be called United States with a child keyword of Florida and finally a parent called Cities with a child called Miami Beach.

Below is an example of an image of a blue iceberg from Antarctica, with proper keywording. The top level Parent Keywords are in CAPS but they are private metadata and act as a placeholder

and do not export with the image. All the child levels have the first letter of each word capitalized.

Location is an obvious keyword but there are many keywords that aren't as obvious that make finding and organizing images a breeze. We have a Parent called Technique, for example (**Figure 7.35**) whose Children include items like Blur, Reflections, Macro and Motion. This really helps when looking for certain types of images. We have another Parent called View (**Figure 7.36**) with Children like Aerial, Fisheye, Front View, and Landscape. Again, the more specific the keyword, list the easier it becomes to find images that you seek.

FIG 7.34
An image with extensive keywords applied

Technique			View	
Blur	207		Above	7
Cropped	10		Aerial	592
Cross Processed	0		Back View	8
Design	98		Background	17
Detail	0		Below	0
Glare	1		Bending Over	1
Graphic	1082		Cityscape	96
Haze	91		Close Up	49
High Contrast	3		Exterior	5
Human Likeness	14		Eye Contact	38
Lens Baby	14		Fisheye	12
Lens Flare	4		Front View	5
Macro	267		Full-Length	38
Mirror Image	143		Group	8
Moire	6		Head And Shoulders	30
Montage	3		Head Shot	19
Motion	261		High Angle View	26
Movement	267		Holding Hands	3
Multi-Colored	2		Horizontal	36
Pan	20		Landscape	1705
Panning	1		Logo	3
Pattern	483		Looking Away	5
Reflection	625		looking up	1
Ripples	103		Low Angle View	19
Selective Focus	12		Negative Space	6
Sequence	16		Nudity	1
Shadows	14		Open Arms	1
Silhouette	1377		Panorama	227
Soft Focus	1		Partial Nudity	1
Spiral	9		Portrait	182
Spot	1		Profile	2
Sunburst	12		Raised Arms	2

FIG 7.35
Keyword Technique

FIG 7.36
Keyword View

Creating and Managing Keywords

Keywords can be generated by clicking on the + sign to the left of Keyword List. Keywords can be removed by highlighting the keyword and clicking on the – sign to the left of Keyword List. Keywords can also be created by typing in a keyword in the "Click here to add keywords" box under Enter Keywords in the Keywording Panel.

Click the + icon to create a new keyword tag

Keyword List ▼	
Filter Keywords	
► ACTION	1788
► ANATOMY	772
► ANIMALS	1335
► ARCHITECTURE	527
► ART	207
► BUSINESS	50
► CLOTHING	124
► COLOR	1989
► CONCEPTS	2326
► CONCEPTS BASIC EMOTIONS	
► DIRECTIONS	820
► DISASTER	455
► EDUCATION	55
► ENERGY	32
► ENVIRONMENT	3305
► ETHNICITY	546
► EXPRESSIONS	250
► FOOD	243
► HOLIDAY	513
► LANDFORM	4581
► LIGHT	1332

FIG 7.37
Adding Keywords to the
Keyword List

▼ ENVIRONMENT	3305
✓ Antarctic Convergence	560
✓ Antarctic Landscape	2515
Asbestos	95
Atmosphere	185
Beach Erosion	78
Bioindicator	0
Carbon Footprint	13
Clear Cut	2
Contaminant	1
Coral Reef	188
Corrosion	74
Deforestation	1
Desert Climate	6
Drake Lake	7
Drake Shake	124
Earth Science	325
Eclipse	28
Ecological Footprint	96
Ecology	443
✓ Ecosystem	2901
✓ Ecotourism	3847
Endangered	302
✓ Environment	2600
Environmental Hazard	221
✓ Environmental Impact	3909
Environmental Issues	11
Erode	90
Eroded	59
Erosion	379
Erosive	27
Extinction	132
✓ Extreme Environment	3984

FIG 7.38
Parents and Children in
Keyword List.

The top level parents are in capitals and are private meaning that they do not export. They are placeholders only.

The first letter of each child is capitalized

The number of images that contain a given keyword are displayed to the right of the keyword.

By clicking on the number adjacent to any keyword tag, you will go to those images that contain that keyword.

Creating Keyword Tags with Synonyms and Export Options

When creating keywords, you can add synonyms and export options. Synonyms are similar or related terms for keyword tags. Synonyms allow you to apply one keyword and automatically apply additional synonyms. For those of you keywording animals, for example, one very useful tidbit is to use the Latin name or scientific name of the animal as a synonym.

You can also choose to include keywords or exclude keywords on export. This too is a very valuable feature. D-65 uses keywords for jobs and for names of folks we know. We put this type of information into a Parent Keyword called Private Metadata and exclude it on export. This way the information becomes useful in searching within *Lightroom* but it isn't included in the images on export.

Keyword tags can be created as children of parent keyword tags. For example, a parent tag might be "Weather" and the child could be "Hurricane" and you could apply a group of synonyms at the same time.

Create Keyword Tag

Keyword Name: Hurricane

Synonyms: Storm, Violent, Destruction, Wind, Rain, Catastrophic,

Keyword Tag Options

☑ Include on Export
☑ Export Containing Keywords
☑ Export Synonyms

Creation Options

☑ Put inside "Storm Type"
☐ Add to selected photos

Cancel Create

FIG 7.39
Creating Keywords with Synonyms and Options

The Keyword Filter

The Keyword Filter is a very useful tool. In our Keyword List, we have over 5500 keywords all listed in a hierarchy. One of the problems of working with keywords in a hierarchy is locating a particular keyword. The Keyword Filter makes this easy. Simply type in the keyword you are looking for in the filter and it locates it for you in the hierarchy. In **Figure 7.40** we searched for the keyword "Reflection" and the filter traced it to the parent Technique and the child Reflection. It also conveniently displays the number of images with this keyword.

Keywording also utilizes autofill. The application tries to fill in the remainder of a word before you finish typing. While most folks find this useful, if you want to turn this off, open Catalog Settings — Metadata tab then deactivate "Offer suggestions from recently entered values."

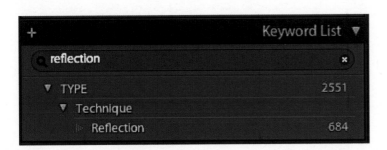

FIG 7.40
Keyword Filter

KEYWORDING TIPS:

• *If an asterisk appears next to a keyword that means that this keyword is present in some but not in all of the selected images.*

> If the keyword has an asterisk next to it, that means that the keyword is present in some, but not all of the images selected.

FIG 7.41
Asterisk in
Keyword Tags

• *In the Grid mode, you can see that an image has keywords with the keyword badge. Clicking on this badge will bring you to the Keywords panel and display the keywords in the image.*

> In the Grid mode, you can see that an image has keywords with the keyword badge. Clicking on this badge will bring you to the Keywords panel and display the keywords in the image.

FIG 7.42
Keyword Badge

• *Clicking on the number of keywords for a keyword will bring up all of those images in the Grid. In Figure 7.43, we clicked on the number 68 next to God Light and all 68 related images appear in the Grid. It is an awesome way to cull images and create collections of specific types of images. Every time you add a keyword to an image, the Keywords Tags panel will keep track of how many images in your entire Library have that specific keyword.*

FIG 7.43
Clicking on the number of keywords for a given keyword will bring up all of those images in the Grid.

Keyword Sets

Keyword tags can also be organized into categories called keyword sets. We might create a keyword set for "Lightning," for example, which includes words like Electrical Storm, Lightning, Thunder, Thunderstorm, Ominous, and Downpour. Every time lightning is photographed, this entire keyword set can be applied to those images. To create a Keyword Set, go to the Keyword Set Panel and click on drop-down menu, choosing "Save current settings as a new preset."

FIG 7.44
Keyword Sets

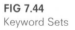

Organizing Keywords in Workflow

Keywording, while very powerful, can quickly get out of hand if the keywords aren't organized. In order to keep your keywords organized, we suggest creating keywords in the Keywording Tags panel and to regularly arrange Parents and Children in the Keyword List. Do not wait until you have several hundred keywords to begin the organization. D-65's advice is to organize on a regular basis.

Creating and Applying Keywords

You can create and apply keywords in various ways in the Library Module. We'll demonstrate them all below, even though a few of the tools haven't been covered yet in this chapter.

1. **Keywording Panel:** The Keywording Panel is located on the right-hand side of the Library Module. To use it, select one or more images in the Grid and start typing the keyword(s) you want to insert in the keyword tags panel. Hit Return and the keywords will be placed in the image(s). **Note:** To create parent-child relationship hierarchies, use the pipe key (|) between the keywords or drag keywords from the keyword list into other keywords.

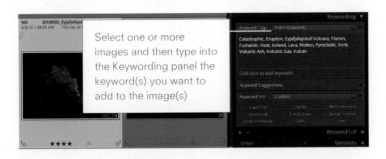

FIG 7.45
Enter Keywords

2. **Copy and Paste Keywords:** Select one image, keyword it, and then copy and paste the keywords from one image to another.

3. **Sync Keywords:** Select one image, keyword it, then select the other images you want to contain those keywords and choose Sync Metadata. Scroll down and place a checkmark in Keywords.

Synchronize Metadata

▶ ☐ Basic Info

▶ ☐ IPTC Content

▶ ☐ IPTC Copyright

▶ ☐ IPTC Creator

▶ ☐ IPTC Image

▶ ☐ IPTC Status

▶ ☐ IPTC Extension Administrative

▶ ☐ IPTC Extension Artwork

▶ ☐ IPTC Extension Description

▶ ☐ IPTC Extension Models

▶ ☐ IPTC Extension Rights

▼ ☑ Keywords

Keywords | Catastrophic, Eruption, Eyjafjallajokull Volcano, Flames, Fumarole, Heat, Iceland, Lava, Molten, Pyroclastic, Vent, Volcanic Ash, Volcanic Gas, Vulcan ☑

(Check All) (Check None) (Check Filled) (Cancel) (Synchronize)

FIG 7.46
Sync Keywords

4. **Drag Keywords:** Select one image or a group of images and either drag the image(s) to the keyword as in **Fig 7.47** or drag the keyword to the image(s) as in **Fig 7.48**.

FIG 7.47
Drag image to Keyword

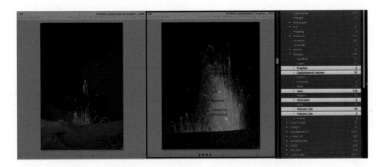

FIG 7.48
Drag Keyword to image

5. **Painter Tool:** Click on the Painter Tool in the Toolbar and add keywords to the field in the Toolbar. After the keyword(s) are added, hit Return to save them. The Painter Tool can then be used to apply these keywords to other images. Click on the image(s) that you want keyworded with the Painter Tool. Once you click on the image(s) you will see the assigned keywords on your screen and that the keywords have been applied.

FIG 7.49
Painter Tool to
paint keywords

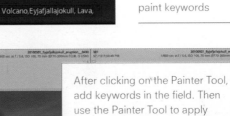

After clicking on the Painter Tool, add keywords in the field. Then use the Painter Tool to apply those keywords to other images.

Assigned Keywords: Eyjafjallajokull Volcano, Eruption, Lava, Volcanic Ash

FIG 7.50
Painting Keywords using the Painter Tool

PAINTER TOOL WORKFLOW TIPS:

NEW

• *New in Lightroom 3 Using the Option key will turn the Painter Tool into an Eraser Tool—in Lightroom 2 the Painter automatically became an eraser after applying the Painter—the use of the Option key to toggle the Painter Tool to an Eraser Tool is a welcome change for 3.0*

• *Remember to click off the Painter Tool when you are done with it, or you will continue to "paint" all your images*

• *If the Painter Tool has a keyword associated with it, the shortcut Shift-K will apply the keyword—this is totally cool because you can be in full screen view and use the shortcut Shift-K to apply keywords*

6. **Check Box in the Keyword List Panel:** Select one image or a group of images and click on the check box next to the keyword you want to apply as in **Figure 7.51**.

FIG 7.51
Using the checkbox to apply keywords

7. **Keyword Suggestions and Keyword Set:** One feature that is truly fantastic is Keyword Suggestions in the Keywording panel. The concept is that if you apply a keyword to a specific image, that keyword will become a suggested keyword for any other images that share a close enough capture time. This feature is great most of the time and should allow a faster way to generate and apply keywords, but just because the capture times are similar does not always mean that the images are similar. To apply both keywords from the Keyword Set and or from the Keyword Suggestions, simply select your image(s) and click on the keyword(s) in the set or in the suggestions.

| Keyword Tags | Enter Keywords | | ◀ |

Keyword Suggestions ▼

Volcano	Volcanic Ash	Ragnar Th Sigurdsson
Iceland	Lava	Eyjafjallajokull Volcano
Eyjafjallajokull	Eruption	Volcanic Gas

| Keyword Set | Recent Keywords | | ▼ |

Iceland	Eyjafjallajokull Volcano	Volcanic Ash
Eruption	Lava	Eyjafjallajokull
Volcano	Heat	Vulcan

FIG 7.52
To apply both keywords from the Keyword Set and or from the Keyword Suggestions simply select your image(s) and click on the keyword(s) in the set or in the suggestion.

I METADATA PANEL

The Metadata Panel is on the right side of the Library under the Keyword List. The metadata panel displays all the metadata in the image. You can apply metadata to one image and sync to other images. You can also create metadata templates, save them, and apply them using the drop down arrow next to Preset in the Metadata Panel.You can delete, add, or change metadata to any single image or group of images. The list of metadata can be a long list, so the panel is configurable to show different subsets of available metadata. *New in Lightroom 3* While D-65 prefers to show EXIF and IPTC Metadata, there are several views available as shown below in **Figure 7.53**.

NEW

| Default |
| All Plug-in Metadata |
| EXIF |
| ✓ EXIF and IPTC |
| IPTC |
| IPTC Extension |
| Large Caption |
| Location |
| Minimal |
| Quick Describe |

Keyword List ◀

Metadata ▼

right

Eyjafjallajokull_eruption__

FIG 7.53
The Metadata Panel

Quick Describe View

While D-65 prefers to show all metadata, one view that is very popular is Quick Describe which is shown in **Figure 7.54** below.

FIG 7.54
Quick Describe View in
the Metadata Panel

NEW

IPTC Extension *New in Lightroom 3* is the ability to have IPTC Extension. This is a new IPTC standard as of June 2009, going far beyond IPTC Core which is widely used right now. IPTC Extension has many new fields for "objects shown," "model name," "model's age," "release contract" and such and conforms with the PLUS Coalition Standards. PLUS has established universal standards for communicating image rights metadata.

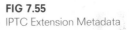

IPTC Extension	:	Metadata ▼

Preset | None

File Name | 20100509_bimini_0014.CR2
Metadata Status | Has been changed

Description

Person Shown | Luci Tash Resnick
Location Created |
Location Shown | • Bimini
Name of Org Shown |
Code of Org Shown |
Event |

Artworks

Artwork Shown |

Models

Additional Info |
Age | 2
Minor Age | Age 14 or Under :
Release Status | Unlimited Model Releases :
Release Id | 20100509_bimini_0014_MR

Admin

Image Supplier |
Image Registry Entry |
Max Avail Height |
Max Avail Width |
Source Type | Original digital capture from a real l... :

Rights

Image Creator | 1. Seth Resnick
Copyright Owner | 1. unnamed
Licensor |
Release Id |
Release Status | Not Applicable :

Others

PLUS Version | 1.2.0

FIG 7.55
IPTC Extension Metadata

Using the Metadata Panel in Workflow

Now, and certainly in the future, all searching will be based on metadata. All the fields are important to fill out but particularly important are keywords and the Caption Field. A good caption and an image maintain a symbiotic relationship. A caption describes the unseen. The caption brings totality to the image by providing context and adding depth. The image draws attention to the caption, and the caption helps to provide the complete picture. The caption should provide the "who, what, when and where" as well as information that can't necessarily be derived by simply looking at the image.

All of this information is searchable, which means that a good caption can be the difference between finding an image or not finding it. This is crucial for photographers looking at licensing stock. A good caption and proper keywording can give you an edge on your competition. D-65 applies a basic metadata template including copyright and contact information on import, and then uses the metadata panel to apply selective metadata once the images are in the Library.

You can copy Metadata from one image and paste it into other images. For example, if you didn't apply metadata such as IPTC on import, then you could write it to one file and copy and paste it into the rest of your shoot. The Sync Metadata Button works in the same way and overwrites any existing metadata in the selected images.

You can also edit the Capture Time if your camera was incorrectly set.

FIG 7.56
Default Metadata Template filled out with Caption information

Sample Caption for Image

A large striated blue iceberg with Chinstrap Penguins in the
Scotia Sea of Antarctica. A large iceberg that has rolled over
many times showing striations etched in the berg caused from
trapped air and waves appears blue in color. Blue icebergs aren't
really blue. They're perfectly clear, which allows light to pass
through. Since ice filters out all colors except blue, the iceberg
emits blue light. Typically, blue icebergs are very compressed,
originating from the bottom of a glacier. They can easily be
80,000 years old. Once they hit water they typically only last
a few years. Glaciers in Antarctica calve more than 100,000
icebergs each year. An iceberg is only one-fifth above the water;
the other four-fifths is submerged. Icebergs have many different
forms, depending on their origin and age.

FIG 7.57
Sample Caption
for Image

METADATA TIPS:

- *There is a drop-down menu next to Preset which allows you
 to apply a metadata preset that you have already created,
 or edit a preset and save a new one*

- *There is an icon to the right of File Name, which allows you
 to Batch Rename an individual photo, or groups of photos*

- *To the right of Copy Name (when you are working on
 metadata on a virtual copy) there is an arrow that will bring
 you to the master file*

- *To the right of Folder, there is an arrow that will display the folder from the selected image (good for use in Collections)*

- *Clicking on the arrow to the right of Date/Time Original will filter based on the exact date of the selected image—all of your images shot on that date will appear in the Grid*

- *Under Email, Website and Copyright Info URL, you can go directly to the URL or create an email by clicking on the arrow on the right*

- *If an image has been cropped, it will show crop dimensions and you can go directly to crop overlay*

- *Images with GPS data (open in Google Maps)*

- *Images with WAV files attached will play the audio*

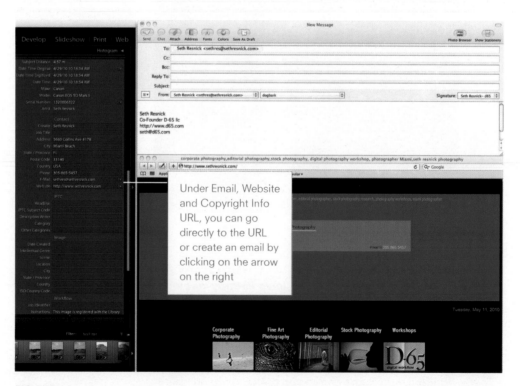

FIG 7.58

From Metadata menu you can create and email or navigate to a web page

- **When metadata has been changed or is not up to date, a badge in the image will show in the Grid mode (*Figure 7.59*) if Unsaved Metadata is checked in Lightroom Library View Options**

- **Clicking on the badge will update the metadata in the selected images (*Figure 7.60*)**

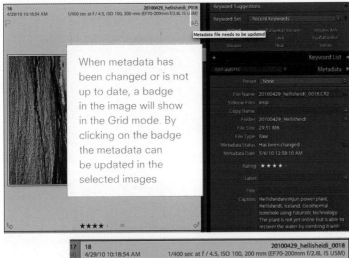

When metadata has been changed or is not up to date, a badge in the image will show in the Grid mode. By clicking on the badge the metadata can be updated in the selected images

FIG 7.59
Metadata Badge showing update is needed

FIG 7.60
Updating Metadata in image

Adding Metadata to Images

Adding metadata to one or more images is done in a manner similar to keywording and can be accomplished in several ways.

1. **Metadata Panel:** Select one or more images in the Grid and start typing the metadata into the fields you want to insert in the metadata panel. Hit Return and the metadata will be placed in the image(s).

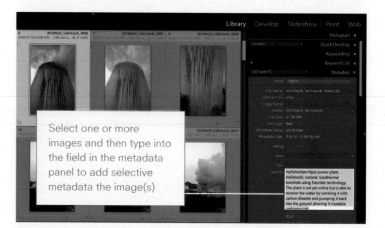

Select one or more images and then type into the field in the metadata panel to add selective metadata the image(s)

FIG 7.61
Inserting Metadata

2. **Sync Metadata Button:**

FIG 7.62
Sync Metadata

a) Add metadata to the Metadata Panel and hit Return. Select the other images to which you would like to apply this metadata.

b) Click on the Sync Metadata button to the right of the Toolbar.

c) The Synchronize Metadata window will appear.

d) You can choose what fields you would like to synchronize by checking the boxes on the right.

e) You can also change the information in any field in this window and apply it.

f) Click on Synchronize when you are ready to apply the metadata to your images.

FIG 7.63
Sync Metadata between images using Sync Metadata Button and Synchronize

3. **Copy and Paste Metadata:** You can also select one image, add metadata to a field, and then copy and paste the metadata from one image to another.

4. **Spraying Metadata with the Painter Tool**

 a) Click on the Painter Tool and choose to paint Metadata from the drop-down menu. Choose a template that you have created and hit return.

 b) The Painter Tool can then be used to apply this metadata to other images. Click on the image(s) to which you want to add metadata with the Painter Tool. Once you click on the image(s) you will see the newly assigned metadata that has been applied on your screen.

Paint : Metadata ÷ 2010 copyright ÷

FIG 7.64
Painter Tool for Metadata

Creating a new Metadata Preset

You can create a metadata preset and choose it at any time or apply it during import. A template is useful if it is something you are going to use over and over again. D-65 creates a basic copyright metadata preset which contains copyright information and creator information. Filling out metadata creator information can aid in a defense against the pending Orphan Works Act which is a proposed change to current copyright law.

To create a new metadata preset:

1. Mouse down on the metadata preset drop-down menu (**Figure 7.65**) and choose Edit Presets (**Figure 7.66**). An old preset can be edited and updated or a new preset can be created and saved with a preset name.

NEW

New in Lightroom 3 In *Lightroom* 3 you can also edit a Metadata Preset by going to Library Main Menu>Metadata> Edit Metadata Presets.

FIG 7.65
Mouse down on drop down menu and choose Edit Presets

FIG 7.66
Edit Metadata Preset

FIG 7.67
Creating or Editing a
Metadata Presets

I THE LIBRARY FILTER

The Library Filter is located above the Grid. The Library Filter
contains search criteria based on Text, Attribute and Metadata.

Text can be searched for in File Name, Title, Caption, Keywords,
Searchable Metadata, IPTC Metadata or Searchable EXIF
Metadata.

Attribute (we're not so fond of this name) provides the ability to
search based on Stars, Flags, Color Labels, Master Copy, Virtual
Copies or Video which is *New in Lightroom 3*.

NEW

Metadata can be searched by Date, File Type, Keyword, Label,
Camera, Camera Serial Number, Lens, Focal Length, Shutter
Speed, Aperture, ISO, Flash State, GPS Data, Location, City,
State, Country, Creator, Copyright Status, Job, Aspect Ratio,
Treatment and Develop Presets. When someone asks you what
your favorite F-stop or shutter speed is, you can now accurately
give them an answer.

The Filter uses the Boolean operators "and" between the columns and "or" within the columns. You can even add more columns by pressing down on the drop-down menu at the far right of the Library Filter.

All these features gathered under one roof makes this a pretty strong searching mechanism. Of course, after the search has been performed, the images can be viewed in the Grid, and you can make the selection into a Quick Collection, Collection, or even a Smart Collection.

Library Filter Keyboard Shortcut

The left-slash (\) key will hide or open the Library Filter.

Using the Library Filter

Starting with **Figure 7.68**, we demonstrate the power of the Library Filter. We have selected our entire Library and hit the \ key to open the Library Filter. We mouse down on the Text menu and select Keywords from the drop-down menu. We choose Start With and type in the keyword Graphic. By the time we finish typing "g-r-a-p-h, there are 582 images matching that criteria.

FIG 7.68
Library Filter

FIG 7.69
Filtering using Keywords

In **Figure 7.70** we choose to show images with an Attribute of 3 or more stars and from Metadata we choose All Cameras, and All Lenses. This refines the matching selection down to 95 images.

FIG 7.70
Refining the selection

In **Figure 7.71**, we have click on the drop-down menu at the far right next to Label and choose Add Column.

FIG 7.71

We add Camera Serial Number in **Figure 7.72**.

FIG 7.72

This narrows our search down to five images (**Figure 7.73**). We could, of course, save this final selection as a Quick Collection or Collection if we choose.

FIG 7.73
Our search criteria narrowed our choice to five images

We can even save this set of search criteria as a preset to use in the future as demonstrated in **Figure 7.74**. The Library Filter is truly an amazing new tool for *Lightroom*.

FIG 7.74
Saving Filtered Results as a Preset

LIBRARY FILTER TIP:

New in Lightroom 3 Filters are no longer sticky. They are disabled as you switch folders unless you click the lock icon on the Filter bar. The filters are no longer specific to each folder. This is a big plus for Lightroom 3.

We used to suggest that at the end of a session of filtering, you turned off the filtering. If you didn't turn it off, the next time you came back to that specific folder, filtering was still turned on and this would cause a scare because it might appear that many of your images were missing. This was due to the fact that you were still filtering from a previous session in that folder.

I IMPORT

We've finished the Panels and Library Filter, and now are moving back to the left-hand side to cover the import and export buttons.

FIG 7.75
Import and Export buttons in Library Module

In order to work on any image in *Lightroom*, it must first be imported into the *Lightroom* Library. You can choose to import by either moving, copying or referencing the files into the Library. After the specified files have been imported, *Lightroom* will begin building previews, which will appear in the Grid and Filmstrip views. We demonstrate the steps for import in Chapter 13.

Lightroom 3.0 can import the following file formats, and supports up to 65,000 pixels long or wide. *New in Lightroom 3* is also the ability to support CMYK files as well as RGB.

The supported file formats are:

• RAW

• DNG

• TIFF

• PSD

• JPEG

• Video files captured by newer DSLR cameras
New in Lightroom 3

NEW

I VIDEO FORMAT SUPPORT

Video files captured by newer DSLR cameras, especially the Canon 5D, are now more and more part of many photographers' repertoire. **New in Lightroom 3** is support for these files so photographers can import and manage both their still and video content.

NEW

Tagging, rating, filtering, Collection and Smart Collection features are available for organizing video content. Video filter will help narrow down your collection to just your video files instantly. In the Grid and Loupe views of *Lightroom*, the duration of a video file is displayed on the preview. The actual video will be open and can be played in your default video player.

FIG 7.76
Video Support in Library

FIG 7.77
Duration of a video file is presented on the preview

LIBRARY VIDEO SUPPORT TIPS:

- *Videos can be rated, filtered, tagged, added to Collections, saved in Smart Collections, and managed*

- *The video camera icon identifies the image as a video and shows its length*

- *Double-clicking on the video, or clicking on the icon, will launch the video in your default video software*

| EXPORT

Lightroom allows you to export single or multiple images from the Library or Develop Modules to the location of your choice. D-65 uses the Export button after we have tweaked our files in the Develop Module. The files can be up-sized, down-sized or processed in really any way you need them.

One very cool feature is that exporting works in the background, allowing you to perform multiple exports at the same time. We could even create an Action in Photoshop and turn that Action into a Droplet and have that Droplet executed automatically by *Lightroom*, which is really cool. We will discuss exporting further in Chapter 13.

Exporting formats include:

• JPEG

• PSD

• TIFF

• DNG

• Original

| THE LIBRARY TOOLBAR

The Toolbar is located under the Grid and to the right of the Export button. The Toolbar is turned on and off with the letter T key. There are several buttons on the Toolbar that come as a default. Clicking on each tool will add additional buttons to the Toolbar that are associated with that specific tool. The default Toolbar buttons in the Grid View are:

• Grid View, which displays the images like a light table

• Loupe View, which allows you to zoom in on an image up to 11:1 ratio

• Compare View

• Survey Mode

These change the views in the Library.

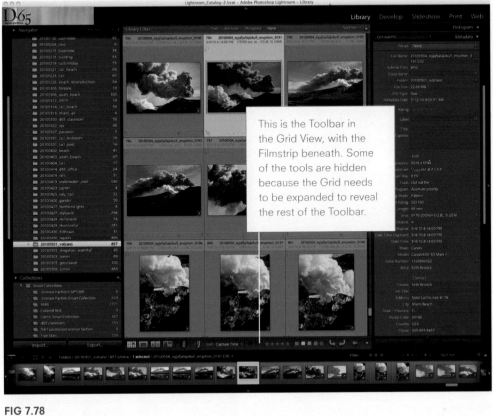

This is the Toolbar in the Grid View, with the Filmstrip beneath. Some of the tools are hidden because the Grid needs to be expanded to reveal the rest of the Toolbar.

FIG 7.78
The Library Toolbar

Expanded Toolbar

Additionally, there are other options that you can add to the Toolbar. There is a drop-down arrow on the far right of the Toolbar, to the left of the Sync Settings button. Clicking on that drop-down menu will give you the options to add to the Toolbar and customize it for your needs. Simply place a check next to the field that you'd like to show. Anything checked in the drop-down menu will appear on the Toolbar. Your screen size will affect how many options you can have showing on your Toolbar.

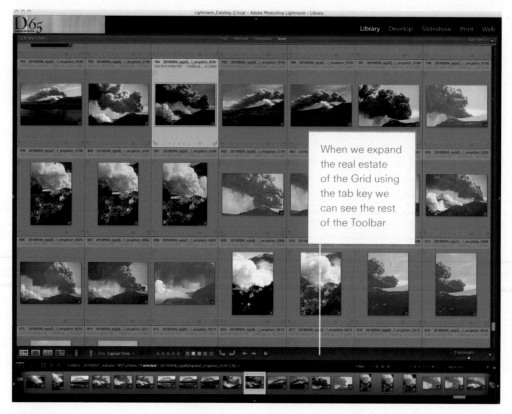

When we expand the real estate of the Grid using the tab key we can see the rest of the Toolbar

FIG 7.79
When the side panels are expanded all of the tools on the Toolbar will be available

Toolbar Drop-Down Menu

Toolbar options available from the dropdown menu

FIG 7.80
Use the Toolbar drop-Down menu to select tools in the Toolbar.

Survey and Compare Modes

When you are editing your images in *Lightroom*, you can select combinations of images and use the Compare or Survey buttons to help cull your edit. Once in either Compare or Survey mode, you can zoom in and check detail by using the zoom slider. You can collapse both the left and right side panels to view the images even larger by clicking on the Tab Key or using the arrows on the side of the panels. To exit Compare mode, press the C key.

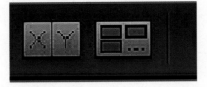

FIG 7.81
Survey and Compare
Mode Buttons

Compare Mode

The Compare Mode cycles through a group of images to find the best picture within that group. When you click done, you can rank your select or add it to a Quick Collection if you are using Quick Collections for editing.

To use this feature, first highlight an image from the Filmstrip. This will be your "select." Using the arrow key on the Toolbar (or your keyboard arrow keys) move through your images. When you find another candidate that you like better than the original select, click on the XY Make Select button. That takes your original select out, and tags the new image as your select and you can move through and compare all of the images to that select.

Next to the Compare Button in the Toolbar is an icon that looks like a lock. It is called the Link Focus Icon. Locking the Link Focus Icon allows you to zoom in simultaneously on both images using the zoom slider. Unlocking the Link Focus Icon allows you to zoom in on the selected image. Using the Sync button next to the zoom slider can synchronize the zoom ratios between images. This is a great tool for editing and checking sharpness between images.

TIP: The spacebar can also be used to toggle between Fit and 1:1 View

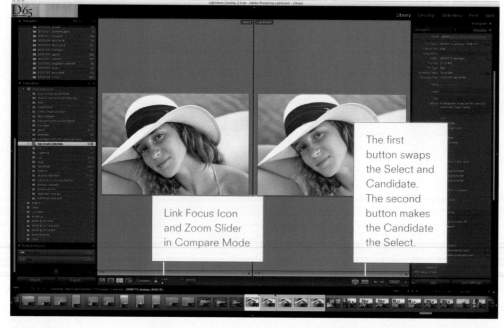

FIG 7.82
Compare Mode

In **Figure 7.82** we compare two images. In **Figure 7.83**, we lock the zoom and check focus and can see that the Select is sharper than the Candidate.

FIG 7.83
Zoom is locked and focus checked in Compare Mode

Survey Mode

Survey Mode displays the active photo (the one you clicked on
first is denoted with a white box around it) and then one or more
selected photos to compare it to (images with an x). If you want
to compare more than two images at one time, it works great.
You can change the orientation of the images, and zoom in and
rate the images too.

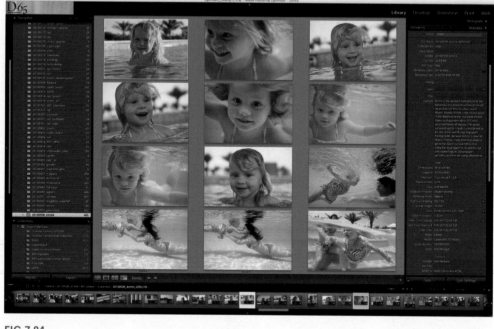

FIG 7.84
Survey Mode

Painter Tool

By clicking on the spray can icon, you have the ability to "paint" in Keywords, Labels, Flags, Ratings, Metadata, Settings, Rotation and Target Collection. A field opens next to the spray can and you insert the information you want to spray into the image. Click the Painter Tool icon on an image or images in the Grid view and the information will be inserted. The spray can becomes an eraser with the Option Key after you apply it to the image, which is *New in Lightroom 3*.

NEW

FIG 7.85
Painter Tool

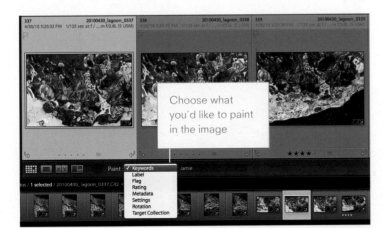

Choose what you'd like to paint in the image

FIG 7.86
Choosing options for the Painter Tool

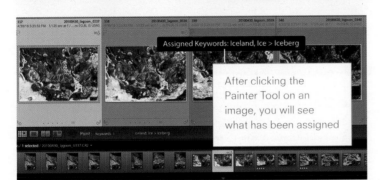

Assigned Keywords: Iceland, Ice > Iceberg

After clicking the Painter Tool on an image, you will see what has been assigned

FIG 7.87
Spraying on the option with the Painter Tool

I SORT DIRECTION AND SORT CRITERIA

FIG 7.88
Sort Button

Next to the Painter is Sort Direction. This allows you to choose between ascending and descending order for your images to appear. There is a drop-down menu located next to the icon, which further allows you to define your sort criteria (**Figure 7.89**). You can even choose "User Order" and organize the images yourself by moving them into any order you prefer in the Grid view. It is important to note that "User Order" is only an option if you are on a folder. If you are on your entire catalog, user order is not an option.

NEW

New in Lightroom 3 is the ability to sort by aspect ratio.

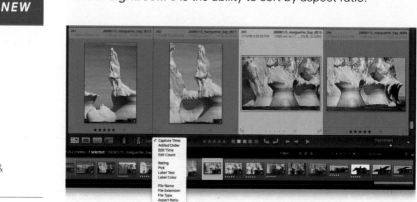

FIG 7.89
Sort Direction &
Sort Criteria

I STARS, FLAGS AND LABELS

Ranking and editing in *Lightroom* works in much the same way that a film-based photographer works on a light table. First, we click on an image and use the navigator tool with an appropriate zoom level to move through the image and check focus. After checking focus, a photographer typically used a star or a dot to mark a select, two stars to mark second tier selects and three or four stars to mark and cull "keepers."

You can do exactly this within *Lightroom*. You can add and remove stars from an image by using the Toolbar, or by using the number keys 1 thru 5, or by using the left ([) and right (]) bracket keys. You can also add color labels via the Toolbar, and by using the numbers 6 through 9. You can also rate and color label using the Photo Menu and then choosing Set Rating, Set Color Label or Set Flag. Additionally, you can select an image in *Lightroom* and manually add or subtract stars by clicking on the dots immediately below the thumbnail.

In short, there are quite a few ways to rate and color label your images. These rankings and color labels will stay with the image, in its metadata, even after you process the files.

Why would you use both rankings and labels? There is always going to be a best image from a shoot and that image might get 4 stars. However, just because it is the best image from a shoot doesn't necessarily mean that it is a portfolio image. You could

give 4 stars plus a color label to define an image that is the best from a shoot and a portfolio image.

FIG 7.90
Toolbar for ratings and labels

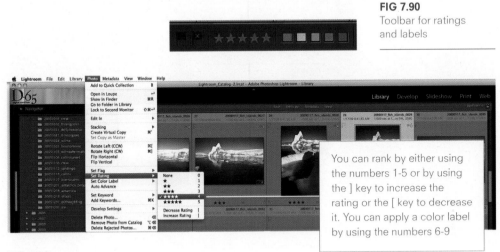

You can rank by either using the numbers 1-5 or by using the] key to increase the rating or the [key to decrease it. You can apply a color label by using the numbers 6-9

FIG 7.91
Ranking with Stars and Color Labels

Color Label Sets

You can enhance labels even further by creating a Color Label Set. D-65 creates a custom label set using different colors for different stock agencies and to label an image as a portfolio image.

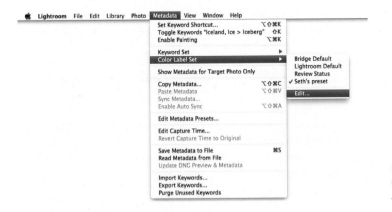

FIG 7.92
Color Label Edit Menu

Edit Color Label Set

Preset: [Seth's preset (edited)]

Portfolio 6
ScienceFaction 7
Corbis 8
JewelBox 9
Personal Stock

If you wish to maintain compatibility with labels in Adobe Bridge, use the same names in both applications.

(Cancel) (Change)

FIG 7.93
Creating Custom Color
Label Sets

RATING SHORTCUT TIPS TO SPEED UP WORKFLOW:

• *You can use the] key to increase the rating and the [key to lower the rating and Command-Z will undo a rating*

• *Having CAPS LOCK on while you are rating images automatically moves to the next image after you rate one image*

• *You can also Set a Flag as a Pick, instead of rating and color labeling. For our workflow, we use ratings and color labels for our choice images and the X Key and U Key for marking images for deletion. We do not typically use the P key but P is a Pick, the X key is a reject and the U key removes the flag.*

• *It is extremely useful to go through a group of images using the X Key to flag for deletion and delete them when you are done editing with Lightroom>Library>Photo> Delete Rejected Photos*

FIG 7.94
Deleting Rejected Photos using the X Key to Flag for deletion

I ROTATE AND ADVANCE

You can manually rotate your images, counter clockwise with the
left rotate icon, and clockwise with the right rotate icon, or by
Control-[on a PC and Command-[on a Mac rotates the photo.
You can also select the next photo or previous photo with the left
and right arrow keys.

FIG 7.95
Rotate and Advance
Buttons on the Toolbar

I IMPROMPTU SLIDESHOW

At any time you can select a folder or group of images and
build a slideshow on the fly by clicking on the slideshow
icon. The slideshow will start playing almost immediately.
Pressing the Escape button gets you out of the slideshow. The
spacebar pauses and resumes playing the slideshow. The show
automatically advances, but you can also use your arrow keys to
go back and forth.

FIG 7.96
Impromptu
Slideshow Button

I THUMBNAIL SLIDER

In the Grid View Toolbar, you can scale your thumbnails with the Thumbnail Slider. The thumbnail size in the Filmstrip is also scalable. To change the Thumbnail preview size in the Filmstrip, move your mouse between the Grid and the Filmstrip and then drag the Filmstrip larger or smaller.

FIG 7.97
Thumbnail Slider

I THE FILMSTRIP AND FILMSTRIP SOURCE

Located below the Toolbar is the Filmstrip. The Filmstrip displays your most current selection of images, based on either a folder, collection, keyword set or Quick Collection. You can move through the Filmstrip using the arrow keys.

On top of the images in the Filmstrip is your Filmstrip Source. This shows the folder, search, or collection that you have selected, the number of images in that selection, as well as any active image name. At the top left of the Filmstrip is the ability to turn on a second monitor and to go backward or forward in your browsing history. Filtering tools are located at the far right of the Filmstrip Source.

FIG 7.98
Filmstrip and
Filmstrip Source

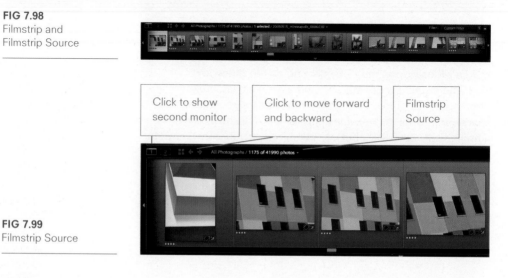

Click to show
second monitor

Click to move forward
and backward

Filmstrip
Source

FIG 7.99
Filmstrip Source

Filtering with
Stars and Labels

Turn Filtering
on and off

FIG 7.100
Filtering in the
Filmstrip Source

I MULTIPLE MONITORS

Using dual displays or multiple monitors in *Lightroom* rocks.
This is fantastic for editing and culling images and once you try
a second monitor you will never want to work on just one
monitor again.

FIG 7.101
Multiple Monitors in
Filmstrip Source
above Filmstrip

Grid, Loupe, Compare, Survey and Slideshow are all available to
use on either the first, second or on both monitors. This enables
you, for example, to see the Grid of all your images as thumbnails
on one monitor and the Loupe of a specific image on the second
monitor at the same time. This is very useful indeed. If you don't
have a second display, the new window will appear as a second
window on your main display.

**There are three views available for the Loupe View on the
second monitor:**

Normal mode, Live mode and **Locked mode**. With Normal
mode, the image on the second monitor is the same image as on
the main monitor but you can use a different zoom ratio, which is
fantastic for checking sharpness on the fly. With Live mode, the
second monitor is continually updated showing the image that
the mouse is over on the main display. With Locked mode, the
image on the second monitor is fixed which allows you to really
compare two images in full screen on two monitors.

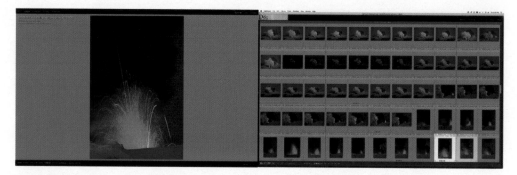

FIG 7.102
Multiple monitors in Normal View with Grid on one screen and loupe on second

FIG 7.103
Multiple monitors in Locked Mode. One image locked on the left monitor in Loupe View and another image in Loupe View on the right monitor. This really makes details like checking eyes for sharpness between two similar images a breeze.

Keyboard Shortcuts for Multiple Monitors:

- Grid (Shift-G)

- Loupe (Shift-E)

- Compare (Shift-C)

- Survey (Shift-N)

- Click and hold shows the Multiple Monitor list

- Slideshow Command-Shift-Option-Return

I GRID AND GO FORWARD AND GO BACKWARD BUTTONS

One very cool feature that has always been in *Lightroom* but few people seem to know about is the ability to move forward and backward in your workflow. This is especially useful when you leave a folder to accomplish a different task and then want to get back to that folder. The figures below demonstrate leaving a folder to go to a specific set of keywords and then use the Go Back button to get back to the original folder.

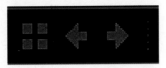

FIG 7.104
Grid and Go Forward and Go Backward Buttons in Filmstrip Source above Filmstrip

In **FIG 7.105**, we are on a folder of images called 2010508_bimini. As we browse this folder, we see that there are images with jellyfish and we decide we want to see how many other images in the entire catalog have jellyfish.

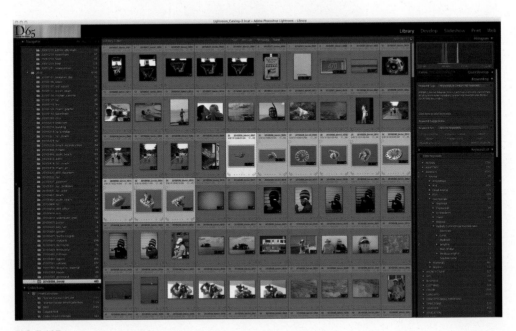

FIG 7.105
Folder of images called 2010508_bimini with jellyfish images.

FIG 7.106

The Go Back and Go Forward Buttons and selection of 9 images of jellyfish

Since all of our images are keyworded, we go to the keyword list (**Figure 7.107**) and click on the number 54 next to the keyword "Jellyfish."

FIG 7.107

Clicking on the number 54 next to Jellyfish in our Keyword list on the right side panel will bring up all of the images of jellyfish

After we click on the number 54 next to "Jellyfish," we are now in the entire Catalog showing all the images that contain the keyword "Jellyfish." We might consider making a collection of Jellyfish or we might want to go back to our Bimini images. Most folks end up navigating through the hierarchy of folders and this can be tedious and time consuming.

FIG 7.108
Catalog showing all photographs with Jellyfish. No longer in Bimini Folder

Instead, clicking on the "Go Back" button in the Filmstrip, we can return to our original Bimini folder (**Figure 7.109**). While we only went back once in this demonstration, the Go Back and Go Forward Buttons allow you to go back or forward to ten, twenty or even a hundred locations if you so desire.

FIG 7.109
Using the Go Back Button to move back to our original folder 2010508_bimini

I FILTERING IN FILM STRIP SOURCE

The Filmstrip also contains filters in addition to the Library Filter covered earlier. The Film Strip Source Filter contains Attribute

from the Library Filter and is sort of the "lite" version of filtering. At the very end of the Film Strip Source is the filter on/off switch. Finding your rated and color labeled images is easy in *Lightroom*. Go to the Filters and select how you want to filter. **Filtering can be based on:**

• Flag status: Picks, Picks Only, Picks and Unflagged Photos, or Any Flag

• Star rating

• Color label

• Or a combination of color label and rating

Filtering can be further defined by including the Boolean operators greater than or equal to (≥), less than or equal to (≤), or equal to (=).

The last button on the Filmstrip Source next to the color labels is Filter On/Off.

FIG 7.110
Filtering for Attribute in the Film Strip Source

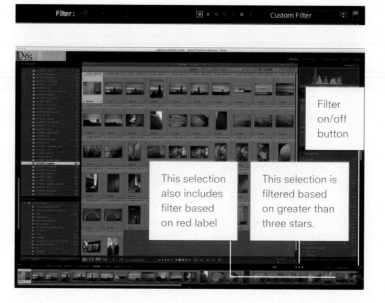

FIG 7.111
Filtering for Attribute of three or more stars

New in Lightroom 3 the Library Filter Source has some very cool added features including the ability to add favorites to the Filmstrip drop-down menu to the immediate right of the file name. **(Figure 7.112)**

NEW

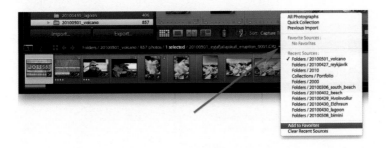

FIG 7.112

I THE MAIN MENU IN THE LIBRARY MODULE

The majority of your workflow can be accomplished in the window of the Library Module, but there are also some very important features that can be located from the menu bar. We'll cover each menu one by one below, pointing out the basics.

🍎 **Lightroom** File Edit Library Photo Metadata View Window Help

FIG 7.113
Lightroom Library
Main Menu

I FILE MENU

The File Menu allows you to import, export and work with Quick Collections. It also allows you to export catalogs, and create new catalogs. We'll talk more about exporting as a catalog later on in Chapter 15.

New in Lightroom 3 The big change for *Lightroom* 3 and the File Menu is that Optimize Catalog is now available directly from this menu and Tethered Capture now provides support for Canon and some Nikon cameras.

NEW

| 🍎 | Lightroom | File | Edit | Library | Photo | Metadata | View | Window | Help |

New Catalog...
Open Catalog... ⇧⌘O

Open Recent ▶

Optimize Catalog...

Import Photos... ⇧⌘I
Import from Catalog...
Tethered Capture ▶
Auto Import ▶

Export... ⇧⌘E
Export with Previous ⌥⇧⌘E
Export with Preset ▶
Export as Catalog...

Plug-in Manager... ⌥⇧⌘,
Plug-in Extras ▶

Show Quick Collection ⌘B
Save Quick Collection... ⌥⌘B
Clear Quick Collection ⇧⌘B
Set Quick Collection as Target ⌥⇧⌘B

Library Filters ▶

Page Setup... ⇧⌘P
Print... ⌘P

FIG 7.114
Lightroom Library
File Menu

I TETHERED CAPTURE FROM THE FILE MENU

NEW

New in Lightroom 3 For Canon and some Nikon users who require a tethered workflow, there is now happiness in *Lightroom* 3. Simply plug in your Nikon or Canon camera via USB or Firewire, start a tethered session and view important camera settings, control the shutter release or apply metadata and develop settings to incoming images.

There is no longer any need for camera manufacturer or third party software or "watched" folders. For this first release of *Lightroom* 3, a limited number of Nikon and Canon DSLR models are included. If your camera isn't supported, think twice before you scream at Adobe. Support is directly related to the camera makers' willingness to supply a software development kit (SDK) to Adobe.

Here is the list of cameras included in the first release of *Lightroom* 3:

Canon:

• EOS 1Ds Mark II*

- EOS 1D Mark III

- EOS 1Ds Mark III

- EOS 1D Mark IV

- EOS 5D*

- EOS 5D Mark II

- EOS 40D

- EOS 450D (Digital Rebel XSi/EOS Kiss X2)

- EOS 500D (Digital Rebel T1i/EOS Kiss X3 Digital)

- EOS 7D

- EOS 1000D (Digital Rebel XS/EOS Kiss F)

Nikon:

- D3

- D3X

- D3s

- D300

- D300s

- D5000

- D700

- D90

*Tethered support is not available on Windows 64-bit systems for
 these cameras.

To use Tethered Capture, go to the Library File Menu and choose Tethered Capture>Start Tethered Capture (**Figure 7.115**).

FIG 7.115
Tethered Capture from the Lightroom Library File Menu

The Tethered Capture Settings Dialog Box will open. Configure the Session Name, Choose a naming template, the destination where the images will reside and any metadata template. When complete, press OK at the bottom of the dialog box.

FIG 7.116
Starting Tethered Capture

The Tethered Capture Control Panel will open. As long as the camera is connected, the model number of the camera will be displayed. You can shoot directly from the camera or you can use the Capture Button on the bottom right to trigger the camera.

FIG 7.117
Tethered Capture
Control Panel

TETHERED CAPTURE SETTINGS TIPS:

- *The Develop Settings menu allows you to choose any Camera Raw profiles that are installed*

- *The X button on the top right of the control panel will close the panel*

- *The panel can be hidden by using Command-T on a MAC or Control-T on a PC*

I EDIT MENU

The Edit Menu handles selections. In *Lightroom*, images that are selected will appear in both the Filmstrip and the Library Grid. You can change your ratings, flags and color labels here, as well as checking your spelling. There are no changes in *Lightroom* 3 to the Edit Menu.

FIG 7.118
Library Edit Menu

Active Photos

While you can select multiple images, only one image at a time is considered Active. The Active image's cell color is lighter and more opaque and is also the image that appears in the Navigator (**Figure 7.119**).

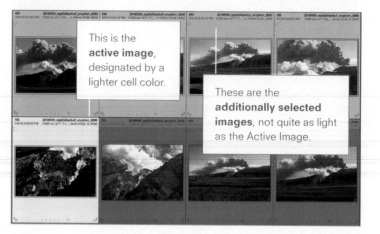

This is the **active image**, designated by a lighter cell color.

These are the **additionally selected images**, not quite as light as the Active Image.

FIG 7.119
Active and Additionally
Selected Images

I LIBRARY MENU

It is in the Library Menu that you create new collections and folders, find images and turn filtering on and off.

Refine Photos causes any unflagged images in the folder to be marked as rejected and will set any picks back to unflagged. The rejected images will not go anywhere until you choose Delete Rejected Photos (from the Photo Menu). It is a way of editing.

You can also rename your images and convert to DNG, define preview quality and move through your selected images. D-65 renames its images here for the second time after editing if necessary (the first rename is on import).

You can change the quality of previously rendered previews here by selecting the folder of images, individual images, or even your entire Library. While 1:1 Previews may be desirable, they do take up a lot of space and it can take a long time to generate a Library of high res previews.

One tip that we like is to check Show Photos in Subfolders. Doing this keeps the count correct on the parent folders in the Library. With this unchecked, the parent folder shows 0 images and only the subfolders show the correct count.

New in Lightroom 3 The two big changes in *Lightroom* 3 in the Library menu are Find Missing Photos to locate offline or missing photos and Find Previous Process Photos to locate photos first processed in an earlier version of *Lightroom*. More on Process versions when we cover the Develop Module.

NEW

FIG 7.120
Lightroom Library Menu

I PHOTO MENU

The Photo Menu has some Library basics such as Set Rating, Set Flag, Open in Loupe and Rotations. It is from the Photo Menu that we can also directly Edit in Photoshop and then save the edits back into *Lightroom*. This will be covered later. There are also some very cool features in the Photo Menu demonstrated below like Stacking and Virtual Copies.

NEW *New in Lightroom 3* is the ability to Match Total Exposures which is available from Develop Settings.

| Lightroom | File | Edit | Library | **Photo** | Metadata | View | Window | Help |

Add to Quick Collection	B
Open in Loupe	↵
Show in Finder	⌘R
Go to Folder in Library	
Lock to Second Monitor	⇧⌘↵
Edit In	▶
Stacking	▶
Create Virtual Copies	⌘'
Set Copy as Master	
Rotate Left (CCW)	⌘[
Rotate Right (CW)	⌘]
Flip Horizontal	
Flip Vertical	
Set Flag	▶
Set Rating	▶
Set Color Label	▶
Auto Advance	
Set Keyword	▶
Add Keywords...	⌘K
Develop Settings	▶
Delete Photos...	⌫
Remove Photos from Catalog	⌥⌫
Delete Rejected Photos...	⌘⌫

FIG 7.121
Lightroom Library
Photo Menu

Stacking

Stacking allows you to group images together, so there is one top image, and similar images that are nested below the top image or select. To create a stack, select the images that you want together and then from the Photo Menu, drop down to Stacking and fly out to Group into Stack or use the keyboard shortcut, Command-G.

You can open or close stacks by clicking on the stack icon in the top left of the image or through the menu or via the Photo Menu or by pressing the S key. You can move through stacks and even Auto Stack by Capture Time.

Note: When applying changes to a stack, such as Renaming Photos, only the top image in the stack will be affected. If you want to apply a change to all the images in a stack, you will need to unstack them first. Also stacks can't contain images from different folders.

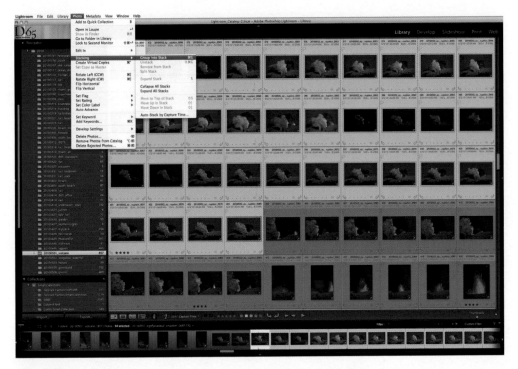

FIG 7.122
Choosing Group into Stack in Lightroom Library Photo Menu

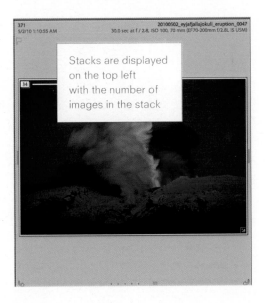

Stacks are displayed on the top left with the number of images in the stack

FIG 7.123
Group into Stack in *Lightroom* Library

FIG 7.124
Stack Badges can be
toggled on and off in
the Filmstrip

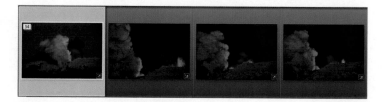

GROUP INTO STACK TIPS:

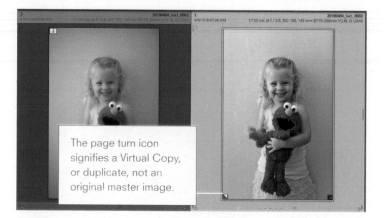

NEW

- *New in Lightroom 3 Double-clicking on stack count badge now expands the stack with all photos selected*

- *Stack Badges can be toggled on and off in the Filmstrip.*

Virtual Copy

Virtual Copy may just be one of the coolest features in *Lightroom*. A virtual copy is a copy of the metadata in the *Lightroom* Library, which acts like a duplicate of the image. You would use this when you want have multiple versions of one image with different adjustments. You are not physically duplicating the image. You still only have one image, but with multiple sets of metadata. You can export a "real" file from any virtual copy. The metadata on the virtual copy becomes an actual image on export only. Now, that's cool!

FIG 7.125
Virtual Copy Created
from *Lightroom* Library
Photo Menu

The page turn icon
signifies a Virtual Copy,
or duplicate, not an
original master image.

VIRTUAL COPY TIP:

• *By default, Lightroom only stores information about Virtual Copies in the catalog. It is NOT stored in the XMP metadata, so this is a real potential problem if your catalog becomes corrupt. But there is a pretty good workaround: when you are done working on your Virtual Copy, save a Snapshot. When you go back to the original image, you'll notice that the Snapshot is also available next to the original.*

I METADATA MENU

There are many useful features in the Metadata Menu. Many of them have been covered earlier in the chapter like Set Keyword Shortcut, Color Label Set, Edit Metadata Presets, and Save Metadata to File. Under the Metadata Menu is where you can Import and Export Keywords, Purge Unused Keywords and a totally cool feature which allows you to Edit Capture Time.

FIG 7.126
Lightroom Library
Metadata Menu

Edit Capture Time

The ability to edit capture time is a noteworthy feature in this menu. Ideally, you would want to have your camera date and

time set correctly, but many times, this is not the case especially when crossing time zones. *Lightroom* offers a solution allowing you to adjust camera-generated time and date by adjusting to a specified date and time or by shifting by set number of hours or by changing the file's creation date.

FIG 7.127
Lightroom Library
Metadata Menu Edit
Capture Time

Edit Capture Time

Modify the capture time stored in this photo by entering the correct time adjustment below.

Type of Adjustment

⊙ Adjust to a specified date and time
○ Shift by set number of hours (time zone adjust)
○ Change to file's creation date

New Time

Original Time: 5/ 8/2010 4:20:13 PM
Corrected Time: 5/ 8/2010 4:20:13 PM

This operation cannot be undone. (Cancel) (Change)

Save Metadata to File

Metadata is automatically saved within the *Lightroom* Catalog. You can set metadata to automatically write changes to XMP in Catalog Settings, but as previously explained, this uses an awful lot of processing power. D-65 chooses to set our preferences to turn off "Automatically write changes to XMP" but we do save the metadata manually on a regular basis. To save the metadata to the file manually, you can either select Save Metadata to File from the drop-down menu or use our choice, the shortcut of Command-S.

Match Total Exposures

Match Total Exposure was present in previous versions of *Lightroom*. However, **New in Lightroom 3** it is also accessible in the Library module from Library>Photo> Develop Settings>Match Total Exposure. If you highlight an individual image in the series and select "Match Total Exposure," the other images in that selection will auto correct the exposure value to match the exposure of the primary selected image. It is looking to match the values calculated by combining shutter speed, ISO, aperture, and exposure compensation. The more common usage would be to even out the results from a set of related shots.

I VIEW MENU

The View Menu contains lots of good shortcuts to help customize your workflow. They include Hide Toolbar, Show Filter Bar, Toggle Loupe View and Zoom View, Zoom In and Zoom Out, Increase and Decrease Grid Size, Sort Options, Grid, Loupe, Compare, Survey, Go to Develop, Crop, Spot Removal, Adjustment Brush, Graduated Filter, Adjust White Balance, View Options, Grid View Style, Loupe Info, and Enable Mirror Image Mode. The Spot Removal and Adjustment Brush were present in previous versions of *Lightroom* but **New in Lightroom 3** they are accessible from the View Menu.

NEW

View Options, Grid View Style and Loupe information were covered when we set up *Lightroom's* Preferences.

Choosing Enable Mirror Image Mode will flip all the images in your entire library as if viewed in a mirror. This may be useful when showing someone portraits of himself or herself. Remember, when most people see themselves, they see themselves in a mirror and are not used to looking at themselves straight on. This is one feature where we understand the explanation, but that we would never use.

FIG 7.128
Lightroom Library
View Menu

| WINDOW MENU

The Window menu brings you through the modules, determines screen mode and Lights Out. Lights Out, keyboard shortcut L, has three modes. The first is Dim Lights, which darkens everything in your screen, including a second monitor, except the images. The second is Full Lights Out Mode, which completely blacks out everything on the screen except the image(s). You can cycle through the various modes using the L key. Additionally, you can control options for a Secondary Display in the Window menu.

FIG 7.129
Lightroom Library
View Menu

| HELP MENU

Lightroom's online help is terrific. You can also check for updates and find keyboard shortcuts for each module in the Help Menu.

FIG 7.130
Lightroom Library
Help Menu

Library Shortcuts

View Shortcuts

Esc	Return to previous view
Return	Enter Loupe or 1:1 view
G	Enter Grid Mode
E	Enter Loupe view
C	Enter Compare mode
N	Enter Survey mode
Command + Return	Enter Impromptu Slideshow mode
F	Cycle to next Screen Mode
Command + Option + F	Return to Normal Screen Mode
L	Cycle through Lights Out modes
Command + J	Grid View Options
J	Cycle Grid Views
\	Hide/Show the Filter Bar

Rating Shortcuts

1-5	Set ratings
Shift + 1-5	Set ratings and move to next photo
6-9	Set color labels
Shift + 6-9	Set color labels and move to next photo
0	Reset ratings to none
[Decrease the rating
]	Increase the rating

Flagging Shortcuts

`	Toggle Flagged Status
Command + Up Arrow	Increase Flag Status
Command + Down Arrow	Decrease Flag Status

Target Collection Shortcuts

B	Add to Target Collection
Command + B	Show Target Collection
Command + Shift + B	Clear Quick Collection

Photo Shortcuts

Command + Shift + I	Import photos
Command + Shift + E	Export photos
Command + [Rotate left
Command +]	Rotate right
Command + E	Edit in Photoshop
Command + S	Save Metadata to File
Command + -	Zoom out
Command + =	Zoom in
Z	Zoom to 100%
Command + G	Stack photos
Command + Shift + G	Unstack photos
Command + R	Reveal in Finder
Delete	Remove from Library
F2	Rename File
Command + Shift + C	Copy Develop Settings
Command + Shift + V	Paste Develop Settings
Command + Left Arrow	Previous selected photo
Command + Right Arrow	Next selected photo
Command + L	Enable/Disable Library Filters

Panel Shortcuts

Tab	Hide/Show the side panels
Shift + Tab	Hide/Show all the panels
T	Hide/Show the toolbar
Command + F	Activate the search field
Command + K	Activate the keyword entry field
Command + Option + Up Arrow	Return to the previous module

FIG 7.131
Lightroom Library Shortcuts

I SUMMARY

The Library Module is "command central" for *Lightroom*. This is your digital asset management system. It is where you view, sort, search, manage, organize, rank, compare and browse through your images.

The *Lightroom* Library Module is a true database that catalogs all imported images so that you can view previews and data whether the images are online or not. The left panel holds the Navigator, Catalog, Folders, Collections and Publish Services panels as well as the Import and Export buttons. The right-hand panel holds Histogram, Quick Develop, Keywording, Keyword List, Metadata and Comments as well as the Sync Settings and Sync Metadata buttons. The Library Filter is located above the Grid, which resides in the middle of the main window and displays your images. At the bottom of the Grid is the Toolbar. The Filmstrip is located underneath the Toolbar.

The Develop Module holds all the controls that you need to adjust images. It is D-65's "tweaking command central." The image processing engine used in *Lightroom* is Adobe *Photoshop Camera Raw*, which ensures that digital RAW images processed in *Lightroom* are fully compatible with *Camera Raw* and vice versa. Synchronization, Exposure, Shadows and White Balance will seem very familiar, plus there is a great deal of added new functionality in *Lightroom* 3 with the especially welcome inclusion of lens corrections. Also included are improved sharpening, color noise reduction and much better RAW conversions.

For the most part, the way *Lightroom* processes files has been revamped. The demosaic algorithms (a digital image process used to reconstruct a full color image from the incomplete color samples output from an image sensor overlaid with a color filter array (CFA)) have been improved to give a cleaner, more pleasing effect and to respond better to noise reduction and sharpening. You should notice much finer details and texture in your images.

Here is a list of some of the changes occurring in the *Lightroom* 3 Develop Module:

I PROCESS VERSION

The process version specifies which version of *Camera Raw* image processing technology should be used when rendering and editing files. Because the processing engine has been so improved, there is a substantial difference in images processed in *Lightroom* 1 and 2 and *Lightroom* 3. A "process version" has been introduced to differentiate between the old process and new process and to allow you to choose how you want to process your images. The process version allows *Lightroom* to maintain virtually identical representation of images you've edited in the past, but will also allow you to take advantage of updating the image to the latest processing version. All images edited prior to *Lightroom* 3 are associated with Process Version 2003.

• Process Versions 1 and 2 have been renamed 2003 and 2010, relating to the year that each process version was introduced

• Any images with existing settings will be set to the old 2003 Process Version

• Any new images imported into *Lightroom* 3 will be assigned the new 2010 Process Version

• There's a warning exclamation mark in the lower right of the image if it's set to the old 2003 Process Version which you can click if you want to update to the 2010 Process Version

• Process Version is under the Settings menu, in the Calibration panel and the Sync dialog box

- The New 2010 Process Version affects highlight recovery, fill light, sharpening and noise reduction

- There is a graphic in the lower right-hand corner of the image to let you know that the current image selected in the Develop Module is a previous process version

- By clicking on the Process Version graphic you have the ability to see a before/after view of the old and new Process Versions and have the ability to update all the selected images or all of the images in the filmstrip at the same time

I LENS CORRECTIONS

This is an exciting development for our non-destructive editing technology and is designed to address lens correction via two methods: Lens Profiles and Manual Correction. This feature finally allows most lens distortion to be corrected.

I NOISE REDUCTION AND SHARPENING

- Lots of work has been done on improving the noise reduction without losing fine detail

- Luminance noise reduction is much improved

- Edge Detail slider refines the edges on extremely noisy images shot at high ISO

- There have also been subtle but improved changes to the capture sharpening

I CURVES

Point Curve enables a traditional point curve commonly found in the *Camera Raw* plug-in or in *Photoshop*.

I LOCALIZED ADJUSTMENT BRUSH

• Yay!, they removed the annoying buttons and kept the sliders

• The Adjustment Brush and Graduated Filter sliders can be reset

• The ability to stack brush strokes or gradients to strengthen the effect have been added

• New icon (a cross x) shows when no color tint is being applied

• Show/Hide pins are in the toolbar when the Brush or Gradient tool is active

• Show Selected Mask Overlay is available

• The sharpening adjustment brush, when set to -50 or greater, now becomes a 'blur' brush

I PREVIEWS

Previews now show sharpening and noise reduction at less than 1:1 view when using the new 2010 Process Version.

I EFFECTS PANEL

A new effects panel has Grain and Post-Crop Vignetting.

I GRAIN

A traditional film-style grain slider provides a very natural looking grain.

I POST-CROP VIGNETTE

There is now a choice of three separate vignette styles: Highlight Priority, Color Priority and Paint Overlay.

| CROP

• The list of crop ratios combines identical ratios like 2×3 and 4×6

• There's now a keyboard shortcut, the X key, to swap crop orientation

• A new feature, Constrain to Warp, has been added

| GRAYSCALE

Grayscale has been changed to Black and White throughout.

| AUTO TONE

Auto tone now includes Fill Light.

| SYNC/AUTOSYNC

There is now a Sync/Autosync Switch to easily toggle between the two.

| DEVELOP PRESETS

There are tons of new develop presets included in *Lightroom* 3.

We will explain each panel and slider fully within this chapter, but first we'll explain the concept of Parametric Editing. The Develop Module utilizes sliders, and it will be much easier to comprehend the power of these sliders and how to adjust your images if you understand specifically what each of sliders is designed to do.

Non Destructive or Parametric Editing

While *Photoshop* has a mix of destructive and non-destructive editing features, adjustments to images made in *Lightroom* are done with a very new approach. All the edits made in *Lightroom* are non-destructive. What does this mean?

A non-destructive edit doesn't alter the original pixels in your image. The big advantage of non-destructive editing is that you can undo any edit at any time, and in any order. You can go back and change the parameters of any edit at any time, keeping the history of a file even after the file is closed. *Lightroom* also allows all of the controls to be used not only for RAW and DNG files but also for JPG, TIF and PSD files. It is completely non-destructive on RAW files, and non-destructive on other files until you export the file. This is a major breakthrough for adjusting images.

The editing data is stored inside the *Lightroom* Catalog, whether you choose to import your images into the Library or leave them in their original locations and import them as references. If you're working with RAW files, you can also choose to have the edits and metadata changes stored in the sidecar XMP files, which D-65 strongly suggests.

WORKFLOW TIP: *Decide in advance if you are the type of person who can remember to manually save metadata after adjustments. If you can remember this, then simply Choose Command-S every now and then and save the metadata to file manually. If you are the type of person who is going to forget this critical step, then choose to activate the metadata auto save feature by going to Lightroom>Catalog Settings>Metadata, and checking the "Automatically write changes into XMP sidecar files" option. This second option* **does slow down performance,** *but if you are going to have a tough time remembering to do it manually, it alleviates potential issues with regards to losing the XMP sidecar files. More on this later.*

While RAW files don't have an embedded color profile, the Develop Module assumes a very wide color space based on the values of ProPhoto RGB. Technically, it is Melissa RGB ProPhoto with a gamma of 1.0. ProPhoto is a color space that contains all of the colors that your camera is able to capture. Since ProPhoto is really a 16-bit space, *Lightroom* uses a native bit-depth of 16 bits per channel. *Lightroom* is capable of 32,000 levels of tonal information, which surpasses the amount from any digital camera today. Quite simply, in English, *Lightroom* can safely contain all the tone and color information from any camera.

Lightroom manages color internally by using a gamma of 1.0 instead of 1.8. A gamma of 1.0 matches the native gamma of

RAW camera files. But here is where it gets a bit complicated. To provide useful information in displaying the Histogram and corresponding RGB values, *Lightroom* utilizes a gamma value of 2.2.

I FEATURES IN DEVELOP

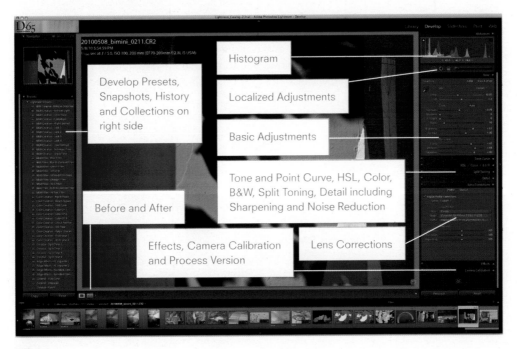

Develop Presets, Snapshots, History and Collections on right side

Histogram

Localized Adjustments

Basic Adjustments

Tone and Point Curve, HSL, Color, B&W, Split Toning, Detail including Sharpening and Noise Reduction

Before and After

Effects, Camera Calibration and Process Version

Lens Corrections

FIG 8.1
The Develop Module Main Window

I TOOLBAR IN DEVELOP MODULE

We'll start off with the Toolbar, and then move to the left-side and right-side panels in the Develop Module. The letter T key always opens and closes the Toolbar, so if you suddenly think your version did not ship with a Toolbar, try the letter T key to solve the problem.

FIG 8.2
The Toolbar in the Develop Module

Loupe View

The first button is Loupe View, which offers you the ability to zoom in on an image, same as in the Library.

Before and After View

The next button to the right is Before & After View, which is a very handy feature. This allows you to compare an image before and after you have made adjustments. You can view either side by side, or top and bottom. The down arrow next to the Before & After view allows you to choose the orientation. The backslash key (\) will also act as a Before & After view toggle.

Flag as Pick or Rejected

You can flag an image as a Pick or as Rejected in the Develop Toolbar.

Ranking and Labels

You can rank an image and/or apply a color label in the Develop Toolbar.

Move Forward or Backward

You can move forward or backward through the Filmstrip with these buttons.

Impromptu Slideshow

This button lets you create a slideshow on the fly.

Zoom Fit

With this button you can go from Fit all the way to 11:1.

Select Toolbar Contents

At the far right is the Select Toolbar Contents drop-down arrow. You can use this button to select what features you want to see in the Toolbar.

I DEVELOP MODULE PANELS

Now let's move to the right-side panels.

Histogram

The *Lightroom* Histogram appears in the top right-hand corner
of both the Develop and the Library Modules. A histogram is a
visual representation of the tonal range in your image and how
much of any given tone exists. The Histogram shows three layers
of color representing the red, green and blue data channels.
The left side of the Histogram represents pixels with 0%
luminance (black) while the right side represents pixels with
100% luminance (white).

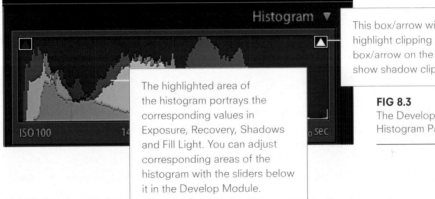

This box/arrow will display
highlight clipping and the
box/arrow on the left will
show shadow clipping.

The highlighted area of
the histogram portrays the
corresponding values in
Exposure, Recovery, Shadows
and Fill Light. You can adjust
corresponding areas of the
histogram with the sliders below
it in the Develop Module.

FIG 8.3
The Develop Module
Histogram Panel

The Histogram panel in *Lightroom*'s Develop Module becomes a
tool. You can adjust an image by adjusting the Histogram itself.
The Blacks, Fill Light, Exposure and Highlight Recovery, all shown
in the Histogram, directly relate to the tone sliders below the
histogram. You can physically make adjustments to an image by
dragging the tone sliders or in the Histogram itself.

The Histogram also allows you to preview the image with a
clipping warning for both Shadows and Highlights by clicking
on the Shadow and Highlight buttons in the upper left-hand and
right-hand corners. A color overlay with blue indicates shadow
clipping and a color overlay with red indicates highlight clipping
(shown in **Figure 8.4**).

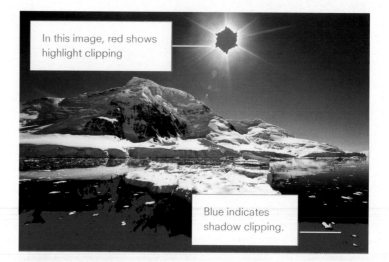

In this image, red shows highlight clipping

Blue indicates shadow clipping.

FIG 8.4
Image showing clipping in Shadows (blue) and Highlights (Red)

Localized Adjustments

Localized Adjustments were one of the greatest changes in *Lightroom* 2 and they have been refined and improved in *Lightroom* 3.

NEW

New In Lightroom 3

• Yay!, they removed the annoying buttons

• Added drop-down menu for amount or the full range of sliders

• New icon, cross-x, shows when no color tint is being applied

• Show/Hide "pins" are in the toolbar when the Brush or Gradient is active

• The sharpening adjustment brush, when set to -50 or greater, now becomes a 'blur' brush

Up until *Lightroom* 2, corrections were "global," meaning that they affected the entire image. *Lightroom* 2.0 provided localized corrections with a paintbrush. *Lightroom* 2.0 also provided a Graduated Filter.

The engineering team did a fantastic job of bringing what was only before available in *Photoshop* to *Lightroom* 3.

The adjustments are done using masks. You paint a mask and fill it with one of the adjustments listed below. And the best thing of all is that: it is non-destructive.

You can "paint" on the following adjustments:

• Exposure

• Brightness

• Contrast

• Saturation

• Clarity

• Sharpness

• Color

Cropping, Spot Removal and Red Eye Reduction are also located in the Tool Strip. Clicking on each one then opens its own tool drawer. We'll explain how these work in the order that they appear from left to right.

FIG 8.5
Localized
Adjustment Panel

Crop Overlay and Straighten Tool

When you click on the Crop Tool or press the R key, the Tool Strip expands and offers more options, including the Crop Frame Tool, Lock, drop-down menu with crop presets, the Straighten Tool and Constrain to Warp. The Reset button on the bottom of the panel clears the settings you apply in this panel.

Clicking on the Crop Overlay Tool will present a crop bounding box that allows you to crop your image. You can choose to constrain the image by locking the lock button and by using the handles on the crop overlay or by moving the image behind it.

You can also choose from a drop-down menu of aspect ratio presets next to the Lock. You can also enter and save custom presets.

FIG 8.6
Crop Panel

NEW

New in Lightroom 3

• The list of crop ratios combines identical ratios like 2×3 and 4×6.

• There's now a keyboard shortcut, the X key, to swap crop orientation

• Another new addition is Constrain to Warp

FIG 8.7
The List of crop ratios combines identical ratios like 2×3 and 4×6.

Another new addition in *Lightroom* 3 is Constrain to Warp. This one took a bit of time to figure out. You won't see a difference trying to figure it out in the Crop Panel. It correlates to Lens Correction. Constrain to warp crops the image so that the areas that are excluded after lens corrections (the grey areas)

in manual mode are applied correctly. If you go to the Lens Correction Panel, you will see Constrain Crop which is the same thing as Constrain to Warp. In fact, they are linked together. It is confusing that the same tool has a different name in two panels and to complicate it more, *Camera Raw* calls the same tool Constrain to Image.

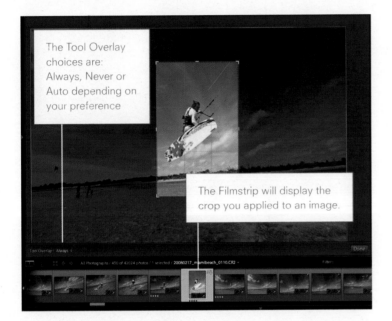

The Tool Overlay choices are: Always, Never or Auto depending on your preference

The Filmstrip will display the crop you applied to an image.

FIG 8.8
Crop Overlay with Tool Overlay on

Straighten Tool and the Straighten Tool Slider

This tool is great for straightening a horizon line.

Using the Straighten Tool and Straighten Tool Slider

You can straighten an image in two ways:

1. Mousing down on the Straighten Slider, and dragging it to the right or left will straighten out your image in live time using a grid to align the horizontal or vertical access.

2. The Straighten Tool (the ruler) works by grabbing it from the Toolbar, mousing down, dragging the tool into the image and drawing a line along the path you want to straighten, as demonstrated in **Figures 8.10** through **8.14**.

FIG 8.9
Straighten Tool

Use the Straighten Ruler or Slider to correct your image.

20100508_bimini_0196.CR2
5/8/10 4:43:13 PM
$^1/_{400}$ sec at ƒ / 8.0, ISO 100, 200 mm (EF70-200mm f/2.8L IS USM)

FIG 8.10
Image needs gate
straightened with
horizon line.

FIG 8.11
Grab the Straighten
Tool and Mouse down
in the image.

FIG 8.12
Drag the tool along
the line of the path you
want to straighten.

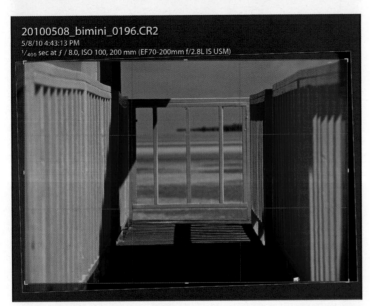

20100508_bimini_0196.CR2
5/8/10 4:43:13 PM
$^1/_{400}$ Sec at ƒ / 8.0, ISO 100, 200 mm (EF70-200mm f/2.8L IS USM)

FIG 8.13
The image with the
cropping guides
showing after using the
Straighten Tool.

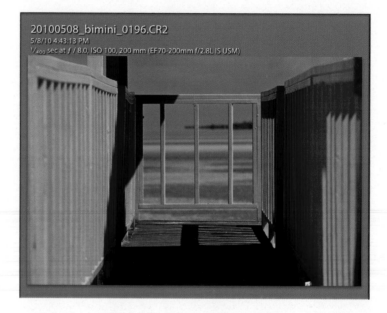

20100508_bimini_0196.CR2
5/8/10 4:43:13 PM
1/400 sec at f / 8.0, ISO 100, 200 mm (EF70-200mm f/2.8L IS USM)

FIG 8.14
Hit Return and set the crop and the final image is cropped and skyline is straight.

Red Eye Correction Tool

The Red Eye Correction Tool does exactly what its name implies, that is, it reduces and/or corrects red eye.

Tool : **Red Eye Correction**

Drag from the center of the eye or click to use current size.

Reset | Close

FIG 8.15
Red Eye Correction Tool

Using the Red Eye Correction Tool

Click on a red eye to see the slider. Make a selection around the red eye using the Pupil Size slider, which increases the size of the selected area (**Figure 8.16**).

FIG 8.16
Make a selection around
the red eye using the
Pupil Size slider, which
increases the size of the
selected area.

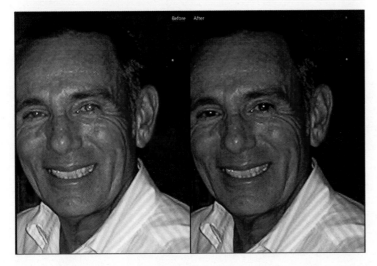

FIG 8.17
Before and after using
Red Eye Reduction and
the White Balance tool.

Spot Removal Tool

Dust on sensors is inherent in digital imaging. The Spot Removal
Tool gives you the ability to get rid of them quickly and with ease.
Clicking on the Spot Removal button will give you the options of
Cloning or Healing, a Size Slider and Opacity.

Cloning and Healing

There is a difference between the Cloning and Healing tools. Cloning applies the same sampled area to a different area—it is an exact duplicate of what you are selecting. Healing matches texture, lighting and shading from the sampled area to the selected area you are correcting.

Generally the Cloning tool is a better choice when removing a spot close to an edge, and the Healing Tool a better choice when you are away from a defined edge.

Let's look at an example. There are some dust spots on the sensor in the upper right-hand corner of **Figure 8.18**. The spot is in the sky, so the Spot Healing Tool would be fine, but we are going to demonstrate both methods.

Using the Spot Removal Tool

Click on the Spot Removal Tool to open the menu (see **Figure 8.19**).

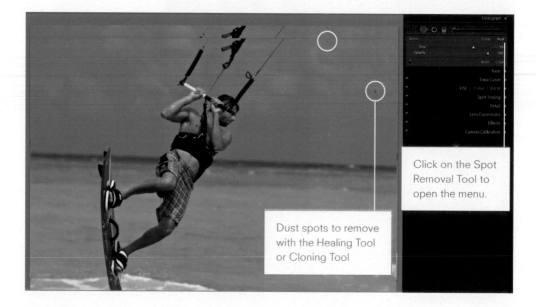

FIG 8.18
Dust spots on sensor need to be removed with Spot Removal Tool.

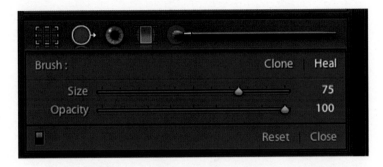

FIG 8.19
Spot Removal includes
Clone Brush and
Heal Brush.

Using the Navigator, navigate to the dust spot using the little rectangle and zoom in to at least 1:1 to see the dust spot. In this case we are zooming to 2:1.

FIG 8.20
Zooming to 2:1 using
the Navigator to see the
dust spot.

To Clone: Choose Clone and a brush size the same size or a bit larger than the object you want to clone. Mouse down and move the circle to the area you want to clone. Note that the left bracket key ([) will make the selection area smaller and the right bracket key (]) will make the selection area larger. The scroll wheel on the mouse will also adjust the size of the selection.

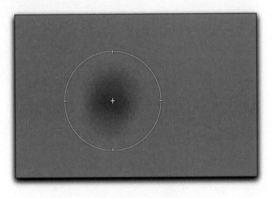

FIG 8.21
Pick Clone and a brush
size the same size or a
bit larger than the object
you want to clone.

Mouse Down and drag the circle to the Clone Source or the location from which you want to clone.

FIG 8.22
Mouse Down and drag the circle to the Clone Source.

Release the mouse and the cloned object will appear. Both the size of the selection circle and the Opacity can be adjusted further after you release the mouse.

FIG 8.23
Release the mouse and the cloned object will appear.

To Heal: Select the Healing Brush and size it a little larger than what you want healed. Mouse down on what you want healed and bingo!

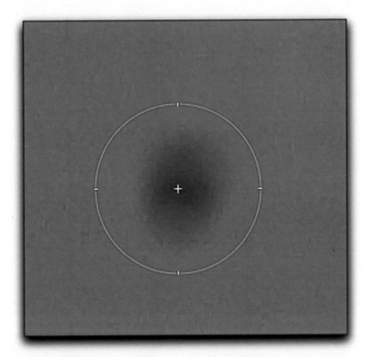

FIG 8.24
To heal, select the
Healing Brush and
mouse down on what
you want healed.

The Heal Brush will automatically make a selection matching
the texture, lighting and shading of the sampled adjacent area.
This will remove the dust or spot quite easily. D-65 uses Healing
for most dust and spot removal on our RAW files. It is
an awesome tool!

FIG 8.25
The Heal Brush will
automatically make a
selection matching the
texture, lighting and
shading of the sampled
adjacent area.

SPOT REMOVAL TOOL WORKFLOW TIP:

- *The H key toggles the Spot Removal Tool--we use the H key a lot to hide the Spot Removal Tool so that we can see if there's another spot close by, then H again to reveal the Spot Removal Tool*

- *The letter Q key is the Keyboard Shortcut for entering Spot Removal Mode*

- *Spotting can be synchronized like other Develop tools, but be mindful that if the dust spot on the sensor is in the sky in one image and on a building in a second image, the sync probably won't work well*

Localized Corrections Graduated Filter

Localized corrections appeared in *Lightroom* 2 and they are still one of the coolest features in the Develop Module. First we will cover the Graduated Filter Tool. To activate the Graduated Filter, click on the gradient icon or use the keyboard shortcut, the M key.

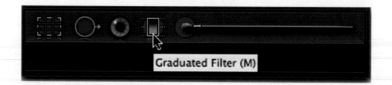

FIG 8.26
The Graduated
Filter Tool

The Graduated Filter panel offers many choices:

- Exposure corresponds to F stops with a range of minus 4.00 to plus 4.00

- Brightness makes a mid-point, or gamma adjustment, to your image--think of Brightness as a mid-tone adjustment

- Contrast increases or decreases contrast by adjusting the white and black points simultaneously

- Saturation works like vibrance:

 ✓ Add saturation by moving the slider towards the plus side

✓ Desaturate by moving the slider towards the minus side

• Clarity is mid-tone contrast and it works like sharpening–it needs edges:

 ✓ More clarity is adding sharpness but in a tonal way

 ✓ Less clarity is like smoothing and is great for skin tones

• Sharpness adjusts overall sharpness of an image

• Color allows you to create a tint within an image

New in Lightroom 3 They removed the annoying buttons and kept the sliders.

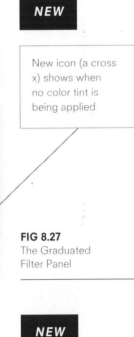

NEW

New icon (a cross x) shows when no color tint is being applied

FIG 8.27
The Graduated Filter Panel

New in Lightroom 3 New icon (a cross x) shows when no color tint is being applied.

NEW

New in Lightroom 3 The adjustment brush and graduated filter sliders can be reset by holding down Option and clicking on Effect which becomes Reset.

FIG 8.28
The Panel can be reset
by holding down Option
and Clicking on Effect

Mask:

Effect becomes Reset
when holding down the
Option Key and Clicking

Reset Custom ⬍

New in Lightroom 3 The ability to stack brush strokes or
gradients to strengthen the effect.

New in Lightroom 3 Show/Hide pins are in the Toolbar when the
Brush/Gradient tool is active

FIG 8.29
Show/Hide pins in
the Toolbar

New in Lightroom 3 The sharpening adjustment brush, when set
to -50 or greater, now becomes a blur brush.

Using the Graduated Filter

The image in **Figure 8.32** would be more pleasing to the eye
in multiple ways by using *Lightroom*'s Graduated Filter. When
talking about adjusting images, I love a comment I heard from
friend and business partner Jeff Schewe. Jeff said that when he
adjusts images, he starts by letting the image talk to him and tell
him what needs to be done. In this case the image is telling me
that the sky needs to come down and it could use some color
and the front beach area needs to be opened up and it too could
use a little color.

The adjustment panel comes with some presets and you can
even create your own or we can go about these adjustments in a
totally customized fashion.

FIG 8.30
Mouse down
on Exposure to
open Presets

Effect: Exposure ⬍

Mask : New | Edit

Effect : ✓ Exposure
 Exposure Brightness
 Contrast
Brightness Saturation
 Contrast Clarity
Saturation Sharpness
 Clarity Color

Sharpness Burn (Darken)
 Color Dodge (Lighten)
 Iris Enhance
 Soften Skin
 Teeth Whitening

 Save Current Settings as New Preset...

FIG 8.31
Drop-down menu
accessed by clicking
on Exposure.

FIG 8.32
The Graduated Filter can help make this image more pleasing

For starters, we could bring down the sky, add a little saturation and add a little blue. We can always change the settings after the fact, but let's approximate what we want to do first. Let's set exposure to about 1/2 stops down and saturation to 17. To do this, we mouse down and drag the slider tool from the top down to the horizon line to apply the Graduated Filter.

GRADUATED FILTER WORKFLOW TIP: Hold the Shift key down when you drag down the Graduated Filter, and it will be applied perfectly level. This is an ideal tool for this image. If you do not hold the Shift Key down the Graduated Filter can be applied at an angle.

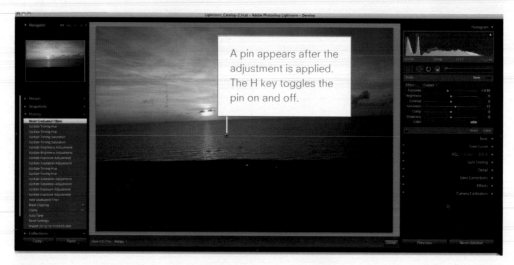

FIG 8.33
Gradient applied and now it can be further edited.

After we make our basic adjustment, we can refine the Graduated Filter and see the effects in live time. In **Figure 8.34**, we open up the Color Floating Panel, keep the mouse button depressed and go into the image to sample color from the image, which is very cool.

FIG 8.34
Color sampled from the image by depressing the mouse button and holding it down on the Color Floating Panel and dragging the sample into the image.

We make some further changes to the image and get the first gradient to look the way we want and we hit Return to set the gradient. We can always edit it later by clicking on the pin which will allow us to edit the gradient. The pin is the name for the place holder or marker for the gradient. The letter H will toggle the pin on and off. Notice the pin in **Figure 8.35**.

FIG 8.35
Additional edits are done on the gradient. The pin for the gradient is in the center of the image. It can be toggled on and off with the letter H.

Now it is time to apply our second gradient. This time we will apply a gradient from the bottom of the image, opening up the foreground and adding a little color sampled from the warm sky.

FIG 8.36
New gradient is applied from the bottom of the image up. We add a little color from the sky and open up Exposure to 2.57, Brightness to 39, Saturation to 40 and we add a little negative clarity to soften the foreground.

We apply one more gradient on the top of the image to darken the blue. We have three gradients with one on top of another on the top of the image and one gradient on the bottom. We straighten the horizon line with the Straighten tool and we are pretty close to done.

FIG 8.37
A third gradient is applied at the top and the horizon is straightened with the Straighten tool.

FIG 8.38
A before and after comparison. The sky has been successfully darkened and warmed up and the foreground has been lightened. All of this is non-destructive and relatively easy to apply.

GRADUATED FILTER TIPS:

- *Using Auto next to Show Edit Pins will reveal the pin when the mouse is over the image*

- *The letter H key will hide and reveal the pin*

- *The letter M key opens the Gradient Tool*

- *Constrain gradient to vertical—hold down the Shift key while dragging mouse*

- *Invert gradient—Apostrophe key (')*

- *Set a gradient—Enter key*

- *Delete selected pin—Delete key*

- *Holding down the Option/Alt keys activates Erase mode*

Localized Corrections Adjustment Brush

In addition to the Graduated Filter, there is a Localized Adjustment Brush which is also totally cool.

FIG 8.39
Adjustment Brush

This adjustment brush just plain rocks, providing a simple painting tool to locally and non-destructively adjust Exposure, Brightness, Contrast, Saturation, Clarity, Sharpness and Tint. There is an Effect drop down menu that defines the initial setting for the Brush. You can also create two preset brushes (A and B). Each preset brush can be adjusted for Size, Feather, Flow and Density. There even is an Auto Mask capability which confines the brush strokes to areas of similar color.

FIG 8.40
Adjustment Brush Panel

Using the Adjustment Brush

To define a brush tint value click the Color Picker on the palette.

FIG 8.41
Adjustment Brush
Color Picker

The Localized Corrections Adjustment Brush controls work in the following ways:

- **Exposure** corresponds to F stops with a range of minus 4.00 to plus 4.00

- **Brightness** makes a mid-point, or gamma adjustment, to your image—think of Brightness as a mid-tone adjustment

- **Contrast** increases or decreases contrast by adjusting the white and black points simultaneously

- **Saturation** increases saturation when it is on the plus side and decreases saturation when it is on the minus side

- **Clarity** is midtone contrast and it is like sharpening—it needs edges: more clarity is adding sharpness but in a tonal way; less clarity is like smoothing and is great for skin tones

- **Sharpness** adjusts overall sharpness.

- **Color** allows you to create a tint.

- **Size** controls the diameter of the brush.

- **Feather** creates a soft-edged transition: the larger the feather, the softer the gradation

- **Flow** is the strength at which the tool is working, somewhat like opacity

- **Density** controls the amount of transparency in the stroke

For example, setting the Density to less than 100 will cause brush strokes applied with the lower setting to be some percentage of the Amount specified. This means that you can have an Exposure -4, but if some brush strokes are applied with a density setting of 50, those strokes will only have 50% strength, or -2. The individual strokes can be varied in their density, but still be part of the same pin, which can have its overall strength controlled with the Amount slider.

LOCALIZED ADJUSTMENT BRUSH TIPS:

- *The letter K key will open the Adjustment Brush*

- *Holding down the Option/Alt key will allow you to subtract from the mask*

- *To paint a new adjustment, click New and then change a value, such as Brightness—when you click on it after you have made the adjustment, you can see this is like the ultimate dodge and burn*

- *Auto Sync only syncs global corrections; it does not sync local corrections—Regular Sync will sync everything selected*

- *Increase/decrease brush size with right bracket (]) and left bracket ([)*

- *Increase/decrease feathering with Shift+] and Shift+[*

- *The letter A key will Toggle Auto Mask on and off*

- *The letter O key will toggle the Overlay on and off*

- *Shift+O cycles through additional colors for Overlay*

Using the Localized Adjustment Brush

Figure 8.42 could certainly benefit from lightening the water and part of the island, enhancing and warming up the sky, and boosting saturation in the rainbow.

FIG 8.42
Adjustment Brush
Color Picker

We select Exposure, change the value about 2 stops, then paint a stroke to lighten the water and enhance the color.

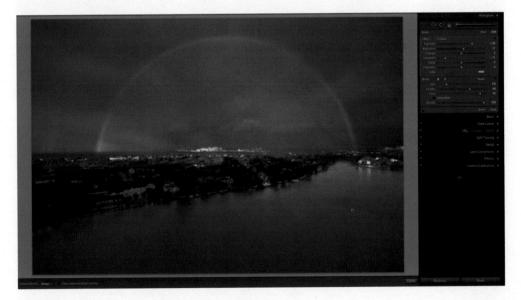

FIG 8.43
Paint strokes to lighten water and enhance the color

LOCALIZED ADJUSTMENT WORKFLOW TIP:

When we complete the task, we can either hover over the pin and check the mask or use the letter O key to toggle the mask on and off, or use **New in Lightroom 3** *Show Selected Mask Overlay with Adjustment Brush in the Toolbar.*

We can then use the Option/Alt key to subtract from the mask and clean up some of the edges.

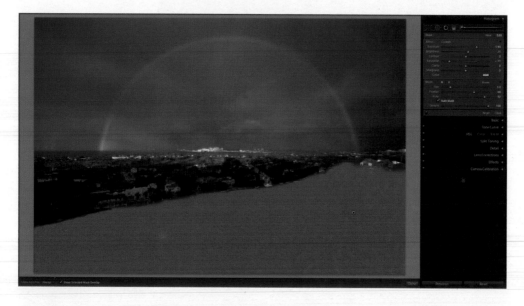

FIG 8.44
Show Selected Mask is on and we can use the Option/Alt key to subtract or erase from the mask

The process is continued as we lighten the sky, lighten and darken parts of the island and add a bit of a tint. Finally we choose Saturation and lightly paint over the rainbow, making it more pronounced and vivid.

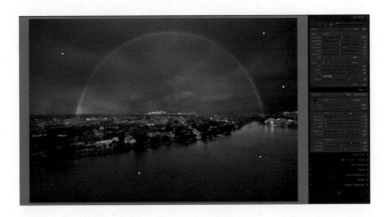

FIG 8.43
Each Pin reveals a
place that was edited
in this image.

We do a few more minor adjustments on the various pins and
voila! we are done. We compare the two images using the Y key
for before/after or the backslash key. All of this took only a few
minutes to complete. Wow!

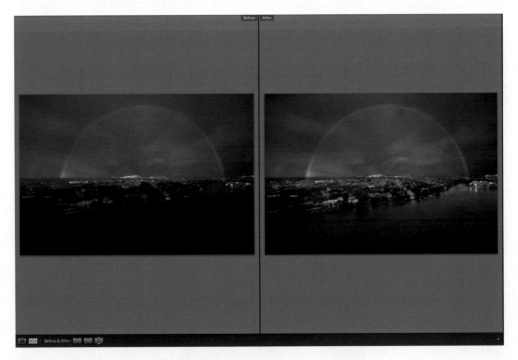
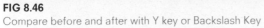

FIG 8.46
Compare before and after with Y key or Backslash Key

I THE BASIC PANEL

The basic panel holds all of our basic adjustments including Temperature, Tint, White Balance, Exposure, Recovery, Fill Light, Blacks, Brightness, Contrast, Clarity, Vibrance and Saturation. It's not so basic, after all. The panel is organized under Treatment, Tone and Presence.

WORKFLOW TIP: Double-click on any slider to reset it to the default.

Treatment

The treatment panel holds the White Balance, Temperature and Tint sliders. You can also convert an image to Black and White in this panel.

NEW

New in Lightroom 3 Grayscale has been changed to Black and White throughout.

New in Lightroom 3 Auto Tone now includes Fill Light.

Black and White Converter

There are nine choices for RAW files in the drop-down menu for White Balance including: As Shot, Auto, Daylight (5500K), Cloudy (6500K), Shade (7500K), Tungsten (2850K), Fluorescent (3800K), Flash (5500K) and Custom (your White Balance setting).

FIG 8.47
Basic Panel in the Develop Module

White Balance

The first slider controls the White Balance. The numbers on
the slider 2000 to 50,000 refer to the temperature measured in
degrees Kelvin. White balance indicates the color of the light
under which the image was captured. The default value is the
white balance at which the image was captured ("As Shot").

The white balance of an image can be adjusted in three ways:

• Choosing a value from the White Balance drop-down menu

• Sliding the Temperature slider and the Tint slider

• Using the White Balance Selector tool to click on a neutral white
 or gray area in the image

Temperature

The Temperature slider allows you to fine-tune the white
balance to a precise color temperature using a Kelvin color
temperature scale. Moving the slider to the left produces a
correction for images taken with a lower temperature. The
slider adds blue to the image to compensate for yellow of lower
temperature values. Moving the slider to the right produces a
correction for images taken with a higher color temperature. The
slider adds yellow to the image to compensate for the blue of
higher temperature values.

Moving the slider to the left makes the images appear cooler,
while moving the slider to the right makes the images appear
warmer. When working with JPEG, TIFF and PSD files, the scale is
-100 to +100, rather than in degrees Kelvin.

Tint

The Tint slider allows you to fine-tune the white balance to
compensate for green or magenta tints in images. Moving the
slider to the left adds green while moving the slider to the right
adds magenta. Think of Tint as a personal adjustment slider. If
you think your images from your camera are slightly green or
magenta, you can correct that cast here.

TINT WORKFLOW TIP: If the cast appears in the shadows, refer to the Shadow Tint Slider in the Camera Calibration Panel.

White Balance Selector Tool

The white balance selector tool is located in the top left of the Basic panel. It looks like an eye dropper. To white balance an image, pick an area that is neutral light gray or close to the second white patch on an X-Rite ColorChecker card. While you are working with this tool, the navigator will display a preview of the color balance as you move the tool around the image.

White Balance Toolbar Options

- **Show Loupe:** Displays a close-up view with the corresponding RGB values

- **Scale Slider:** This zooms the close-up view of the Loupe

- **Auto Dismiss:** This dismisses the White Balance Selector Tool after one click

 - D-65 chooses not to have this checked in our workflow

- **Done:** Dismisses the White Balance Selector Tool, changing it to the Hand or Zoom Tool

Workflow Shortcuts in the Basic Panel

- **Command U:** Auto Tone

- **Command-Shift U:** Auto White Balance

- **Letter W Key:** White Balance Selector Tool

White Balance Demonstration

Let's go ahead and white balance the image in **Figure 8.48**.

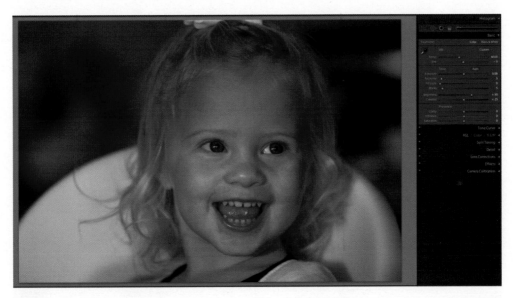

FIG 8.48
Image before being white balanced

We select the White Balance Selector Tool (**Figure 8.49**).

FIG 8.49
White Balance
Selector Tool

When the White Balance Selector Tool is activated, the Toolbar for it opens up under the image. The Toolbar can be toggled on and off with the letter T key.

Next, we go to the Navigator and zoom in to a section of the image that has white with detail. In this case, the white of the eye is perfect.

We choose to uncheck Auto Dismiss in the Toolbar so that we can make multiple selections with the White Balance Tool if we so desire.

We also choose to Show Loupe which displays a close-up view and the RGB values of the pixel.

Then we set the Scale Slider so that we get a close-up view in the Loupe.

Next, we move the White Balance Selector Tool to the white of the eye and click (**Figures 8.50** and **8.51**).

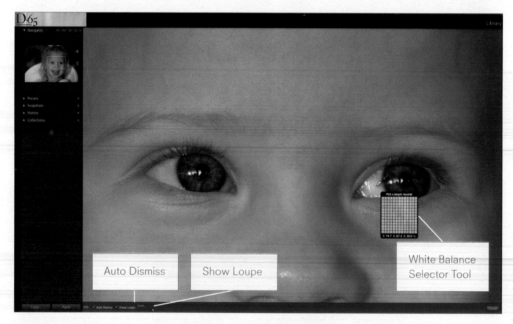

FIG 8.50
Sampling White Balance from eye and checking color in the Navigator.

The Loupe can tell us quite a bit about our image: for instance, the RGB values based on luminance and percentages. White with no detail would thus be 100, 100, 100 and black with no detail would be 0, 0, 0. Neutral is 50, 50, 50. If you wanted to check to see if there was detail in the black of the pupil, you could put the White Balance Selector Tool there and read the value, which is pretty cool. In our case, we see the white of the eye is 74.7, 67.2, 50 which is pretty close to neutral (**Figure 8.51**).

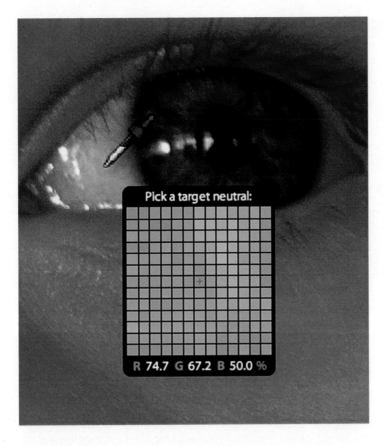

FIG 8.51
Sampling White
Balance from eye and
checking the RGB
values in the Loupe.

We can keep sampling and checking the Navigator window as
we go, which gives us a live time view. Once we have a pleasing
result, we hit Return to set the White Balance (**Figure 8.52**). In
many situations, this technique will work well, assuming you have
some area where there is white with detail.

FIG 8.52
Image after being white-balanced

Using an X-Rite ColorChecker Classic and/or X-Rite ColorChecker Passport to Achieve Critical White Balance

Another way to achieve a more accurate white balance would be to place an X-Rite ColorChecker Classic or Passport into the scene. Using the White Balance Selector Tool, click on the second patch from the bottom right on the checker. This will provide the correct white balance. The corrected image can be synced to a group of other images, which we will cover later.

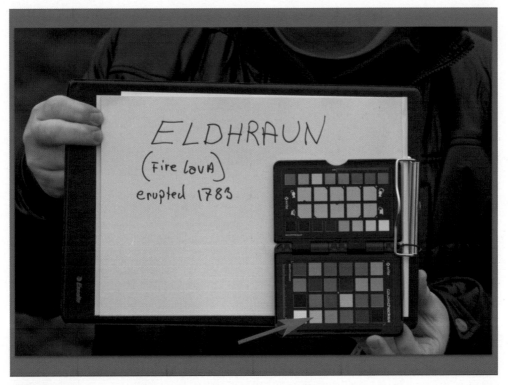

FIG 8.53
X-Rite ColorChecker Passport photographed on location

If you use the ColorChecker, simply use the White Balance Selector Tool and click on the second patch from the left on the bottom as indicated in **Figure 8.53** with the red arrow. If you have X-Rite ColorChecker Passport, you can build a custom camera profile for even more accuracy. This will allow you to use a very accurate calibration each and every time the camera is used at a particular ISO. To do this, select the image of the ColorChecker Passport (**Figure 8.53**) in the *Lightroom* Library and choose Export. You will export to the Passport Plug-in (**Figure 8.54**).

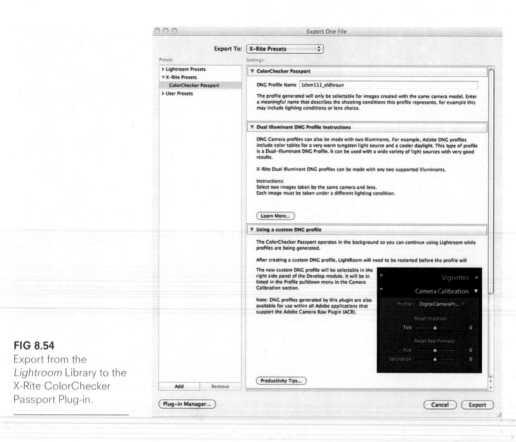

FIG 8.54
Export from the
Lightroom Library to the
X-Rite ColorChecker
Passport Plug-in.

The Passport will create a custom profile that will be available
under Camera Calibration in the Develop Module. You can even
warm this up or cool this down further to customize it using
the image of the ColorChecker Passport Enhancement Target.
You can then set this as a default for a particular camera serial
number and ISO so that you can achieve critically accurate color.

FIG 8.55
Profile is available under
Camera Calibration

Camera Calibration ▼	
Process :	2010 (Current) ⬍
Profile :	1dsm111_eldraun ⬍

FIG 8.56
Camera Calibration
Tab showing the list of
available profiles for a
particular camera by
serial number and ISO

FIG 8.57
By choosing the
calibration desired from
the Calibration Panel
and then pressing the
Option Key, *Lightroom*
can re-set the default
calibration based on
serial number and ISO.
So every time this
camera is used at this
ISO, this calibration can
be automatically applied
to the processing.
Now that is totally,
totally cool.

I THE TONE PANEL

The Tone Panel holds the Exposure, Recovery, Fill Light, Blacks, Brightness, and Contrast Sliders. There is also an Auto button.

New in Lightroom 3 Auto now includes Fill Light as part of the auto adjustment.

The sliders in this panel ideally should be used in the order they appear.

NEW

Exposure Slider

The Exposure Slider sets the white point, controlling the overall image brightness. The values shown on the right of the slider (+1.00) are equivalent to roughly opening up one stop. The slider works in the same way for the negative values.

Using the Exposure Slider to Set White and Black Points

The Exposure Slider provides yet another incredibly valuable tool for a photographer using *Lightroom*. Pressing down the Option key while moving the slider will locate the technically correct white point. The technically correct white point is at the point when you first begin to see detail. This is very similar to the Levels Dialogue in *Photoshop*. The "unclipped" areas of the image are black, and the "clipped" areas appear as white. Move the slider just to the point that an image begins to become clipped, and set the whites and blacks accordingly.

Underexposing to hold highlights when using digital capture is generally a bad idea. You will lose dynamic range, and there will be a tendency to induce posterization when the image is lightened. An ideal exposure has specular highlights just at the point of clipping. One of *Lightroom's* most remarkable features is its extended highlight recovery logic. If you have a choice during capture, it's better to choose overexposure than underexposure.

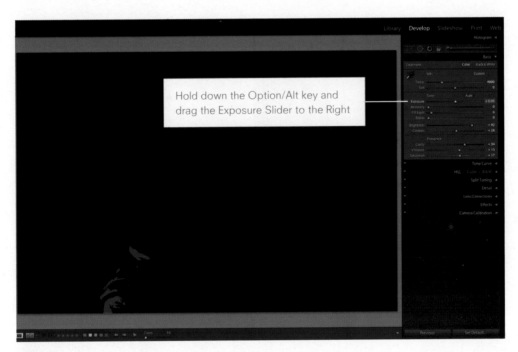

Hold down the Option/Alt key and drag the Exposure Slider to the Right

FIG 8.58
Pressing down the Option/Alt key while moving the Exposure slider will locate the technically correct white point

Recovery

D-65 suggests using the Exposure slider to get the overall image luminance correct and then using Highlight Recovery to bring back any blown highlights. Recovery reduces the tones of extreme highlights that were lost because of camera overexposure. *Lightroom* can actually recover lost detail in RAW image files, even if two channels are clipped.

The Recovery slider works with highlight recovery. It does this by trading between exposure, which acts linearly and clips highlights, and brightness, which acts non-linearly and compresses highlights. By balancing these two, it avoids making changes outside the highlights, so its effects are very subtle. The benefit of this control is that you do not need to move the exposure slider to the left, making a negative move, to recover highlight detail.

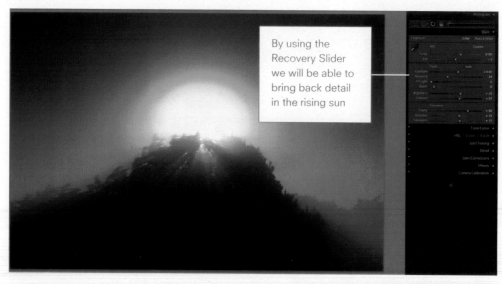

By using the
Recovery Slider
we will be able to
bring back detail
in the rising sun

FIG 8.59
Using the Recovery Slider to reclaim blown out highlights

RECOVERY SLIDER WORKFLOW TIP: Hold down the
Option/Alt key and move the Recovery slider until the
*clipped areas disappear (**Figures 8.60** and **8.61**).*

FIG 8.60
Hold down the
Option/Alt key and
move the Recovery
Slider until the clipped
areas disappear.

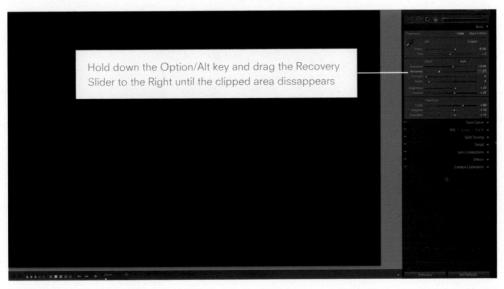

Hold down the Option/Alt key and drag the Recovery
Slider to the Right until the clipped area dissappears

FIG 8.61
Recovery Slider moved to the right

Fill Light

Fill Light gives the ability to pull added detail out of the shadows
without affecting the rest of the image. It really does work as if a
fill light were added to the scene. Notice the yacht interior below
in **Figure 8.62**. Compare it to **Figure 8.63**, where we used the Fill
Light Slider and are able to raise the appearance of the ambient
light in the interior as if we had a very large fill card being held by
two assistants.

FIG 8.62
No Fill Light

FIG 8.63
Addition of Fill Light

Blacks

Blacks controls the amount of black value in an image. It will have its greatest effect on the shadows and in some cases, may increase contrast as well. Moving the slider to the right increases the areas that become black as demonstrated in **Figures 8.64** and **8.65**.

BLACKS WORKFLOW TIP: *Pressing down the Option key while moving the slider will locate the technically correct black point (exactly like Exposure). The technically correct black point is the point when you first begin to see detail.*

FIG 8.64
The image prior to moving the Black Slider to the right

FIG 8.65
Moving the Black Slider to the right to affect shadow areas and increase contrast

Brightness

The Brightness slider adjusts the midtones. This adjustment compresses the highlights and allows you to visually manipulate how bright or dark an image appears. Large changes in brightness will also affect shadow and highlight clipping. You may have to adjust Exposure, Recovery and Blacks if you make large adjustments with Brightness. In **Figure 8.67** we have raised the midtones of **Figure 8.66** by adjusting the Brightness.

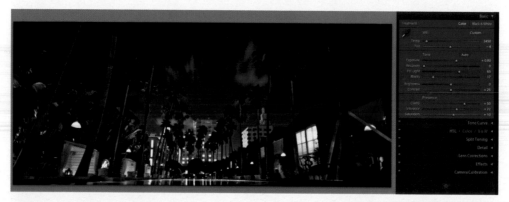

FIG 8.66
The image before adjusting the brightness

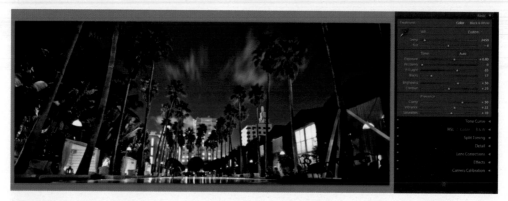

FIG 8.67
Raising the midtones by adjusting Brightness

Contrast

The Contrast Slider increases or decreases contrast in an image. Its greatest effect is on the midtones, like Brightness. As the Contrast Slider is moved to the right, the darker areas of an image will become darker and the lighter areas will become lighter, as shown in **Figures 8.68** and **8.69**.

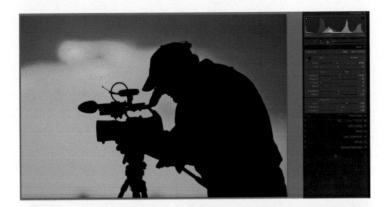

FIG 8.68
The image before adjusting the contrast

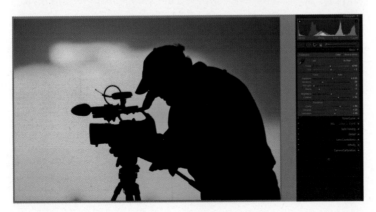

FIG 8.69
As the Contrast Slider is moved to the right, the darker areas of an image will become darker and the lighter areas will become lighter.

Auto

The Auto button will analyze an image creating a custom tone map based on the individual characteristics of the image. Auto will often produce excellent results. Auto is a very good starting point when correcting images, allowing the user to see how *Lightroom* would want to correct a particular image.

WORKFLOW TIPS FOR THE TONE PANEL:

• *Command U autocorrects all of the Tone Panel Sliders*

• *You can set any slider to its default by double-clicking on it*

I THE PRESENCE PANEL

There are three sliders in the Presence panel: Clarity, Vibrance, and Saturation.

Clarity

Clarity is a midtone contrast adjustment tool. It will give your images extra punch. Clarity adds depth to an image by increasing local contrast. When using this setting, it is best to zoom in to 100% or greater. To maximize the effect, increase the setting until you see halos near the edge details of the image, and then reduce the setting slightly. Clarity is one of the most popular and photographer-friendly features in *Lightroom*. In **Figure 8.70**, Clarity is set to 0 and in **Figure 8.71** it is set to 77. Look at the incredible difference!

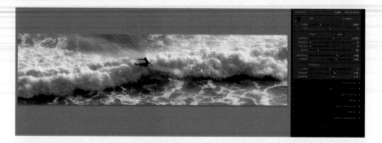

FIG 8.70
Clarity set to 0

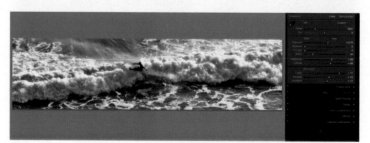

FIG 8.71
Clarity set to 77

While many photographers typically just set Clarity to around 50 because it makes their images look more crisp, they rarely think about negative clarity which is also very cool to use. It softens skin and has a very mystical quality on landscapes. In **Figure 8.72** we have Clarity set to 68 and in **Figure 8.73** we use negative Clarity, setting it to -44.

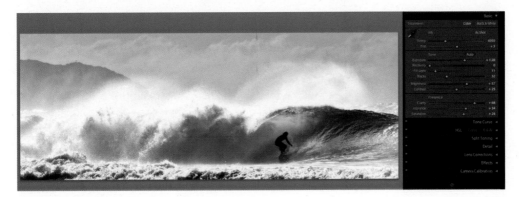

FIG 8.72
Clarity set to 68

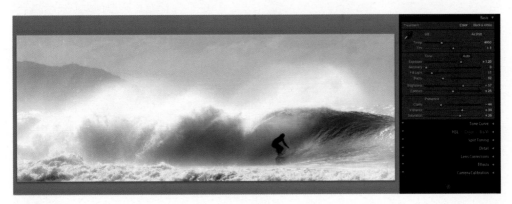

FIG 8.73
Negative Clarity set to -44

Vibrance

Vibrance increases the saturation in a nonlinear or non-equal manner, meaning the lower saturation values are increased more than high saturation values. This differs from Saturation in that Saturation does an across-the-board saturation increase regardless of the current value.

Vibrance is particularly useful in adjusting colors that would otherwise be clipped as they become fully saturated. It constrains the colors that would come out of gamut with printing. It is excellent for adjusting skin tones because it creates saturation without the skin tones going magenta. In **Figure 8.74**, Vibrance is set to 0 on the left and on the right it is set to 17. The blues are popping and the skin and hair are more pleasing without being overly saturated.

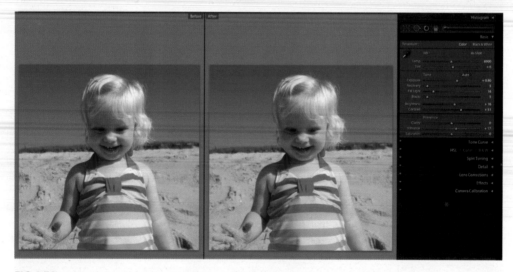

FIG 8.74
Adjusting Vibrance: 0 on the left and 17 on the right

Saturation

Many photographers have always been attracted to the saturated colors of Kodachrome or Velvia. Think of Saturation as your Kodachrome or Velvia adjustment tool. The Saturation slider gives you the option of reproducing that look and feel. Moving the

slider to a value of -100 makes a monochrome image. Moving the slider to a value of +100 doubles the saturation. Be aware, however, that too much saturation can be a bad thing. If you increase the saturation value to a very high number, you are likely to create out-of-gamut colors.

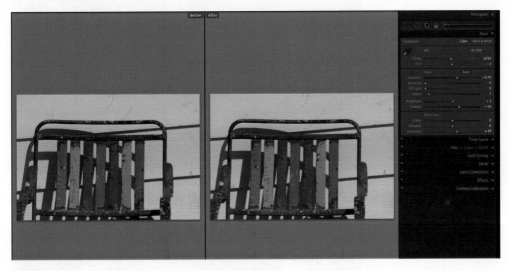

FIG 8.75
Adjusting Saturation: 0 on the left and 17 on the right

I THE TONE CURVE PANEL

FIG 8.76
Traditional
Parametric Curve

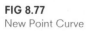
FIG 8.77
New Point Curve

Tone Curve

The Tone Curve tool is perhaps the most powerful and flexible image manipulation tool in *Lightroom*. The Tone Curve affects tones and contrast. Similar to the Levels feature in *Photoshop*, curves can take input tones and selectively stretch or compress them. Unlike Levels, which only has black, white and midpoint control, a tonal curve is controlled using any number of anchor points. The key concept with Tone Curve is that you can redistribute contrast. This is controlled with Highlights, Lights, Darks and Shadows.

• **Highlights:** The brightest points of the image

• **Lights:** From the midtones to the highlights

• **Darks:** From the midtones to the shadows

• **Shadows:** The darkest points of the image

So, if I want to bring down or control the brightest tones in an image, I would concentrate my efforts on the Highlight slider. Being able to work on essentially four different tonal ranges of the image independently gives you a tremendous amount of versatility and control. Each of the controls in the Tone Curve panel is contributing to the shape of the final curve applied to your image.

The histogram in the Tone Curve panel represents the range of values you define when you set your black and white point.

Under the Histogram, you will find three sliders, which give even more control over the range of the area that you are working on. You can narrow or broaden the range of tones affected by the curve by expanding or contracting the area of the curve. As you mouse through the Tone Curve, you will see the corresponding parts of the image made active in the panel. The coolest thing in the Tone Curve panel is the Targeted Adjustment Tool. Click on the Targeted Adjustment Tool and move it into the area(s) of the image you want to adjust. Then click down and use the up and down arrow keys to open up or close down that area of the image. This will be reflected in the Tone Curve. In **Figure 8.78** we have selectively toned down the Highlights and the Darks. **Figure 8.79** shows the before and after.

Point Curve

NEW

New in Lightroom 3

Point Curve enables a traditional point curve commonly found in the *Camera Raw* plug-in or in *Photoshop*. The inclusion of an adjustable point curve has been one of the most requested features in *Lightroom*. Ironically, one day during testing of *Lightroom* 3, it just appeared. Thank you, engineering!

The original parametric curve uses essentially the same concept as the Tone Curve and you can use the Targeted Adjustment Tool or the sliders. The advantage of this approach is that the adjustment of the curve is constrained to predefined limits, which have been optimized to prevent detrimental adjustments to the shadow, midtone and highlight regions. However, these constraints on occasion may not allow for precise adjustments, meaning it is off to *Photoshop*.

With the Point Curve, very fine adjustments to specific parts of the curve are possible because you can set locks and adjust the curve within them. By using the Option/Alt key you get exceptionally precise control.

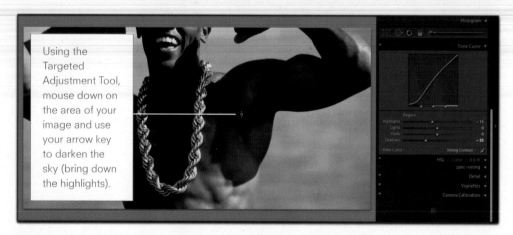

Using the Targeted Adjustment Tool, mouse down on the area of your image and use your arrow key to darken the sky (bring down the highlights).

FIG 8.78
Using the Targeted Adjustment Tool to adjust a parametric Tone Curve

TONE CURVE WORKFLOW TIP: Drag the curve and points in the histogram to make adjustments.

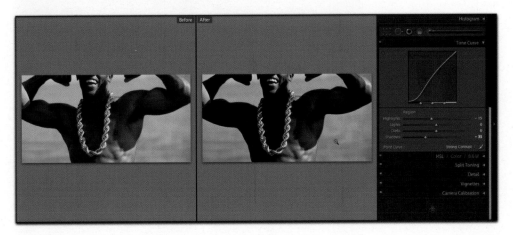

FIG 8.79
Before and after comparison of a Parametric Curve adjustment

I HSL /COLOR / B & W

At first glance, the color adjustment panel seems a bit intimidating, but it actually makes a lot of sense after you play with it for a little while. This panel fine-tunes Hue, Saturation and Luminance on individual channels. Hue changes the color of the chosen channel. Saturation intensifies or reduces the color. Luminance changes the brightness of the color channel.

This panel also has a Targeted Adjustment Tool so that you can click down on any area of an image and using your up and down arrow keys, adjust that specific area in the specific channels that are being affected in Hue, Saturation or Luminance.

FIG 8.80
The Color Adjustment
Panel, HSL / Color /
B & W

Hue

The Hue sliders control color balance. There are six sliders and each slider will produce an effect on that particular hue. There are separate sliders for altering the hue, saturation and luminance of the red, orange, yellow, green, aqua, blue, purple, and magentas in your image. As an example, if you use the Yellow slider, moving it to the right will make the yellows greener and moving it to the left will make the yellows redder.

One little interesting tidbit I can share is that people sometimes ask, "Why aqua?" Well, the truth is that a group of us have gone to Antarctica a few times and one of the crew was Thomas Knolls (check the *Lightroom* or *Photoshop* credits) and ice in Antarctica is an iridescent-like blue. Hence "aqua" was born.

Saturation

The Saturation sliders control the amount of saturation for each hue. Moving them to the right increases saturation and moving them to the left decreases saturation.

Luminance

The Luminance sliders will darken or lighten colors. Moving them to the right will lighten and moving them to the left will darken.

HSL and Color do the same thing, but just have a different display. Color does not have a Targeted Adjustment Tool.

HSL / Color Demonstration

In **Figure 8.81** we wanted to create the look of a Polarizing Filter on the sky. We increase the hue of the blue sky, increase the saturation of the sky, and lower the luminance of the sky.

FIG 8.81
Using HSL to create the effects of a Polarizing Filter

We will use HSL to create the effects of a Polarizing Filter in **FIG 8.81** through **8.85**. We start by putting the Targeted Adjustment Tool on an area of the blue sky. *Lightroom* chooses Blue Hue and bumps it up to plus 13 and purple to plus 2. We accomplish this by using the up arrow tool.

Steps:

1. Change to Saturation and increase Blue Saturation to +31 and Purple Saturation to +4.

2. Change to Luminance and decrease Blue to -49 and Purple Luminance to –6.

3. Comparing the two, we can see that the effect is very similar to using a Polarizing Filter.

Use the up and down arrow Keys to increase or decrease The Targeted Adjustment Tool

FIG 8.82
Increase Blue Hue to +13 and Purple Hue to +2

FIG 8.83
Change to Saturation and increase Blue Saturation to +31 and Purple Saturation to +4

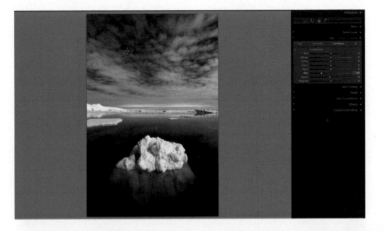

FIG 8.84
Change to Luminance
and decrease Blue
to -49 and Purple
Luminance to –6

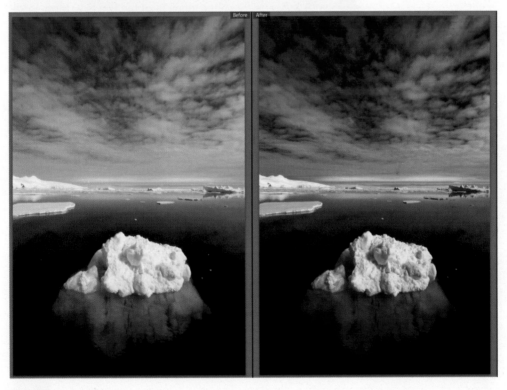

FIG 8.85
Comparing the two, we can see that the effect is very similar to using a Polarizing Filter

I B & W

Selecting B & W activates the B & W Panel which in prior versions was called the Grayscale Panel. The default B & W setting applies an Auto adjustment that is based on the current White Balance and Tint settings. This default setting is a good starting point to work from, as shown in **Figures 8.86** and **8.87**.

Once you get familiar with the Black & White Mix panel, you will be able to create custom black and white conversions by having access to all the color channels using these sliders. This panel also has a Targeted Adjustment Tool, which works great! You can create any black and white effect imaginable. If you can't imagine anything, you will notice a whole bunch of *Lightroom* Presets for different B & W effects on the left side of the Develop Module under Presets (**Figure 8.88**).

FIG 8.86
To convert to B & W we choose B & W in the Color Adjustment Panel

FIG 8.87
Converting to B & W using Auto and then refining the image using some of the sliders

Presets +

 Lightroom Presets

 B&W Creative - Antique Grayscale

 B&W Creative - Antique Light

 B&W Creative - Creamtone

 B&W Creative - Cyanotype

 B&W Creative - High Contrast

 B&W Creative - Look 1

 B&W Creative - Look 2

 B&W Creative - Look 3

 B&W Creative - Look 4

 B&W Creative - Low Contrast

 B&W Creative - Selenium Tone

 B&W Creative - Sepia Tone

 B&W Filter - Blue Filter

 B&W Filter - Blue Hi-Contrast Filter

 B&W Filter - Green Filter

 B&W Filter - Infrared

 B&W Filter - Infrared Film Grain

 B&W Filter - Orange Filter

 B&W Filter - Red Filter

 B&W Filter - Red Hi-Contrast Filter

 B&W Filter - Yellow Filter

FIG 8.88
Presets for B&W available from the Develop Presets Panel.

I THE SPLIT TONING PANEL

Using the Split Toning controls on images after they have been converted to black and white allows you to add some color to the image. You can independently control the Hue shift and saturation of Highlights and Shadows. The Hue sliders adjust the hue and the Saturation sliders can be used to apply varying degrees of color tone. The Balance Slider balances the effect between the Highlights and the Shadows. A positive number on the balance slider increases the effect of the Highlights Slider, while a negative number increases the effect of the Shadows Slider.

This tool is useful for creating black and white effects such as Sepia, Brown Tone, Warm Tone, or Cool Tone. These adjustments can be saved as a Custom Preset and used again later. You can create your own "look" to use over and over again. Of course, you can do this on color images as well, warming highlights and cooling shadows.

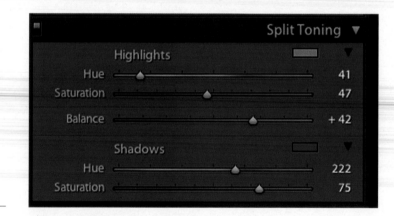

FIG 8.89
Split Toning Panel

To Use Split Toning

You will not see results by simply shifting the Hue slider. You must hold the Option/Alt key down, and click down on Hue and then if you drag the slider back and forth, you will see the hue change. Find a hue you like for the highlights and release the mouse.

Now go to the Saturation slider, starting at 0. Do not hold the Option/Alt key down for this step.

Drag the slider to the right until you have the appropriate saturation of the hue. Do the same thing for the shadows.

The Balance slider can then be used to mix both results together weighting one more than the other.

FIG 8.90
Comparison of before and after Split Toning an image

I THE DETAIL PANEL

New in Lightroom 3 Lots of work has been done on improving the noise reduction without losing fine detail.

New in Lightroom 3 Luminance noise reduction is much improved.

New in Lightroom 3 The Edge Detail slider refines the edges on extremely noisy images at high ISO.

New in Lightroom 3 There have also been subtle but improved changes to the Capture Sharpening.

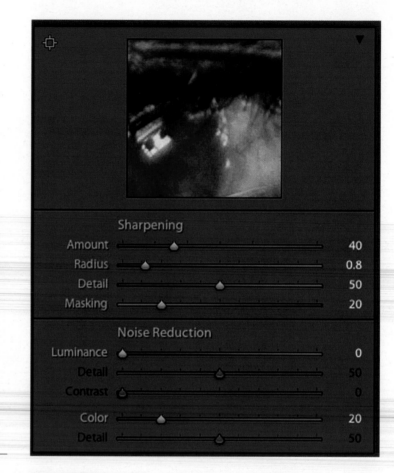

FIG 8.91A
Detail Panel

Sharpening

The Detail Panel in *Lightroom* allows you to sharpen using Amount, Radius, Detail and Masking with the use of sliders. The detail panel also incorporates Noise Reduction and Chromatic Aberration.

The Sharpening Panel has a default set for RAW file processing because most RAW files need some degree of sharpening. We'll explain why.

When photons are digitized to pixels, sharpness is lost. Regardless of how large the camera sensor is, pixels are sampled as a fixed grid of gray tones. These gray tones mimic the

continuous graduations of color perceived by the human eye and are used to shape specific pixels.

Digitization is accomplished by reconstructing data at a "frequency" that produces aliasing or non-alignment. Out of necessity, most cameras today deploy an anti-aliasing filter that eliminates the highest frequency detail. The net effect is that the detail rendered appears soft. Therefore, digital photographs look soft because of the very nature of how the pixel is constructed. For this reason, we typically want to capture and sharpen, defining basic focus to restore any sharpness that was lost in the capture process.

The Sharpening Default for *Lightroom* is:

• Amount 25

• Radius 1.0

• Detail 25

• Masking 0

When sharpening, it is critical to set the zoom level to 100% or greater in order to view the effects of the sharpening controls. A general rule when sharpening is to sharpen pixels without adding any ugly artifacting. There is a magnification window right in the sharpening panel. You can click on the button in the upper left hand corner and wherever your cursor moves, that area will be magnified in the window. A click locks the focus on a specific point (**Figure 8.91B**).

FIG 8.91B
Magnification Window
in Detail Panel

Sharpening Different Types of Images

Most images tend to be either high frequency or low frequency. High frequency images are highly textured and detailed, and low frequency images have less texture and detail. A close-up of text on a soda can would be a good example of high frequency detail and most faces are a good example of low frequency detail.

There are two Sharpening presets that come with *Lightroom* in the Presets Panel. One is a preset for Wide Edges (Faces) and one is a preset for Narrow Edges (Scenics). These are both very good starting points. You may find them satisfactory, or you may want to create your own sharpening custom preset.

Wide Edges (Faces) Preset Applied

Notice in the image below that the skin is smooth while the eyes are sharp. When the Landscape Preset is applied to the same image (**Figures 8.92** and **8.93**), there is a noticeable difference. You can see the hair in detail across the face, and blemishes are emphasized. Everything is very sharp, too sharp for this type of image.

FIG 8.92
Wide Edges (Faces) Preset applied

FIG 8.93
Narrow Edges (Scenics) Preset applied

How to Sharpen

When we view an image, we see the whole image, but the digital image is really comprised of individual pixels each with a distinct shape. When enlarged, they can be viewed as blocks. The edges of these blocks are both light and dark. Sharpening essentially makes the edge of the lighter block a lighter value and the edge of a darker block a darker value.

FIG 8.94
Sharpening makes the edge of the lighter block a lighter value and the edge of a darker block a darker value.

Amount: The Amount regulates how aggressive the sharpening will be by controlling edge definition. With the Amount set to 0 (0 turns off sharpening) the edges will be less prominent and as the Amount is increased, the edges will get more exaggerated. The light lines will get lighter and the dark lines will get darker. This adjustment locates pixels at the transition point that differ from the surrounding pixels, and increases their contrast.

AMOUNT WORKFLOW TIP: *Press Alt (Windows) or Option/Alt (Mac OS) while dragging this slider to view the sharpening on a grayscale preview which may make it easier to see.*

Amount Set to 0

FIG 8.95
Amount slider set to 0

Amount set to 150

FIG 8.96
Amount slider set to 150

Radius: The Radius determines how wide an area is affected by the sharpening. An amount between .8 and 1.8 is generally the effective range. Using a higher radius may cause halos at the edges. Landscapes generally use more radius and portraits generally use less. The amount really depends on the detail of the image. Very fine details need a smaller radius. Using too large a radius will generally produce unnatural looking results.

RADIUS WORKFLOW TIP: Press Alt (Windows) or Option/Alt (Mac OS) while dragging this slider to preview the radius effect in grayscale on edge definition.

FIG 8.97
Radius slider set to 0

Radius at 0

FIG 8.98
Radius slider set to 3

Radius at 3.0

Detail: The Detail slider adjusts the quantity of high-frequency information sharpened and how much suppression is applied to the edges to counteract halos. Lower settings primarily sharpen edges to remove blurring. Higher values are useful for making the textures in the image more pronounced. When Detail is at 100 there is no halo suppression, and when it is at 0 there is total halo suppression.

DETAIL WORKFLOW TIP: Press Alt (Windows) or Option/Alt (Mac OS) while dragging this slider to view the sharpening on a grayscale preview which can make it easier to see.

Detail at 0

FIG 8.99
Detail slider set to 0

Detail at 100

FIG 8.100
Detail slider set to 100

Masking: Masking sets how much of a mask will be applied to the edges. The Edge Masking amount (which you can preview by holding the Option/Alt key) goes from 0 where it's hitting only edges to 100 where there is no edge preservation at all. At zero, everything in the image receives the same degree of sharpening. At 100, sharpening is mostly restricted to the areas near the strongest edges.

MASKING WORKFLOW TIP: *When you hold down the Option/Alt key and drag the slider, the white areas will be sharpened and the black areas will be masked.*

Masking at 7

FIG 8.101
Masking slider set to 7

Masking at 80

FIG 8.102
Masking slider set to 80

D-65's Suggested Starting Point for Sharpening

D-65 has found that as a general rule for all images, a medium ground starting point is:

• Amount between 25-50

• Radius between .8 and 1.8

• Detail between 25-65

• Masking between 15-30

• Landscapes: less masking; portraits: more masking

Noise Reduction

Noise is an inherent issue with digital cameras, long exposures and high ISOs. Noise can only be eliminated at the sensor level. After capture noise can be masked to be less noticeable but it cannot be eliminated because it is inherent in the capture. The way the camera processes the signal will determine how the noise appears in the final image. There are two types of noise which photographers need to address.

Chrominance Noise or Color Noise: is visible as random red and blue speckled pixels you sometimes see upon close inspection in darker midtones and shadow areas. While the reasons for chrominance noise are quite complex, the simple answer is that

with a 12-bit capture, your shadow areas have 1/64 the information of your highlight areas. With less information, there is a greater chance for noise to occur. Chrominance noise is usually very unnatural and obvious on close inspection and can render images unusable if not kept under control. This noise has far less impact than luminance noise on fine details of your subjects, so it can often be reduced without appearing to blur or soften your images.

Luminance Noise: Luminance noise makes an image look grainy and monochromatic on screen. It is typical in high ISO images and in low ISO images where the brightness has been severely edited. It can appear as jaggy edges especially on diagonal lines. Fine detail is a component of luminance noise, so you have to pay careful attention that you do not remove it altogether. It's very easy to blur the noise to a point where you end up with an image that's totally lacking subject detail.

Removing luminance noise reduces the sharpness and removing the chrominance noise damages color. So noise reduction is a balance between how much softness and color damage you are willing to accept.

The need to adjust Luminance and Color Noise Reduction depends on the specific camera model. Shooting at the optimum ISO may eliminate the need to adjust these values for many cameras. Also, some of the new cameras like the Canon 5D Mark II and the Nikon D3 really do a phenomenal job of reducing or eliminating noise at the sensor level. As the ISO increases, noise is inevitable. Certainly with the cameras of today capturing at ISO 1600 or 3200 or more, noise is something that is simply going to happen.

Digital noise tends to be most noticeable in plain, solid areas of a subject, especially if they're midtone or dark areas. A photographer shooting high ISO in a basketball arena will likely see much less noise in the images than a photographer shooting ballet at the same ISO in a dim theatre. You will also see much more noise in the file if it is underexposed.

Noise is not grain and the two should not be confused. Grain can be beautiful, but an image filled with noise is usually not that pleasing to the eye. Noise reduction can present a bit of a dilemma. Removing luminance noise reduces the sharpness of

the image and removing the color noise damages some of the correct color. There is no perfect noise reduction. Something is always sacrificed so noise reduction becomes a balance between how much softness and color damage you can tolerate, and how much noise you want to remove.

Luminance reduces noise in the darker tones, which usually result from shooting at a high ISO. To reduce luminance noise, slide the Luminance Slider to a higher value. Be aware that adjusting the Luminance Slider may impact image sharpness. To reduce color noise, slide the Color Noise Reduction slider until the noise is eliminated from the image.

Lightroom's Noise Reduction masks the effects of noise, while maintaining image detail. To judge noise, you typically want to look at the shadows and make sure that you are at 100%. Some images may contain both color noise and luminance noise. When working on the Luminance channel, you can quickly compromise image detail, so remember the trick is to reduce noise without losing too much image detail. *Lightroom* 3 has five sliders for adjusting noise but the algorithms only apply when editing a Process Version 2010 image.

Luminance: Controls the amount of luminance noise reduction. A value of 0 does not apply any luminance noise reduction. If Luminance is set to 0, the Detail and Contrast sliders will be grayed out and disabled. The Luminance slider is always enabled (for both Process Version 2003 and 2010). The default value is 0.

NEW

New in Lightroom 3

Luminance Detail: Sets the noise threshold. Dragging the slider to right will preserve more detail. The one danger in doing this is that as you move to the right, you may also cause noise to be perceived as detail and therefore not corrected with smoothing. Dragging to the left will increase smoothing. The danger here is that you may cause needed detail to be incorrectly detected as noise that has been smoothed. The key here is to find a balance that works. This slider will be disabled when the image is Process Version 2003, or when the Luminance slider is set to 0. The results of this slider are more noticeable with higher ISO images. The default value is 50.

New in Lightroom 3

Luminance Contrast: Dragging this slider preserves contrast and texture. Be careful, because high ISO images can produce wacky results that look like globs of noise. Dragging the slider to the left enhances fine grain smoothing, but you may sacrifice contrast and texture. This slider will be disabled when the image is Process Version 2003, or when the Luminance slider is set to 0. The results of this slider are more noticeable with higher ISO images. The default value is 0.

Luminance Color: The default setting of 25 isn't bad, but D-65 tends to set it to 20 if we are shooting at optimum ISO (ISO 100 on a Canon). The key to this slider is to reduce color noise while still maintaining edge detail. Setting the slider to 0 means that no color noise reduction will be applied at all. As the slider is moved the right, the amount of color noise reduction is increased. More than 25 is pretty aggressive and eventually it will cause color bleeding around the edges.

New in Lightroom 3

Luminance Color Detail: This slider is really designed for very noisy images. It allows users to refine color noise reduction for detailed edges. As the slider is moved to the right, it aims to retain color detail in the edges but this can cause those red and green speckles to remain obvious in the image. As the slider is moved to the left, color speckled noise is suppressed but edge features can easily become desaturated. Adobe suggests that you try zooming to 400% pixel view to get a clearer understanding of the effect. This slider will be disabled when the image is Process Version 2003, or when the Luminance slider is set to 0. The results of this slider are more noticeable with higher ISO images. The default value is 50.

In **Figure 8.103** we have the ultimate image to test the efficiency of noise reduction in *Lightroom* 3. The shot was taken in Mendocino, California and it is a 84-second exposure at ISO 1000 showing the Milky Way. The camera used for the shot was a Canon 1DS Mark II.

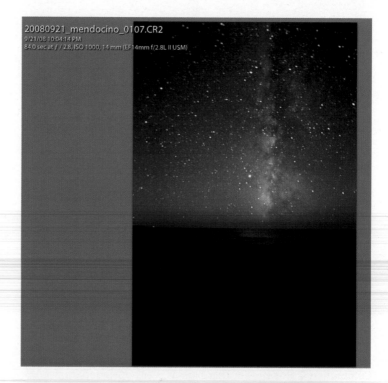

20080921_mendocino_0107.CR2
9/21/08 10:04:14 PM
84.0 sec at f / 2.8, ISO 1000, 14 mm (EF14mm f/2.8L II USM)

FIG 8.103
84 second exposure at
ISO 1000 showing the
Milky Way.

FIG 8.104
When we zoom in
on this image, we
can clearly see both
Luminance noise and
Chrominance Noise
and a lot of it!

FIG 8.105
By moving the Color
Noise Reduction slider
to 20 and the Detail
slider to 15, we have
almost completely
eliminated the
Chrominance Noise,
leaving the Luminance
Noise very visible.

FIG 8.106
By moving the
Luminance Slider to
50, the Detail slider to
30 and the Contrast
slider to 12, we have
greatly reduced
Luminance Noise.

FIG 8.107
A side by side comparison of the Before and After show astounding results

New in Lightroom 3

I THE LENS CORRECTIONS PANEL

If you had to name one top feature for *Lightroom* 3, it would be Lens Corrections. It has long been desired and it is finally here in full force. It provides totally non-destructive editing technology designed to address lens correction via two methods: Lens Profiles and Manual Correction. The engineers have been busy building profiles for popular lenses and many more will be included in the future.

The easiest way to use Lens Corrections is to automatically apply the lens profile technology, which incorporates geometric distortion (barrel and pincushion distortion), chromatic aberration and lens vignetting characteristics. For full manual use, and to build your own profiles, a Lens Profile Creator Utility is posted on Adobe Labs at http://labs.adobe.com/technologies/lensprofile_creator/

Lens Corrections also contains manual distortion corrections that extend beyond traditional geometric distortion and provide horizontal and vertical transformation adjustments.

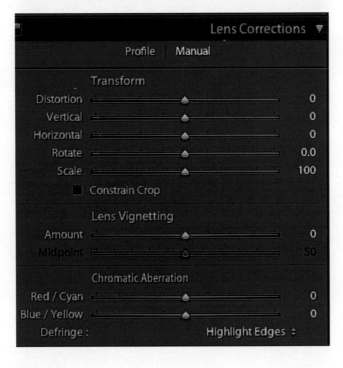

FIG 8.108
Lens Corrections Panel
set to Auto

FIG 8.109
Lens Corrections Panel
in Manual

Automatic Correction

Automatic Correction uses lens profiles to automatically apply corrections which generally work very well. Further, Automatic Corrections can be tweaked for specific effect. For example, you can reduce the amount of Vignetting correction applied by the profile by moving the slider to a value less than 100.

Automatic has three settings:

Default: Will check to see if the user specified a default for the lens and if so will use that.

Auto: Uses computer algorithms for finding what *Lightroom* thinks is the best available profile for your lens.

Custom: Custom will be displayed if you choose different settings from the Make/Model/Profile pop-up menus.

When a profile can't be found, there is a warning message. The user can also save customized settings as well as new lens profile defaults.

FIG 8.110
An iceberg in Antarctica with Chromatic Aberration

FIG 8.111
When we zoom in on the iceberg we can see Chromatic Aberration causing pretty severe magenta fringing at the top of this iceberg. Long lens images with light objects against a dark background will sometimes show this kind of fringing especially on the highlight edges.

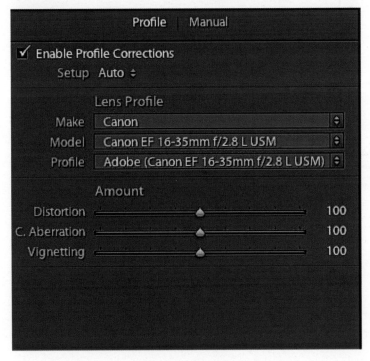

FIG 8.112
Auto uses experience-based technique for finding what *Lightroom* thinks is the best available profile for your lens.

FIG 8.113
Auto quickly and
easily removes the
chromatic aberration.

Lens Corrections in Manual

One of the first questions that arises when folks start to play with the Lens Correction Panel is, "What about what camera body I am using?" Camera body variations are much less important than factors like f-stop, focal length and focus distance.

For example, the Canon 85 f/1.2 lens has almost zero lateral chromatic aberration when focused at infinity, but has a lot of lateral chromatic aberration when focused at 1 meter. This difference—between infinity and 1 meter focus–is much bigger than what you'd see when comparing shooting the same lens on other Canon full-frame bodies. The lens is really the issue, much more than the camera body.

Transform

Distortion: Moving the slider to the right will bend the image in with a concave-like effect. Moving the slider to the left will bend the image out with a convex-like effect.

FIG 8.114
Moving the Distortion slider to the right

FIG 8.115
Moving Distortion slider to the left

Vertical: This slider is for vertical perspective transformation, for example, to correct for keystoning in architectural photography.

FIG 8.116
Moving the Vertical slider to the right

FIG 8.117
Moving the Vertical slider to the left

Horizontal: This slider is for Horizontal perspective transformation. Both the Horizontal and Vertical sliders use calculations that correct perspective and are dependent upon the focal length of the lens in use, specifically, the angle of view. They enable the user to get converging lines to become parallel without strange aspect ratio problems.

FIG 8.118
Moving Horizontal slider to the right

FIG 8.119
Moving Horizontal slider to the left

Rotate: Rotate is effective for dealing with perspective adjustments like keystoning.

FIG 8.120
Moving Rotate slider to the right

FIG 8.121
Moving Rotate slider to the left

Scale: Applying a distortion or perspective adjustment can push pictorial elements out of a frame, making an image no longer a clean rectangle but rather a very weird shape. Scale recovers elements that get pushed out of the frame.

FIG 8.122
Moving Scale slider to the right

FIG 8.123
Moving Scale slider to the left

Lens Vignetting

Amount: Lens Vignetting is fairly common with many wide angle lenses. Lens Vignetting in the Lens Correction panel is different from Lens Vignetting in the Effects Panel. In the Lens Correction panel, Lens Vignetting is used to correct any unwanted light fall-off you might have in one or more corners of your image. Moving the Amount Slider to the right lightens the corners of the image and moving the slider to the left darkens the corners of the image. So negative numbers darken, and positive numbers lighten.

Midpoint: The Midpoint controls how far from the edge the effect begins.

Chromatic Aberration: Chromatic Aberration is caused from the lens focusing colors of light as different frequencies. Each color is in focus but at a slightly different size, and that results in color fringing. The results of these lens defects are enhanced in digital cameras. In the long term, we need better lenses manufactured.

Red/Cyan: Adjusts the size of the red channel relative to the green channel. This compensates for red/cyan color fringing.

Blue/Yellow: Adjusts the size of the blue channel relative to the green channel. This compensates for blue/yellow color fringing.

Defringe: You can choose Highlight Edges, All Edges or Off.

NEW

New in Lightroom 3 A new effects panel

I THE EFFECTS PANEL

FIG 8.124
The New Effects Panel
in *Lightroom* 3

NEW

New in Lightroom 3

I POST-CROP VIGNETTING

There is now a choice of three separate vignette styles:
Highlight Priority, Color Priority and Paint Overlay. To get the
most out of this feature, it is important to upgrade an image to
Process Version 2010, as some of the sliders will not be available
unless the image has been upgraded.

The first thing to address here is the confusion that will likely exist
between Lens Vignetting and Post Crop Vignette. Lens Vignetting
is fall-off that occurs on the sides of some lenses which is fairly
common with many wide angle lenses. This type of vignetting
should be and can be corrected in the Lens Corrections Panel.

Post-Crop Vignette is really designed as a creative tool. To apply
a dark or light vignette for artistic effect to a photo, use the
Post-Crop Vignetting options in the Effects panel. A Post Crop
Vignette can be applied to a cropped or uncropped photo.
Post-Crop Vignette appeared in *Lightroom* 2 where we had

sliders for Amount, Midpoint, Roundness and Feather. Users found the results adequate, but complained that they were not very realistic looking. For *Lightroom* 3, engineering refined Post-Crop Vignette for a more realistic look.

In images rendered previously with Process Version 2003, Post-Crop Vignettes mixed the cropped image values with black or white pixels, which on occasion resulted in a flat appearance. Using Process Version 2010, Post-Crop Vignettes adjust the exposure of the cropped image, preserving the original image contrast and creating a more natural effect.

For optimal results, you will want to remove any Lens Vignetting prior to Post-Crop Vignetting.

In the Post-Crop Vignetting area of the Effects panel of the Develop module, choose an option from the Style menu:

Highlight Priority (Process Version 2010 only): Enables highlight recovery but can lead to color shifts in darkened areas of an image.

Color Priority (Process Version 2010 only): Minimizes color shifts in darkened areas of an image.

Paint Overlay: Paints white or black into the corners.

Amount: Moving the Amount Slider to the right lightens the corners of the image and moving the slider to the left darkens the corners of the image. So negative numbers darken, positive lighten.

Midpoint: The midpoint controls how far from the edge the effect begins. Moving the slider to the left applies the Amount adjustment to a larger area away from the corners. Moving the slider to the right restricts the adjustment to an area closer to the corners.

Roundness: Moving the slider to the left makes the vignette effect more oval. Moving the slider to the right makes the vignette effect more circular.

Feather: Moving the slider to the left reduces softening between the vignette and its surrounding pixels. Moving the slider to the right increases the softening.

Highlights (Process Version 2010 only): Controls the degree of highlight contrast preserved. Suitable for images with small highlights, such as candles and lamps.

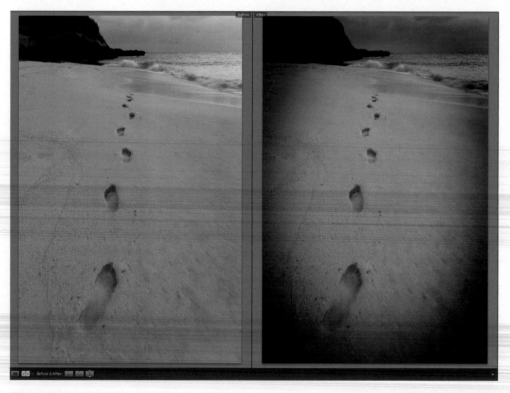

FIG 8.125
Before and after with Post-Crop Vignetting applied

New in Lightroom 3

I GRAIN

A traditional film-style grain slider provides a very natural looking grain. Grain is not noise. It would be pretty rare to look at an image with noise and say to yourself, "Wow! That looks great!" Grain, on the other hand, can be a really beautiful effect. Many photographers in fact have a style with their traditional images that capitalize on a very grainy look. Grain is sort of like a layer of texture but it can create a dramatic effect.
In *Lightroom* 3 there are three sliders to add Grain.

Amount: Amount controls the visibility of the grain effect.

Size: Size controls the diameter of the grain.

Roughness: Roughness defines how the even the grain appears.

FIG 8.126
Before and after with Grain applied

I THE CAMERA CALIBRATION PANEL

FIG 8.127
Camera Calibration
Panel showing a custom
profile and Process
Version 2010

Camera calibration is probably one of the most misunderstood, yet cool functions of the Develop Module. Many folks will never use this feature because they really don't understand what they are missing. They simply assume that what they see on the back of the camera LCD is correct. But, is it really?

A Canon rendering of a file is different from a Nikon rendering and both are different from *Lightroom*, Aperture, PhotoMechanic and any other RAW image processor. Different, yes, but not necessarily any more correct. The color you see on the LCD on the back of the camera is your first impression of your image, so the brain assumes it is accurate. In reality, that LCD rendering is composed of a low-res sRGB display. It's not accurate color of the RAW data captured within the image file.

Another factor to consider is that cameras can vary a lot in color response from camera to camera. Each and every chip is slightly

different, so even two cameras of the same make and model may have a slightly different look.

For each camera RAW format that is supported, Thomas Knoll created two profiles, which measure the camera sensors under both tungsten and controlled daylight. This is the default for how your camera's files are rendered in *Lightroom*. If Thomas's renderings don't suit your fancy, you can alter them and this is where *Lightroom's* Camera Calibration Panel comes into play.

The Camera Calibration sliders can be used to fine-tune adjustments to the camera's color response. This means two or more cameras can be made to look alike. If your camera is a little magenta or a little green, it can be corrected. Camera Calibration makes it possible to have the look of Kodachrome, Infrared or even the look of Canon DPP, Nikon Capture or even the rendering style of an individual photographer, like a "Jay Maisel look."

The Camera Calibration Panel also has a drop-down menu where you can save specific looks that you create, or that are created by third party products such as the X-Rite ColorChecker Passport.

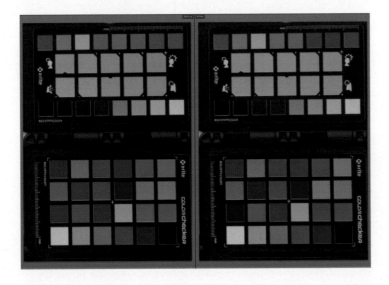

FIG 8.128
Camera Calibration Panel showing a standard profile on the left and a custom profile using X-Rite ColorChecker Passport on the right.

NEW

New in Lightroom 3

I PROCESS VERSION

The Process Version specifies which version of *Camera RAW* image processing technology should be used when rendering and editing files. Because the processing engine has been so improved, there is a substantial difference in images processed in *Lightroom* 1 and 2 and *Lightroom* 3.

A "process version" has been introduced to differentiate between the old process and new processes and to allow you to choose how you want to process. The Process Version allows *Lightroom* to maintain virtually identical representation of images you've edited in the past and will also allow you to take advantage, if you choose, by updating the image to the latest processing version. All images edited prior to *Lightroom* 3 are associated with Process Version 2003.

Process Versions 1 and 2 have been renamed 2003 and 2010, relating to the year that processing was introduced. Any images with existing settings will be set to the old 2003 process version to get an almost identical rendering as in previous versions.

Any new images imported into *Lightroom* 3 will be assigned the new Process Version 2010. There's a warning exclamation mark to the lower right of the image if it's set to the old Process Version 2003 and you can click it if you want to update. Process Version is under the Settings menu, in the Calibration panel and the Sync dialog box.

The New Process Version 2010 affects highlight recovery, fill light, sharpening and noise reduction.

There is a icon in the lower right-hand corner of the image to let you know that the current image selected in the Develop module is a previous process version (**Figure 8.129**).

By clicking on the process version icon, you have the ability to see a before/after view of the old and new process versions and the ability to update all the selected images or all of the images in the filmstrip at the same time (**Figure 8.130**).

FIG 8.129
Icon in the Develop module showing it is a previous Process Version

Update Process Version

Lr

New processing technology is available for this image. Slight to moderate visual changes in noise reduction and sharpening adjustments may occur as part of the update. You may elect to preserve the original settings by selecting Cancel.

☐ Review Changes via Before/After

☐ Don't show again

(Update All Filmstrip Photos) (Cancel) (Update)

FIG 8.130
Icon options for updating an image to Process Version 2010

CAMERA CALIBRATION WORKFLOW TIP: In the "Camera Calibration" panel, choose your preferred profile from the Profile menu. Then hold down the Option/Alt key. The "Reset" button in the lower right turns into a "Set Default" button. Click it. Choose Update to Current Settings. Now all new images for this camera will use your chosen profile.

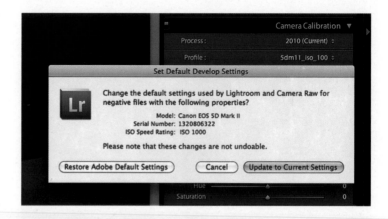

FIG 8.131
Camera Calibration
setting a new
default setting.

I THE PRESETS PANEL

Moving over to the left hand side of the Develop Module, located underneath the Navigator is the Presets Panel. *Lightroom* comes with many Develop Presets. A Preset is a combination of Develop Settings that are already saved that you can apply to one or more images. Scroll over a *Lightroom* Preset and view what the adjustment will look like on the image in the Navigator. If you want to apply that Preset, just click on it. This will synchronize those Preset Develop Settings to your image.

User Presets

Lightroom comes with many Develop Presets, but you can also create your own Custom Presets. These Custom Presets offer a way to save a group of Develop Settings and apply them to other images. Once saved, Presets will appear in the Presets Panel under User Presets. They will also appear in the list of options for Develop Settings when you import images.

FIG 8.132
Scrolling over a Develop Preset shows the result in the Navigator

Why Save A User Preset?

There are some adjustments that we would like to do to every image we process. These are called "global changes." For example, D-65 shoots with several Canon 1DS Mark III cameras and even though the color temperature may be set identically on the two cameras, the results are slightly different because no two sensors are exactly the same. On one camera, shooting on cloudy produces 6400K and on the other camera, it produces 6350K. To create consistency between the cameras, we create a global setting of 6500K, the traditional industry standard for cloudy and apply that to all files shot on the cloudy setting.

Presets can also be used to create a certain "look". We personally have always liked the saturation from Kodachrome film. Another preset we've created is called Seth Kodachrome which simulates Seth's interpretation of a memorable case of Kodachrome. These presets can be applied in the Develop Module, and also on files being imported into *Lightroom*. D-65

suggests saving any Develop setting or adjustment that you may want to use again in the future as a User Preset.

Creating a User Preset

We create a Preset that we use over and over again on Import on many of our daylight images.
This Preset does the following:

• Color temperature to 6500K

• Tint to +10

• Blacks to +3

• Clarity to +50

• Vibrance to +15

• Saturation to +17

• Sharpening: Amount 40, Radius .8, Detail 50, Masking 35

• Color Noise Reduction to 20

• Process Version 2010

• Camera Calibration for Canon 5D Mark II (if already created)

1. To create this preset, make the above changes in the Develop Module. For the Camera Calibration you would need to use the X-Rite ColorChecker Passport. If you do not have one, you would leave this step out.

2. Click on the plus (+) sign next to Presets on the left-hand side to open the New Develop Preset dialog box.

3. Check the settings that correspond with the develop settings we are saving.

4. The Preset is given a name of SETH KODACHROME 5DMII outdoors 6500

5. After this, we choose Create from the lower right-hand corner of the Presets dialog box (**Figure 8.133**).

FIG 8.133
Creating a
Develop Preset

After naming and saving our Preset, it appears under User Presets, as shown in **Figure 8.134**. This preset can even be applied to images in the future as they are imported.

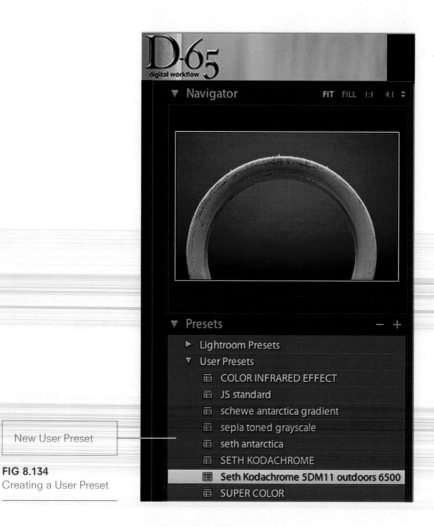

New User Preset

FIG 8.134
Creating a User Preset

I THE HISTORY PANEL

History saves all Develop adjustments as a state. The History Panel will list any Develop Preset that was applied at import, and also lists all subsequent Develop adjustments as they are applied. These are listed in a chronological order within the History Panel. You can go forwards and backwards in History by rolling over a state and you will see the preview in the Navigator. You can even copy and paste states to other images. As you make these changes, they are recorded in the History panel. Any time you want to compare a previous interpretation, or return to one, just click on that state in the History Panel and you're right there.

FIG 8.135
History Panel

I THE SNAPSHOTS PANEL

The Snapshots Panel is located right above the History Panel. Snapshots are basically saving specific steps of image History to which you might want to revert. When the History List becomes too long, you can create a Snapshot to save a specific state. This allows you to go back to a state in History, once it has been cleared.

Technically, the Snapshot Function is used to perform a sequence of steps in the Develop Module similar to an action in *Photoshop* that can be stored as a single step. Snapshots can be used to store your favorite history states as a saved setting. Rather than use the History panel to wade through a long list of history states, it is often more convenient to use Snapshots. Some folks simply prefer to use Virtual Copies instead of Snapshots but the choice is yours.

To create a Snapshot, click on the History state you want to save for an image. Then click on the plus button next to the Snapshots Panel. Name the Snapshot and click off the field. You can delete Snapshots with the minus button.

FIG 8.136
Snapshots Panel

BEFORE/AFTER WORKFLOW TIP: When you edit an image in one of the Before/After viewing modes, you can make umpteen adjustments and at any time compare the "After" with the "Before." The problem is that you are always comparing back to the original state. A neat way to compare to the last state is to copy settings from the After image to the Before image. This will update the "Before" with the "After." This is very much like creating a snapshot of the settings, allowing you to make further adjustments and compare these with the latest version. The other method is

to take the changes you want to start with and make a Virtual Copy and then make more changes. When you use Before and After, the Virtual Copy will show as the Before and your latest changes will show as the After.

I SUMMARY

Adjustments to images made in *Lightroom's* Develop Module use Parametric Editing and are non-destructive. While *Photoshop* has a mix of destructive and non-destructive editing features, all the edits you make in *Lightroom* are non-destructive. A non-destructive edit doesn't alter the original pixels in your image.

The big advantage of non-destructive editing is that you can undo any edit at any time, and in any order, and you can go back and change the parameters of any edit at any time, keeping the history of a file even after the file is closed. Once you get used to the non-destructive editing system in *Lightroom*, it will be hard to go back to a destructive system.

The Develop module holds all the controls that you need to adjust images. It is D-65's "Tweaking Command Central." The image processing engine used by *Lightroom* is Adobe *Photoshop Camera Raw*, which ensures that digital RAW images processed in *Lightroom* are fully compatible with *Camera Raw* and vice versa. Synchronization, Exposure, Shadows and White Balance will seem very familiar to *Photoshop* users or to earlier *Lightroom* users, plus there is a great deal of added new functionality in *Lightroom* 3.

The biggest changes that you will find in the Develop Module for *Lightroom* 3 are Lens Corrections and new Noise Reduction as well as a whole new way to process RAW files, Process Version 2010.

CHAPTER 9

SYNCHRONIZING DEVELOP SETTINGS

We have seen what all the buttons and controls in the Develop Module can do, and the power of parametric editing. A key to using *Lightroom* effectively is to adjust an image in the Develop Module and apply those changes to other images or groups of images. This is known as synchronizing settings or "Sync." This really makes the work flow quickly within *Lightroom*.

Let's go ahead and adjust an image and then synchronize the settings from one image to a group of others that are similar.

There are two things that are really important to keep in mind as you set out to tweak your images. The first is that *Lightroom* is so good, you may be inclined to start fixing bad images. This is not an efficient workflow. If you waste all your time trying to fix bad images, you will slow down your workflow. If an image is poor to begin with, move on.

Second, try to assess what you want to do to an image *before* you start working on it. Our friend Jeff Schewe says let the image talk to you. You can always find more areas to adjust, but again, the goal is efficient workflow. If you just keep playing without an end in mind, you will again be wasting time and slowing down your workflow.

I ADJUSTING AN IMAGE IN THE DEVELOP MODULE

We have a group of images that were shot on Breidarmerkursandur Beach in South Iceland. We make some basic adjustments to one image including sharpening, punching black and vibrance, a little noise reduction and a lens correction.

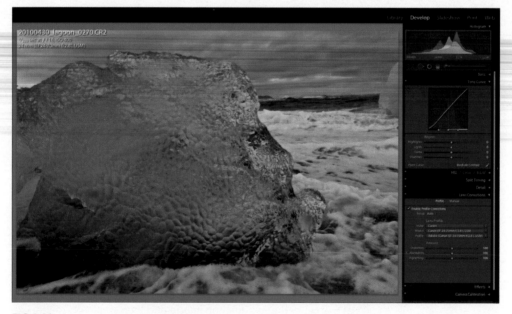

FIG 9.01
We make basic adjustments to one image.

| SYNCHRONIZING DEVELOP SETTINGS
BETWEEN MULTIPLE IMAGES

Now, we want to synchronize these settings to other
similar images.

First, we select the image that we just worked on in the Filmstrip
of the Develop Module.

FIG 9.02
We select our adjusted image in the filmstrip of the Develop Module.

Then, we select the images we want synced with that adjusted
image. **You must** select the adjusted image first, then select the
other images to synchronize to the first image.

FIG 9.03
Then, select the images we want synced with that adjusted image.

Then choose the Sync button at the bottom of the
Develop Module.

FIG 9.04
Choose Sync at
the bottom of the
Develop Module.

After we choose Sync, the Synchronize Settings dialog box
appears (**Figure 9.05**). We choose just the settings we want to
sync and click on Synchronize. You can sync all the adjustments,
or any part of the adjustments to the other image(s).

Synchronize Settings

☑ White Balance	☑ Treatment (Color)	☑ Lens Corrections	☐ Spot Removal
		☑ Transform	
☑ Basic Tone	☑ Color	☑ Lens Profile Corrections	☐ Crop
☑ Exposure	☑ Saturation	☑ Chromatic Aberration	☐ Straighten Angle
☑ Highlight Recovery	☑ Vibrance	☑ Lens Vignetting	☐ Aspect Ratio
☑ Fill Light	☑ Color Adjustments		
☑ Black Clipping		☐ Effects	
☑ Brightness	☐ Split Toning	☐ Post-Crop Vignetting	
☑ Contrast		☐ Grain	
☑ Tone Curve	☐ Local Adjustments		
	☐ Brush	☑ Process Version	
☑ Clarity	☐ Graduated Filters	☑ Calibration	
☑ Sharpening	☑ Noise Reduction		
	☑ Luminance		
	☑ Color		

(Check All) (Check None) (Cancel) (Synchronize)

FIG 9.05
Synchronize Settings
Dialog Box

After you Synchronize, a progress bar appears, showing that the settings are being pasted into other images and thus synchronized to the first selected image.

FIG 9.06
Settings are being pasted into other images and thus synchronized.

Lr Pasting Settings
Task completed _____×

The Filmstrip will then display the Develop settings being applied to the images.

FIG 9.07
The Filmstrip will display the Develop settings being applied to the images.

I OTHER OPTIONS AVAILABLE WHEN ADJUSTING IMAGES IN THE DEVELOP MODULE

Copy/Paste Buttons

You can adjust one image and choose Copy on the left-hand side of the Toolbar, then select another image(s) and choose Paste (also on the left-hand side of the Toolbar). This will apply the Develop settings from the first image to the newly selected image(s).

Sync Button

You can adjust one image, choose another image(s) and choose Sync, from the right-hand side of the Toolbar. The Synchronize Settings Dialog Box will pop up. You can choose to synchronize all the settings by selecting Synchronize. If you want to synchronize a component or any combination of the settings, for example, a crop, but no color adjustments, then you could uncheck any of the boxes that you didn't want to Synchronize. This is our favorite way of working and the one demonstrated above.

Previous Button

Choosing Shift-Command on the Sync button will change it to the Previous Button. This allows you to sync or copy settings from the last adjusted image to a new image, without having the prior image selected.

Reset Button

The Reset button takes the image back to camera default—the way it was shot without any Develop settings.

Auto Sync

Command-clicking on the Sync button will change it to Auto Sync. Auto Sync bypasses the Synchronize dialog box.

It is critical for you to know what was checked in the Sync dialog box the last time you used it before choosing this option, because all of those settings will be synchronized.

Local corrections cannot Auto Sync.

Set Default

Option-clicking on Reset sets a new default. This will allow you to change the basic default Develop settings. For example, you may want black to be 0 instead of 5. *Lightroom* and *Camera Raw* support the saving of user-defined Develop settings on a camera model, serial number and/or ISO rating basis.

Reset Adobe

Shift-clicking on Reset resets to the default Adobe settings.

I SUMMARY

Lightroom can significantly increase the efficiency and speed of your workflow by decreasing the time needed to tweak your files.

Don't waste time on bad images, but rather concentrate on improving your good images.

Analyze your images and decide what it is that you want to accomplish before you start playing in the Develop module.

Look at groups of images that are similar and take advantage of the ability to synchronize the settings from one image to another group of images. You can sync all or just some of the Develop settings.

THE SLIDESHOW MODULE

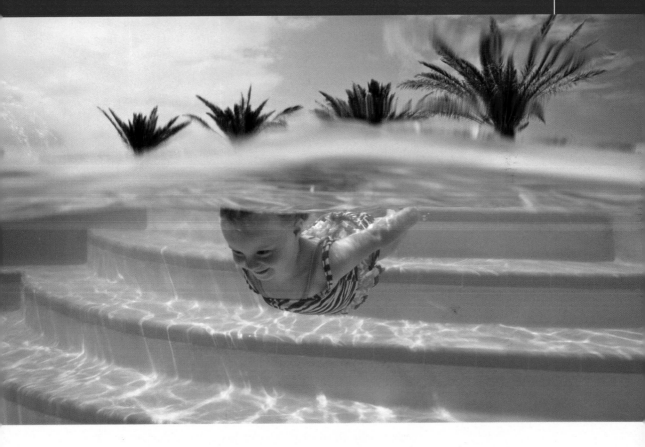

The Slideshow module in *Lightroom* offers an elegant way to assemble your images for a slideshow presentation. Slideshows can be used as a way to deliver images to clients, show your portfolio, or even show your friends and family your favorite images.

The Slideshow, Print and Web Modules all work relatively in the same fashion. The left panels contain a list of templates and collections along with a preview of each template. The center view displays the images. The toolbar contains controls for

playing a preview of the slideshow and adding text to the slides. The right panels provide the controls for specifying how the images appear.

Slideshows can be created directly in *Lightroom*, and can include music from your iTunes library and be played from your computer, or the slideshow can be exported as a PDF. If exported as a PDF, one can take advantage of everything that a PDF offers, including password protection for viewing, opening, editing and/or printing.

NEW ***New in Lightroom 3*** One new feature in *Lightroom* 3.0 is the ability to Export with music as a video.

New in Lightroom 3

• A new Slideshow option to Prepare Previews in Advance will ensure that a slideshow is never interrupted waiting for image information to render to the display

• Export your slideshows from *Lightroom* 3 as HD video

• Double-clicking on the music track will automatically adjust the slide change time so that the slideshow duration matches the music

• The Playback panel has been enhanced to include new buttons for selecting the music and automatically adjusting the slide change time

• There is now the ability to include color fades

• Watermark editing is now extended to the Slideshow Module

Creating a Slideshow

Select your images for a slideshow in the Library Module and click on the Slideshow Module. If you have Collections, they will be available directly from within the Slideshow Module on the left side Collections Panel.

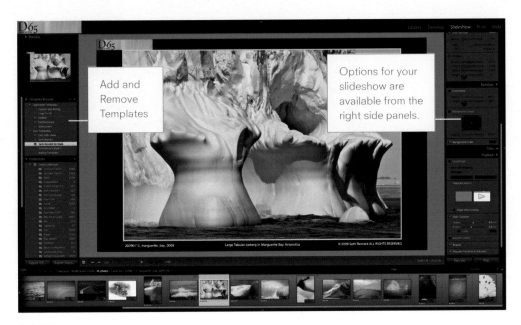

FIG 10.01
The Slideshow Module

One important notation: The default in the Toolbar is "All Filmstrip Photos," so even if you selected eight or ten images in the Grid, when you switch to Slideshow the Toolbar may still say all Filmstrip Photos.

FIG 10.02
Choose Selected Photos if you are choosing images on an individual basis.

SLIDESHOW WORKFLOW TIP: *If you want to create a slideshow using images from multiple folders, then create a Quick Collection of those images and make the slideshow from that collection.*

We'll go through all the options available in the Slideshow Module in order.

| TEMPLATE BROWSER

Various presets and custom slideshows can be saved and will be available in the Template Browser. As you roll over the presets, you can get a preview of how the slideshow will look in the Preview Window. User-created custom slideshow presets will appear under the User Templates.

Slideshow Template Presets

The Slideshow Module comes with template presets, or you can create your own custom templates. The included templates are:

- **Caption and Rating:** Centers images on a gray background— the stars and caption metadata are included

- **Crop to Fill:** Displays a full screen image—note that verticals might be cropped to fit the screen aspect ratio

- **Default:** Very similar to Caption and Rating—centers images on a gray background with stars with an identity plate included

- **EXIF Metadata:** Centers images on a black background with stars, EXIF information, and an identity plate

- **Widescreen:** Displays full frame of each image, adding black bars to fill the aspect ratio of the screen

FIG 10.03
Slideshow Template
Browser showing
preview of Exif
Metadata Template

I OPTIONS PANEL

Moving over to the right-hand side of the Slideshow Module you
will find the Options Panel. This is where you begin to control
how the images in the slideshow will appear. Use the Options
Panel to zoom the image to fill the frame, or not, to add a border
with a specific color and size or even to cast a shadow.

FIG 10.04
Options Panel in
Slideshow Module

FIG 10.05
Options Panel in Slideshow Module with Zoom to Fill Frame not checked

FIG 10.06
Options Panel in Slideshow Module with Zoom to Fill Frame checked

Stroke Border

Stroke Border provides the ability to add a border around your image in a specific color and pixel size. We have chosen a black border, 8 pixels wide, as shown in **Figures 10.07** and **10.08**.

FIG 10.07
Options Panel in Slideshow Module with Stroke Border set to black and 8 pixels

FIG 10.08
Setting Stroke Border to
8 Pixels in Options Panel
in Slideshow Module

*COLOR PICKER WORKFLOW TIP: While the Color Picker
is open, drag the cursor (eyedropper) onto the image to
sample a color from the image.*

FIG 10.09
Sampling color with
the Color Picker in
Options Panel in
Slideshow Module.

Cast Shadow

There are four options for working with Cast Shadow:

• **Opacity:** Displays the darkness of the shadow cast

• **Offset:** The distance of the shadow from the image

• **Radius:** The hardness of the edge of the shadow

• **Angle:** The direction of shadow

FIG 10.10
Cast Shadow in
Slideshow Module
Options Panel

FIG 10.11
Cast Shadow in Slideshow Module with following settings: Opacity at 55%, Offset 53 pixels, Radius 34 pixels. Angle -45

I LAYOUT PANEL

The Layout Panel controls the guides and margins for the slideshow. Visual guides can be linked or controlled separately.

FIG 10.12
Layout Panel in Slideshow Module

FIG 10.13
Layout Panel with show guides in Slideshow Module

FIG 10.14
Layout Panel with show guides turned off in Slideshow Module

I OVERLAYS PANEL

If you create an Identity Plate, it will be available in the Overlays Panel to drop into your slideshow. The Overlays Panel gives you the ability to control the placement, scale and opacity of your Identity Plate. You can also create and show text overlays, watermarking, ratings, and control text drop shadows.

The shadows for the text overlays have the same controls as in Cast Shadows:

• **Opacity:** Adjusts the darkness of the shadow cast

• **Offset:** The distance of the shadow from the image example

• **Radius:** Displays the hardness or softness of the edge of the shadow

• **Angle:** The direction of the shadow

Overlays ▼

✓ Identity Plate

D-65
digital workflow

☐ Override Color

Opacity 100 %
Scale 15 %

☐ Render behind image

✓ Watermarking : Seth Resnick ⇕

✓ Rating Stars

Opacity 72 %
Scale 70 %

✓ Text Overlays

Opacity 100 %

Font : Myriad Web Pro ⇕
Face : Regular ⇕

✓ Shadow

Opacity 77 %
Offset 10 px
Radius 6 px
Angle − 78 °

FIG 10.15
Overlay Panel in
Slideshow Module

FIG 10.16
Overlay Panel in Slideshow Module with Identity Plate, Watermarking, Rating Stars, Text Overlays and Shadow applied.

I BACKDROP PANEL

The Backdrop Panel allows you to apply a color wash or a gradient shading on the background. You can control the opacity of the wash as well as the angle of the wash.

You can also use an image as a backdrop or set the backdrop color. Color Wash applies a gradient wash on top of the background image.

FIG 10.17
Backdrop Panel in
Slideshow Module

Adding a Background Image to a Slideshow

Drag an image from the Filmstrip into the background of the
slide, as shown in **Figure 10.18**. Use the Opacity slider to adjust
the image's transparency.

FIG 10.18
Adjusting a background
image's transparency.

FIG 10.19
Image added as a
background image

BACKGROUND IMAGE WORKFLOW TIP: *You can't remove an image from the background, but you can add a new image just by dragging the new image over the old one. You can also set the opacity to 0% or uncheck the background image option to "remove" the image.*

Background Color

FIG 10.20
The Background Color
sets the color of the
background.

The Background Color sets the color of the background.

☑ Background Color

I TITLE PANEL

The Title Panel allows you to create both opening and closing title slides for your slideshow. The opening and closing slides can be text only, image only, or both.

FIG 10.21
The Title Panel in Slideshow Module

I PLAYBACK PANEL

Soundtrack allows you to select music and *New in Lightroom 3*, the soundtrack can be fit to the exact duration of the slide show using Fit to Music.

NEW

The Playback Panel settings control the transition and duration of the transition. You can also choose to add music from iTunes or randomize the slides.

The Playback Screen selector comes in very handy with dual monitors. You can choose which screen to play the slideshow on, and blank out the second screen.

Slide Duration controls the amount of time an image is on the screen and the length of time for a fade and *New in Lightroom 3*, includes the addition of color fades.

NEW

Random Order will play the slides in a random order.

Repeat will repeat the slideshow from the beginning.

FIG 10.22
The Playback Panel in
Slideshow Module

NEW

New In Lightroom 3

Prepare Previews in Advance

Prepare Previews in Advance will ensure that a slideshow is never interrupted by waiting for image information to render to the display monitor.

FIG 10.23
Prepare Previews
in Advance

I SLIDESHOW TOOLBAR

Adding Customized Text

The ABC Button located on the Toolbar allows you to add text, including the ability to add metadata and custom metadata from an image. You can scale the text and place it anywhere in the slideshow. The Toolbar also controls going to the next or previous slide, rotation, stopping and playing of the slideshow as well as a text field and a drop-down menu that allows you to choose All Filmstrip Photos, Selected Photos or Flagged Photos.

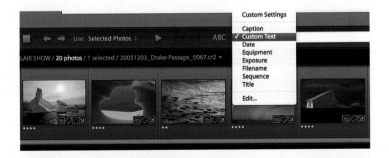

FIG 10.24
Slideshow
Module Toolbar

I EXPORTING AND PLAYING

The Export PDF button allows you to export the slideshow as a PDF file. Holding down the Option/Alt key while clicking on the Export PDF button toggles the buttonto Export JPEG and allows you to make slideshows to your own specifications using any third party slideshow product. Preview provides a preview of the show and Play will play the full slideshow.

New in Lightroom 3 Export Video allows export as HD Video.

NEW

FIG 10.25
Slideshow Module Export
as PDF, Export JPEG,
Export as HD Video

Export PDF... Export Video...

FIG 10.26
Slideshow Module
Preview and Play

Preview Play

Quality: Sets the quality using JPEG options: the lower the number, the lower the quality. The photos are automatically embedded with sRGB.

Width and Height: Pixel dimensions for the slideshow. The pixel dimensions of your screen are the default size.

D-65 exports the slideshow to a job folder, using a file naming convention that corresponds to the job name, such as 20100601_clientx_slideshow.pdf. We then send that slideshow to a client for viewing.

EXPORTING AS A PDF WORKFLOW TIP: With the full version of Adobe Acrobat, the user can apply security settings to the PDF saved from within Lightroom. This means you have control over an end user opening the document, printing or editing it. So for a client who may have presented payment problems in the past, you could save the document with a password required to open the document. The document can be delivered but not opened. When payment is received, the password can then be relayed and the document opened.

I SUMMARY

The Slideshow module in *Lightroom* offers an elegant
way to assemble your images for creation of a
slideshow presentation.

The left panels contain a list of templates and a preview
of each.

The center displays the photos.

The toolbar contains controls for playing a preview of
the slideshow and adding text to the slides.

The right panels provide the controls for specifying how
the photos appear.

When using a collection from the Slideshow, Print or
Web Modules, your settings are remembered in that
collection, and when you double-click from the Library
you are taken directly to the module in which you worked
on that collection, such as Slideshow.

Lightroom really makes printing a breeze with many features for all your printing needs. You can place multiple size images on a single page and have multiple pages of multiple picture layouts. You can even use draft mode printing which renders from the Previews. This is even more amazing because you can select a group of images, print them as a PDF and accomplish the task in seconds.

Another plus is the ability to print straight to JPEG and to attach a profile. That means that you can produce print packages for a client and allow the client to print their own photos at their

local lab. You can print more than one image at a time. In fact, you can actually send your entire catalog to the printer, or just one image at a time. There are pre-configured presets which provide all kinds of options including contact sheets. You can also create your own custom presets and save them for future use. The coolest feature of all is the ability to render an image automatically at the native resolution using Dimensions.

NEW

New in Lightroom 3 Custom Print Package. Print a group of photos in any configuration on one page or more than one pages. You can add cells and simply drag the images into them. You can also create a free-form layout by dragging the images directly to a blank page then resizing them in place.

New in Lightroom 3 Colors can be selected for a print layout background.

New in Lightroom 3 The Identity Plate can be moved with precision by selecting it and using the arrow keys.

New in Lightroom 3 Watermarking can be added to prints.

New in Lightroom 3 Maximum print resolution is increased to 720 ppi.

New in Lightroom 3 In the custom print package layout tools, there is a Rotate to Fit option and a Rotate Cell command.

The Print, Slideshow, and Web Modules all have quite similar features and behavior. The left panel contains templates of page layouts and the right panel contains all the options and controls for each layout. First, let's take a look at panels and features in the Print Module and then we will go through the correct setup for making great prints.

You can create
a Custom
Template or
remove a
Template, and
you can print
directly from
your Collections.

FIG 11.01
The Print Module

I THE TEMPLATE BROWSER PANEL

The Template Browser holds many preconfigured layouts for
printing, or you can completely create your own custom layouts
and add them to the Template Browser. You add and delete
templates from this panel by clicking on the + and - signs.

FIG 11.02
The Template Browser
in the Print Module

Creating a Custom Print Template

To create a new template, you can modify existing templates or start from scratch. The easiest method is:

1. Select a template from the Template Browser.

2. Use the settings in the right panels to setup the layout you want.

3. Save it as a custom template by clicking on the + button on the right of the Template Browser.

4. Give the template a name and choose Create.

5. The template will be saved in the User Templates folder of *Lightroom*.

TIP: One very cool thing that you can do in Lightroom 3 is to simply drag the images into a blank template and size them on the fly.

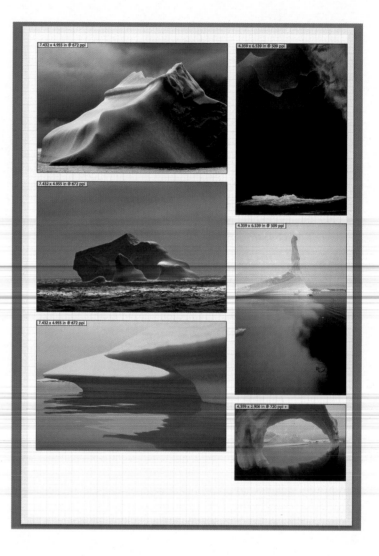

FIG 11.03
Creating a Custom Print
Template by dragging
and dropping and sizing
on the fly

| THE COLLECTIONS PANEL

You can make selections for the Print Module from the Library
Module or directly from your Collections, which appear in the
Print Module. You can also make print-specific collections.
Either choose the images you want to print from the Library
Grid, or choose a Collection from the Collections Panel in the
Print Module.

▼ Collections		− +.
▼ 🔲 Smart Collections		
🗃 Science Faction CAPTURE		1044
🗃 Science Faction Smart Collection		1163
🗃 5660		3026
🗃 Colored Red		3
🗃 Corbis Smart Collection		671
🗃 d65 classroom		353
🗃 feb1submission science faction		134
🗃 Five Stars		746
🗃 Jamie		3565
🗃 JewelBox		2
🗃 JewelBox CAPTURE Smart Collection		343
🗃 Kaly Smart Collection		1679
🗃 leo		114
🗃 Lightning		77
🗃 Luci		3732
🗃 Paige		1516
🗃 Past Month		2301
🗃 Portfolio		**321**
🗃 Recently Modified		1544

FIG 11.04
The Collections
Panel in the *Lightroom*
Print Module

I PAGE SETUP AND PRINT SETTINGS BUTTONS

On the lower left-hand corner of the Print Module is Page Setup
and Print Settings. Here is where you select your paper size,
orientation, color management and printer. Our settings are from
the Snow Leopard drivers updated in May 2010.

FIG 11.05
Page Setup and
Print Settings in the
Lightroom Print Module

Page Setup...	Print Settings...

FIG 11.06
Page Setup Dialog with
Epson 3800 and Super
A3 Paper selected.

Print

Printer: EPSON Stylus Pro 3800

Presets: Standard

Copies: 1 ☑ Collated

Pages: ⦿ All
⚬ From: 1 to: 1

Printer Settings

Basic Advanced Color Settings

Page Setup: Sheet Feeder

Media Type: Ultra Premium Photo Paper Luster

Ink: Photo Black

Print Mode: AccuPhoto HD2 ☑ 16 Bit Output

Color Mode: Off (No Color Management)

Output Resolution: SuperPhoto – 1440 dpi

☐ High Speed
☐ Flip Horizontal
☐ Finest Detail

? PDF ▾ Preview Supplies... Cancel Save

FIG 11.07
Print Settings Dialog
Box with our choices
for Epson Exhibition
Fiber Paper

I THE LAYOUT STYLE ENGINE PANEL

On the right side of the Print Module is the Layout Style Panel.
The Layout Style Panel contains the Single Image / Contact
Sheet, Picture Package and Custom Package options. Single
Image / Contact Sheet is what you use to print contact sheets or
single images of your selected images.

Layout Style ▾

Single Image / Contact Sheet
Picture Package
Custom Package

FIG 11.08
The Layout Style Panel

FIG 11.09
Single Image/
Contact Sheet

Picture Package creates multi-page layouts for an individual image in several different sizes. Picture Package allows you to create wallet size, 5x7 and 8x10 outputs all at the same time. What is really neat is that *Lightroom* sizes the images to the page. If they won't fit on one page, *Lightroom* creates a new page. You can even create custom image sizes by simply grabbing a border with the mouse and extending it. Shift-click and drag to keep the aspect ratio.

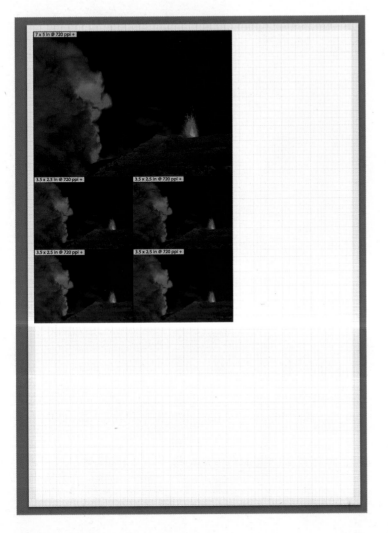

FIG 11.10
Picture Package

New in Lightroom 3 is Custom Package which truly lets you customize any layout.

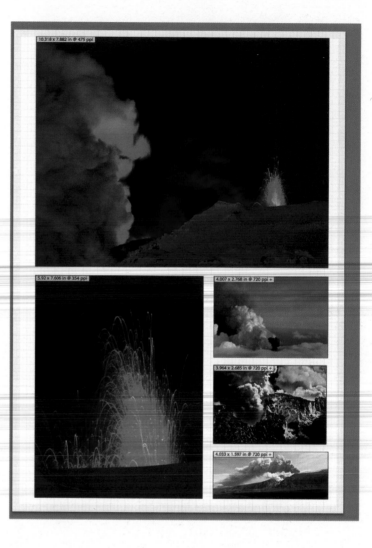

FIG 11.11
Custom Package

New in Lightroom 3 When Custom Package or Picture Package are selected from the Layout Style menu, the Cell Panel is activated.

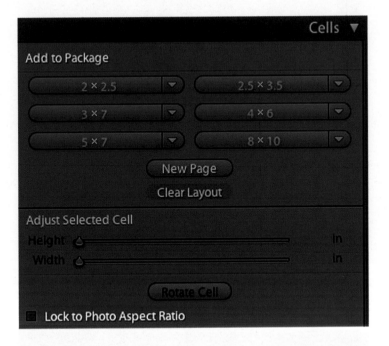

FIG 11.12
The Cell Panel is
activated when Picture
Package or Custom
Package are selected.

I THE IMAGE SETTINGS PANEL

Image settings are used to rotate, crop and fit images in a layout.
The menu choice will change depending on whether you have
Single Image / Contact Sheet selected or whether you have
Picture Package or Custom Package selected.

FIG 11.13
The Image Settings
Panel when Single
Image / Contact
Sheet is selected.

- **Zoom To Fill Frames:** Fills the frame, cropping the edges as necessary

- **Rotate To Fit:** Rotates images to produce the largest image for the layout

- **Repeat One Photo per Page:** This option allows you to repeat a photo multiple times on a page

- **Stroke Border:** You can add a color border to your image to be printed by clicking on the color picker, choosing the appropriate color and adjusting the width of the border with the slider.

FIG 11.14
The Image Settings
Panel when Picture
Package is selected

FIG 11.15
The Image Settings
Panel when Custom
Package is selected

I THE LAYOUT PANEL

The Layout Panel is available for the Single Image / Contact Sheet Layout Style. The Cell Panel (**Figure 11.12**) is available for Picture Package and Custom Package. The Layout Panel controls margins, page grid, cell spacing and cell sizes.

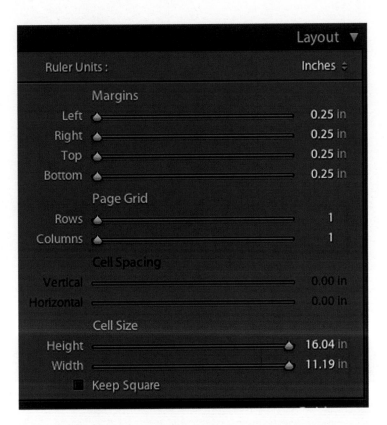

FIG 11.16
The Layout Panel

- **Ruler Units:** Sets the ruler to either inches, centimeters, millimeters, points or picas

- **Margins:** Sets the page margins. Changing the margin will move the image in the layout in real time

- **Page Grid:** Provides control over the number of cell rows and columns

- **Cell Spacing:** Controls the space between cells for rows and columns

- **Cell Size:** Controls the size of the image cells

| THE GUIDES PANEL

The Guides Panel shows or hides rulers, page bleed, margins and gutters, and image cells. The guides can be turned on and off for Page Bleed and layout purposes.

The coolest feature of all in Guides is Dimensions, which really belongs under Print Job. By checking Dimensions and unchecking Print Resolution in the Print Job Dialog box, the file will be ripped at the native resolution with no upsizing or downsizing. This in itself makes *Lightroom* worth every dime.

PRINTING WORKFLOW TIP: Uncheck Print Resolution in the Print Job Dialog box and check Dimensions and the file will be printed at the native resolution, yielding the best possible print.

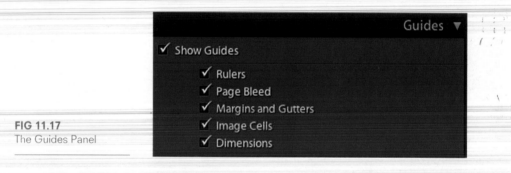

FIG 11.17
The Guides Panel

FIG 11.18
With Dimensions checked and Resolution in the Print Job box unchecked, the print will be made at the optimum native resolution which in this case would be 350 PPI.

| THE PAGE PANEL

Lightroom provides the ability to print various metadata as an overlay from the Photo Info dialog box, along with your Identity Plate and/or watermark. Many photographers like to put their

copyright or logo on proof images and this is the place to create those overlays.

FIG 11.19
Page Panel

Identity Plate

If you have created an Identity Plate, you can choose to include it in your printing by checking this option. You can rotate the Identity Plate with the degree option on the right by clicking on it and selecting No Rotation, Rotate on screen 90, 180 or -90. To move the Identity Plate, simply drag it to the desired location.

New in Lightroom 3 The Identity Plate can be moved with precision by selecting it and using the arrow keys.

NEW

- **Opacity:** Controls the opacity of the Identity Plate

- **Scale:** Controls the size of the Identity Plate

- **Render behind every image:** The Identity Plate will appear behind the photo

- **Render on every image:** The Identity Plate will appear centered on every photo in a multi-photo layout. It can be further scaled using the controls in the Overlays panel

Watermarking

NEW

New in Lightroom 3 If you have created a Watermark, you can choose to include it in your printing by checking this option.

Page Options

- **Page Numbers:** The page numbers will be printed on the bottom right of each page

- **Page Info:** The sharpening setting, profile setting and printer name will be printed on the bottom of each page

- **Crop Marks:** Crop marks can be printed around the image for use as a cutting guide

Photo Info

You can include the filename, title, keywords and caption excerpted from the metadata printed below each image. Select Photo Info and click the drop down menu to the right.

- **Date:** Prints the creation date of the photo

- **Equipment:** Prints the camera and lens information

- **Exposure:** Prints the shutter speed and f/stop

- **Filename:** Prints the name of the image

- **Sequence:** Prints sequential numbers based on how many images are printed as in 1/4, 2/4, 3/4, 4/4 for a sequence of 4 images.

• **Custom Text:** Prints any custom text entered

• **Edit:** For editing in the Text Template Editor

Font Size

You can set the size of the font chosen in point size.

FIG 11.20
Page Panel showing an image with watermarking and other metadata options

I THE PRINT JOB PANEL

This is really the "Control Central" for the Print Module. Color management, print resolution, rendering intents and sharpening are controlled in this panel. You decide whether to print to a printer or to output straight to JPEG and to attach a profile. That

means that you can produce print packages for a client and allow the client to print their own photos at their local lab. You can decide to allow the printer to control color management (not recommended by D-65) or choose a corresponding paper profile and allow *Lightroom* to control your color.

On a Mac running OS X 10.5 or greater, you can even output in 16-bit mode (not available on the PC). D-65 suggests that you let *Lightroom* handle color management. If, however, you choose Draft Mode, the printer automatically handles color.

FIG 11.21
Print Job Panel

Draft Mode Printing

Draft Mode Printing is good for printing contact sheets and quick prints. It is also very cool to print to PDF. You can select some or all the images in your library and print them fairly quickly to a PDF contact sheet based on the preview resolution chosen in the Catalog Preferences. In Draft Mode, the cached preview is used for the print.

If you choose an image without a fully cached preview, the thumbnail data is used and the prints may suffer from "jaggies" and artifacting. Sharpening and color management controls aren't available when using Draft Mode Printing.

You can also deploy PDF security if you have the full version of Adobe *Acrobat* which allows the ability to lock out printing and/ or copying.

FIG 11.22
Choosing Draft Mode Printing and Printing to a PDF with PDF Security.

FIG 11.23
PDF output with PDF
Security using Draft
Mode Printing.

Print Resolution

The print resolution defines pixels per inch (ppi)—for the printer.
The default value is 240 ppi. As a side note, the Epson print
engine can handle any resolution between 180 and 720 ppi.

New in Lightroom 3 Maximum print resolution has been
increased to 720 ppi. The ideal resolution for an image is the one
which has the least change from the native resolution of the file.

> *TIP: The native resolution is best achieved by unchecking
> Resolution in the Print Job Panel and checking
> Dimensions in the Guides Panel. This will output the
> file at its native resolution.*

Print Sharpening

Lightroom includes output print sharpening based on Pixel
Genius PhotoKit Sharpener algorithms. Output sharpening
accounts for pixels being converted to dots on paper. You can

choose the type of paper you are printing to, and the degree
of sharpening. When Draft Mode Printing is enabled, Print
Sharpening is disabled.

16-Bit Output

Lightroom includes the ability to output as 16-bit printing for Mac
OS X 10.5 or above.

Color Management

Profile: Other

If you have loaded paper profiles into your computer, they
will be available in Color Management under Profile>Other. If
you choose a custom printer profile, make sure that all color
management is turned off in the printer driver software. This is
controlled in the Print Settings Button under Color Management.

FIG 11.24
Selecting custom profile
for printing

Managed by Printer

If no profiles are installed in your computer, color will automatically be managed by the Printer. If you do use Manage by Printer, make sure to select ColorSync in the Color Management settings (Mac OS) or enable ICM Method for Image Color Management on the PC.

Depending on the print driver software, you can usually find the color management settings below the Presets menu after the Print dialog box opens on a Mac and after the Print Document dialog box opens at Setup>Properties>Advanced on a PC.

Rendering Intents

The printer's color space is likely smaller then the color space of the image to be printed. The rendering intent you choose will compensate for these out-of-gamut colors. Rendering intents options are Perceptual, Relative Colormetric and Relative.

Perceptual is for strong vibrant colors. Perceptual preserves the visual relationship between colors. Colors that are in-gamut may change as out-of-gamut colors are shifted to reproducible colors.

Relative Colormetric is for muted colors. Relative Colormetric rendering preserves all in gamut colors and shifts out-of-gamut colors to the closest reproducible color.

The Relative option preserves more of the original color and is a good choice when you have few out-of-gamut colors.

I THE PRINT BUTTON

After you have used all of the tools in the Panels to configure your print settings, press the Print button and you will wind up with a gorgeous print!

FIG 11.25
Making a print
by selecting the
Print Button

I DEMONSTRATION: MAKING A PRINT

Printing seems to confuse a lot of folks, so we are going to do
a quick step-by-step tutorial, reviewing the areas that seem to
cause confusion. We are going to print a 13x19 A3 print with the
Epson 3800 using Epson Exhibition Fiber Paper.

Every printer manufacturer will yield a different response to color
and changing inks. Paper will also affect how the print will look.
Lightroom's working color space, ProPhoto RGB, is an extremely
wide and accommodating color space. The range of colors that
are available from printers today may exceed the Adobe 98 color
space. Epson K3 inks and papers like Epson Premium Glossy
or Epson Premium Luster are capable of a gamut well beyond
Adobe 98.

*To achieve the best results and the widest gamut, it is
critical to have your monitor profiled. You can rely on the
colors that you see displayed as being the actual colors that
you are trying to print.*

We are going to make a print and take you through the basic steps.

1. Select an image from the Library, or if the image is part of a collection, select the image from the Collections Panel directly in the Print Module.

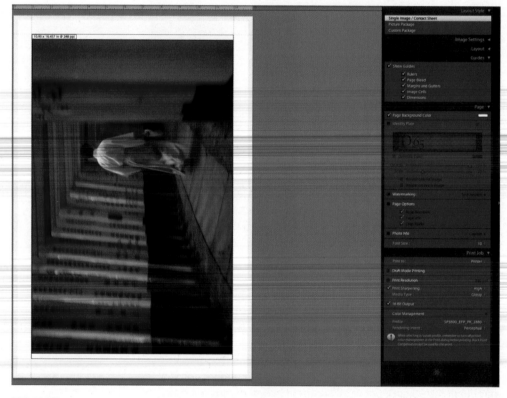

FIG 11.26
Select the image

2. Choose Page Setup from the bottom left of the Print Module to configure your paper size and choose your printer. We select our Epson Stylus Pro 3800. Choose your orientation and Scale to 100%. It is a good idea not to scale images in the Page Setup Dialog.

FIG 11.27
Page Setup

FIG 11.28
Choosing Printer and Paper Size from Page Setup Menu.

3. We use Image Settings and Layout to create a 2-point black
 border and 1 inch margins all around the image.

Layout Style ▼

Single Image / Contact Sheet
Picture Package
Custom Package

Image Settings ▼

☐ Zoom to Fill
☑ Rotate to Fit
☐ Repeat One Photo per Page

☑ Stroke Border ▬▬
 Width ═══◆════════════════════ 2.0 pt

Layout ▼

Ruler Units : Inches ⬍

Margins
 Left ══◆══════════════════════ 1.00 in
 Right ══◆══════════════════════ 1.00 in
 Top ══◆══════════════════════ 1.00 in
Bottom ══◆══════════════════════ 1.00 in

Page Grid
 Rows ◆═══════════════════════ 1
Columns ◆═══════════════════════ 1

Cell Spacing
Vertical ═══════════════════════ 0.00 in
Horizontal ═══════════════════════ 0.00 in

Cell Size
 Height ═════════════════════◆══ 17.00 in
 Width ══════════════════════◆═ 10.95 in
 ☐ Keep Square

FIG 11.29
We set Stroke Border to
2 and margins to 1 in.

4. In order to determine the ideal resolution for printing on
 Exhibition Fiber paper to the Epson printer, we want to
 output at the native resolution. By checking Dimensions in

the Guides Panel and unchecking Print Resolution in the Print Job Panel, we see that the output will be 248 ppi.

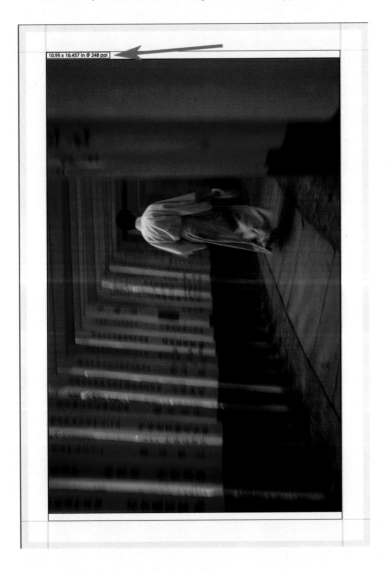

10.95 x 16.457 in @ 248 ppi

FIG 11.30
Resolution is unchecked and Dimension is checked and we can see that the native resolution will be 248ppi.

5. Now comes the confusing part for many photographers, how to handle color management and how to handle the Print Job Panel?

There are two choices when it comes to Color Management. You can use a custom printer profile and have *Lightroom* manage the color, or turn over the color management to your printer. D-65 chooses Application Color Management, which means that Lightroom manages the color, doing the conversions and handling the information off to the print driver.

First, you must turn off color management in the print driver. **Set Color Settings to Off (No Color Adjustment).** This option is the single most important one and also the one that causes the most confusion.

To utilize Application Color Management, you need an ICC profile associated with a particular paper/ink combination. You can download excellent profiles from many printer and paper companies. Epson has excellent free profiles on their website.

FIG 11.31
Color Mode Off No
Color Management

6. In the Printer Settings Dialog Box (**Figure 11.31**), first choose
 the Media Type that matches your paper. We choose Ultra
 Premium Luster Photo Paper.

7. **Print Quality:** We choose 1440 in part because it saves a
 substantial amount of ink. 2880 versus 1440 is debatable,
 as it is impossible to see the difference at a normal viewing
 distance. For the best quality print, it's usually better to leave
 High Speed off while choosing Finest Detail if it is available.

Adding Custom Printer Profiles

To add custom printer profiles, place the profile in your
computer's Colorsync (Mac) or Color (PC) folder. On the Mac,
place the ICC profile in the Colorsync folder in the main Library

folder. In Windows, navigate to the Color folder in C:\Windows\ System32\Spool\Drivers" and drop the ICC profile into the "Color" folder. After placing the new profile in the folder, restart *Lightroom* and under Color Management/Profile toggle to Other. Your profile list will appear.

Printer Manages Color

We don't recommend it, but if you don't have profiles, you have no choice except to select Printer Manages Color. The print driver runs the show, and there can be many OS issues associated when printing this way, as drivers are not always up to date with the OS. The critical thing here is to select Colorsync (Mac) or ICM Color Management (PC) as a Color Correction option. Even with these options, you may still have difficulty getting a print to look exactly the way you expect.

8. To choose the paper profile, click on Other next to Color Management and select the paper profile for the 3800 using Epson Exhibition Fiber. We already had it loaded, but if it wasn't preloaded, you would simply select the appropriate profile from Other.

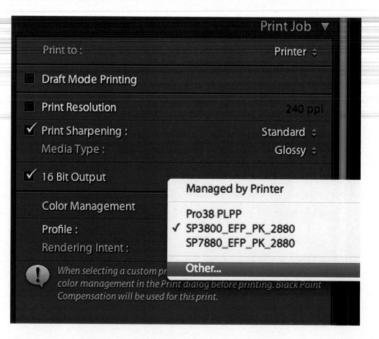

FIG 11.32
We have selected standard sharpening and glossy for the Media Type and we have selected our profile SP3800_EFP_PK_2880

9. The Media Type is Glossy and we are going to output in 16-bit mode which is possible with Mac OS X 10.6. The rendering intent for this image is set to Perceptual as we have strong saturated color.

10. The last series of steps are the most confusing of all. You can choose either Print Settings or Print.

 Print Settings will allow you to save the settings while Print offers the same settings but does not allow you to save.

 D-65 suggests choosing Print Settings so that you can save these final steps to use over again.

FIG 11.33
We have selected
Print Settings to save
the settings

11. Click the Save button when all the options are set correctly. This will ensure that the settings are stored and ready for creating a Print Template.

12. We are almost home free. Select Print One or Print from the lower right-hand panel of the Print Module. We choose to select Print One as long as we are only printing one print. If you select Print, you first get the print dialog box and will have to choose Print on the lower right of the module.

FIG 11.34
Print One

13. Go check the printer and see the results. In **Figure 11.35** we have a print in front of the screen after following the steps above, and it is pretty darn good.

FIG 11.35
The Print is almost identical to the image on screen

14. We will probably use these exact settings again in the future, so let's create a custom template.

 Choose the + sign next to the Template Browser on the left-hand side of the Print Module. Name the New Template and choose Create.

 Now the next time we want to print with Exhibition Fiber at 13x19 on the Epson 3800 all we need to do is select the image and the saved template and hit Print.

 This just *rocks!*

FIG 11.36
Saving a template in the
Print Module

I SUMMARY

Lightroom really makes printing a breeze with all the features in the Print Module. *Lightroom* 3.0 can place multiple size images on a single page and have multiple pages of multiple picture layouts.

Draft mode printing renders from the Previews, enabling speedy prints. Another plus is the ability to print straight to JPEG and to attach a profile.

You can produce print packages for a client and allow the client to print their own photos at their local lab. You can also print more than one image at a time. In fact, you can actually send your entire catalog to the printer, or print just one image at a time.

There are pre-configured presets that provide many options including contact sheets. You can also create your own custom presets and save them for future use.

Best of all is the ability to render the file at the native resolution. Just as in the Slideshow and Web Modules, the left panel contains templates of page layouts and collections and the right panel contains all the options and controls for each layout.

CHAPTER 12
THE WEB MODULE

Lightroom's Web Module allows you to create web galleries directly from RAW images with very little effort and no knowledge of programming. The galleries can be previewed in *Lightroom*, exported to a folder or uploaded to a website. There are a wide variety of templates to choose from or you can create your own using Flash or HTML. There is also an array of third party templates available on the web.

The Web Module is designed to be very similar to the Print and Slideshow Modules, with templates and collections on the

left-hand panels, and features on the right-hand panels. Web Galleries are an excellent way for clients to view your images and you can use your tweaked RAW files to create a gallery for a fast streamlined workflow.

Web Module Features

You can add an Identity Plate with a web link and an e-mail address. You can also choose from a wide array of metadata to display or even create custom tokens of almost any metadata available in *Lightroom*. You can even apply output sharpening to keep the images crisp even when they are small in size on the web. There is also a very cool built in FTP function, allowing you to upload your web gallery directly to your web site.

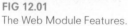 *New in Lightroom 3* Developers can now utilize ActionScript 3 galleries in the Web Module.

New in Lightroom 3 New templates are available in Template Browser

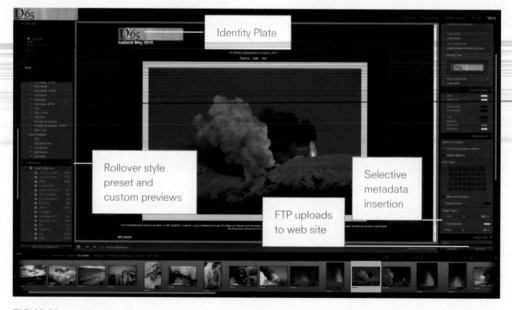

FIG 12.01
The Web Module Features.

Creating a Web Gallery

A web photo gallery can be created by selecting images in the Library Grid Model or from a Collection that is available inside the Web Module. Let's build a Web Gallery and discuss the available features along the way.

1. Choose your selection of images that you want to use to create your web gallery from the Library Module or the Collections Panel in the Web Module. You can choose which images to use: all, selected or flagged. This is the same procedure used for the Slideshow and Print Modules. For this demonstration, we have selected 40 images using the Filmstrip in the Web Module from a Collection called Iceland.

FIG 12.02
We have chosen to use all 40 photos from the filmstrip from a collection called Iceland.

Template Browser and Preview Panels

On the top left-hand side of the Web Module is a Template Browser and a Preview Panel to see what the templates look like. The Template Browser provides two distinct methods of Web Gallery displays. You can choose a traditional HTML style with thumbnails on a main page and enlarged images on individual pages or a Flash Gallery with features like Autoplay.

HTML Galleries use static XHTML, CSS and Javascript. A user can customize these galleries as they contain standard HTML components. The Flash templates are totally cool and offer some of the unique technology of flash directly to the user inside of *Lightroom*.

We have chosen the default HTML gallery for this demonstration.

▼ Preview

HTML

- Clean - HTML
- Dark Poppy Seed
- Dark Poppy Seed - HTML
- Dusk
- Earl Grey
- Earthy
- Earthy - HTML
- Exif metadata
- Flash gallery (default)
- **HTML gallery (default)**
- Ice Blue
- Ivory
- Lightroom UI
- Lightroom UI - HTML
- Midnight
- Mossy Rock
- Night Life
- Paper White
- Pure Black
- Pure Black - HTML
- Pure White
- Pure White - HTML
- Slideshow
- Stationery
- Stationery - HTML
- Taxi
- Taxi - HTML
- The Blues
- Vintage Newspaper
- Vintage Newspaper - HTML
- Warm Day

▼ User Templates
- D65
- D65 grey black
- everglades
- seth resnick
- seth show

Rollover style
preset and
custom previews

FIG 12.03
Template Browser.
We select the
Default HTML gallery
to start customizing.

Layout Style

The Web Gallery Engine has been renamed Layout Style. It is on the top right-hand side of the Web Gallery Module. The Layout Style provides *Lightroom* users with some very interesting third party template options. Although we are going to build our gallery with HTML, we want to show you a few other options available in the Engine.

FIG 12.04
Web Gallery
Layout Style

Figures 12.05 through 12.07 show some of the possibilities from third party vendors for producing web templates.

FIG 12.05

FIG 12.06

FIG 12.07

Site Info Panel

The Site Info Panel offers controls for:

• **Site Title:** Your Name

• **Collection Title:** Your Job Name

• **Collection Description:** What you shot. For example, "Images shot on South Beach for Client XYZ"

- **Contact Info:** Your E-mail Address

- **Web or Mail Link:** http://www.yourwebsite.com

- **Identity Plate:** You can add your identity Plate or Logo with a link to your website. Click on the drop-down menu next to identity plate to create a new one, or use what you have already setup in *Lightroom*. Under Web or Mail Link, put in your website. This creates a link on the logo or identity plate.

2. The next step in producing our web gallery is to fill out the Site Info Panel located on the top right-hand side of the Web Module.

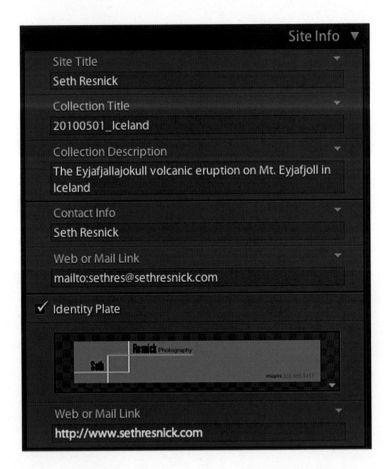

FIG 12.08
The Site Info Panel in the Web Module

Color Palette Panel

The next Panel is the Color Palette. You can choose colors for a variety of options. Choose colors that are different for Text and Detail Text. Detail Matte is the area around the image when it is enlarged, so you might like to create a frame around the image with a different color. Rollover is when you scroll over the images on the index page. The Grid Lines and Colors are also for the index page.

3. We chose black for our Background, gray for our Rollovers and Cells Lines. We sampled blue from our logo for Grid Lines and a light grey for our Text.

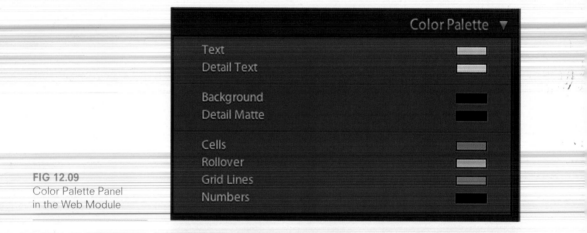

FIG 12.09
Color Palette Panel
in the Web Module

FIG 12.10
Detail Matte for
picking colors for
the Color Palette.

Appearance Panel

The Appearance Panel is where you choose how many rows, and columns you want, the size of the images on the page, and whether you want a border around the images. You can also choose to display a cell number for each image and section borders too (the dotted lines above and below the cells) and whether there is a drop shadow on the background from the image.

4. We choose no drop shadow, a light border defining each section of the gallery, an 8 column wide gallery, a border around each image of 70 pixels and an image size of 800 pixels.

FIG 12.11
Appearance Panel in
Web Module

Image Info Panel

Image Info allows you to decide what metadata you want to display with the images. The Title and Caption can be applied by simply checking the box next to each option. Additional metadata can be displayed by clicking on the drop-down menus.

5. We have chosen to use Title and Caption and to apply customized metadata for Filename. For this to work, the images need to contain title and caption metadata. This is the same for the Print and Slideshow Modules as well. Customized information can be edited and saved in the drop down menu.

FIG 12.12
Image Info Panel in Web Module

FIG 12.13
Creating Custom Metadata for the Image Info Panel

Output Settings Panel

The next choice to make is for Output Settings. You can select the Quality for the JPG output and the degree of Output Sharpening needed for the web gallery. The sharpening algorithms are based upon Pixel Genius *PhotoKit Sharpener* and make a major difference in how the images will look on the web. Lastly, you can choose to show a copyright watermark as well as other metadata.

6. We have chosen to render our images at a JPG quality of 70, show all metadata, apply a copyright watermark and apply standard sharpening for web output. The copyright info is being extracted from the IPTC metadata and will add your copyright to the image as an overlay. We always choose to check this box.

FIG 12.14
Output Settings Panel
In Web Module

Upload Settings

You can configure your Upload Settings so that you can accomplish an FTP transfer directly from *Lightroom* to your website.

FIG 12.15
Upload Settings Panel in Web Module

There is a drop-down menu on the right of the panel so that you can put in your username and password for the FTP transfer and save the settings as a preset.

FIG 12.16
Custom settings for FTP Transfer can be saved as a preset

We filled out all of our FTP information and saved it as a New Preset.

Export / Upload

On the bottom right of the Web Module there is a choice to Export or Upload. Upload initiates the FTP transfer settings set up in Upload Settings. Export will export the web gallery files to a folder and location of your choice for offline viewing, or upload the gallery at a later time using FTP software such as *Transmit* or *Fetch*. One word of caution: for FTP, the gallery is always INDEX.HTML, so unless you have a subfolder selected, it might overwrite an existing INDEX.HTML. The subfolder gets created

automatically if it isn't there or you can just be careful about to which directory you upload.

FIG 12.17
Export and Upload button

Preview

Before Exporting or Uploading, you can preview your web gallery in the default browser.

7. Choose Preview in Browser on the lower left-hand corner of the Web Module to view your web gallery.

FIG 12.18
Preview in Browser

So let's take a look at what our gallery looks like in our default browser, which in our case is *Safari*. **Figure 12.19** shows the index page and **Figure 12.20** shows an image page. If we wanted to keep this as a template to use in the future, we could save it by clicking on + sign to the right of the Template Browser.

FIG 12.19
Index Page for our web gallery

FIG 12.20
Preview in Browser with an image page

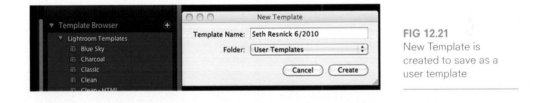

FIG 12.21
New Template is
created to save as a
user template

| SUMMARY

Lightroom's Web Module allows you to create web galleries directly from RAW images with very little effort and no knowledge of programming. The galleries can be previewed in *Lightroom* or exported to a folder.

There are a wide variety of templates to choose from or you can create your own using Flash or HTML. There is also an array of third party templates available on the web.

Lightroom adds many features and controls along with a very cool built in FTP function, allowing you to upload your web gallery directly to your web site.

Web Galleries are an excellent way for clients to view your images and you can use your tweaked RAW files to create a gallery for a fast streamlined workflow.

D-65'S *LIGHTROOM* WORKFLOW

Now that we have reviewed all of *Lightroom*'s Modules and concepts, it's time to put *Lightroom* into action and tie it all together to achieve efficient digital workflow. This chapter covers the D-65 *Lightroom* Workflow. This is where all of your organization and digital asset management system begins.

With D-65's workflow, all of your files are imported, renamed, keyworded, captioned, ranked, processed, and exported in a systematic, standardized methodology adaptable to any photographer's needs. With this system, you will manage your

workflow efficiently, effectively and effortlessly, allowing you more time behind the camera and less time behind the computer.

Before we begin with our workflow and importing our files, it is important how we are going to name files and folders so they can be found in a hierarchical, industry-standard fashion.

File Naming Standards

Digital photography has increased the importance of naming conventions because the digital camera creates the initial name assigned to a file. That's convenient, but these file names, such as "UY74O822," are cryptic and random.

The solution to this problem is for every photographer to develop a naming convention, based on standards, and use it consistently to name your files. This will give you a standardized nomenclature that will help you categorize, organize, and later locate your images. A good file naming system will not only ensure consistency, but will also form the backbone of the file retrieval process.

To create a file-naming system, you need to essentially generate your own secret code. Now, this code does not have to be worthy of an über-geek award. In fact, it doesn't have to involve anything more complicated than giving each image a sequential number or a descriptive name. It may even include IPTC (descriptive information about the image) or EXIF (technical data taken from the camera) data as well as other information of your choosing.

Adhering To Standards

There are some basic rules to follow when it comes to naming files. First, all file names should be limited to a total character length of 31, including the file type extension. Second, all file names must include the correct three-letter file type extension. Examples of file type extensions are JPG, TIF, DNG, PSD and PDF.

To address cross-platform usability, file names should not contain special characters or symbols other than underscore "_" or hyphen "-". In fact, it is best to avoid punctuation characters in file names altogether because some characters are reserved for use only by the operating system. It is wise to use only lower-

case characters because some operating systems, such as UNIX, are case-sensitive.

Once you have a system in place, it should meet these technical guidelines and still provide enough information about the image so you do not have to open the file to identify the image. The file name should give you everything you need to know. Searching on a file name should yield results.

Finding a Simple Solution

Yes, naming a file is important, but doing so correctly is also crucial—and is all too often overlooked by many photographers. Some use relatively generic names, such as"cat1.JPG," but these make it difficult to locate files later. Others simply ignore naming conventions, increasing the risk that the files will not be readable on other computers.

Again, the file-naming convention you come up with needs to address two separate issues: one, a naming system that works for you, and that you can use on the fly—ideally, file naming should be done at the time of capture, not later on; and, two, adherence to certain known standards that will ensure the file names remain intact across a variety of platforms and systems.

The Right Name

Files should be named using a convention that provides accurate information about each file and why it was created. A naming system based on the date you capture the image and a series of letters defining the file is a great place to start. With such a system, you can address criteria such as high-resolution files, layered files, or when they were published.

We will be using images in this tutorial shot in Miami on June 5, 2010. In this case, the file name would be: 20100605_miami_0001.cr2

- "20100605" defines the date, as in June 5, 2010—because computers arrange files in a hierarchical fashion, this system ensures that every file will be organized chronologically

- "miami" defines the actual subject in our naming convention

- "0001" defines the sequential image number

- ".cr2" defines the type of file, in this case, Canon's RAW file format

Your exported images will have the same filename, with a different extension. Using this basic formula, you can add in other components to your file name, which can further help you describe the image files and job. Some additional examples follow:

- 20100605_miami_0001.tif: This is the exported file as a TIFF.

- 20100605_miami_bw_0001.cr2: This is a variation of the file in black and white.

Organization in the Library Module Folders Panel

To start, D-65 organizes the *Lightroom*_Library hard drive with folders of images with the same file naming convention; by the year, month, day and subject name, such as 20100605_miami. Because we shoot so many "jobs" or subjects each year, the scrolling list in the folders panel would become unruly. For that reason, we create Parent Year folders to nest all of our jobs for that year (see **Figure 13.01**). We also name our images with the same file naming convention as described above.

The steps for creating parent folders in the Folder Panel follow.

1. Go to the Folders Panel in the Library Module.

Folders	− +.
Lightroom_Library	0.4 / 1.3 TB ▼
▶ 📁 1998	3
▶ 📁 2000	58
▶ 📁 2001	477
▶ 📁 2002	2125
▶ 📁 2003	1671
▶ 📁 2004	1453
▶ 📁 2005	4137
▶ 📁 2006	5297
▶ 📁 2007	8988
▶ 📁 2008	7982
▶ 📁 2009	5639
▼ 📁 2010	5007
📁 20100101_newyears_day	52
📁 20100106_cassie	7
📁 20100107_red_sunset	52
📁 20100111_ocean_steam	5
📁 20100116_michael_caroline	95
📁 20100117_luci	26
📁 20100119_leo	24
📁 20100125_miami_graphic	3
📁 20100130_superbowl	92
📁 20100208_cleo	6
📁 20100215_boatshow	39
📁 20100218_building	83
📁 20100219_lucibirthday	73
📁 20100221_luci_beach	69
📁 20100223_luci	67
📁 20100226_beach_reconstruction	84
📁 20100306_fishtank	19
📁 20100306_south_beach	105
📁 20100312_XRITE	9
📁 20100314_luci_beach	56
📁 20100319_miami_air	6
📁 20100320_d65_classroom	56
📁 20100322_nyc	68
📁 20100327_passover	5
📁 20100331_luci_bedroom	18

FIG 13.01

2. Click on the + sign. Choose Add folder. Make sure Folder
 Name Only is also selected

FIG 13.02

3. Navigate to the *Lightroom*_Library Hard drive.

4. Select New Folder from bottom left.

FIG 13.03

5. Name the Folder (in the above example we called it 2011, because we already have a 2010 folder).

6. Click on Create.

7. Click on Choose on the lower right.

8. You should now have a new folder called 2011 in your Folders Panel.

D-65 suggests creating parent folder for all the years of images that you will be importing into *Lightroom*. It totally aids in organization.

D-65's Workflow

For this tutorial, we are going to start with a flash memory card with images from a shoot. D-65 always advocates shooting in

the RAW format, but this workflow works with JPEGs, too. These RAW files will be:

1. Downloaded from the memory card and imported in *Lightroom*

2. Edited and ranked

3. Metadata and Keywords applied

4. Renamed

5. Color corrected and "tweaked"

6. Shown to client via Web Gallery, PDF Contact Sheet or Slideshow

7. Exported (if necessary) into the type of files we need for our job

8. Organized into a job folder for archiving

As we go through this tutorial, each major step of the workflow is colored **RED**.

First, make sure that *Lightroom's* preferences are set up correctly and that you have created a *Lightroom*_Catalog, and a *Lightroom*_Library to store images in your desired location (refer to Chapters 5 and 6).

| STEP 1: IMPORTING IMAGES INTO *LIGHTROOM*

There are several ways to import images into *Lightroom*. Images can be imported in the following ways:

• New images directly from a memory card

• Existing images on your computer

• Existing images on external media such as a hard drive, CD or DVD

• Tethered from a camera

While all methods work well with *Lightroom,* each requires different import setup. The D-65 Workflow outlined below is specifically for shooting RAW files and importing from a flash memory card into *Lightroom.*

When you insert a memory card into a card reader, an icon of the card will appear on your desktop and *Lightroom* will automatically open the Import dialog box (below). (*Lightroom* may not automatically launch an import dialog when a memory card is attached to a Windows Vista computer. Please select the Import button in the Library and select the attached card reader to begin the import.)

1. Open *Lightroom.* Load your memory card into your card reader and wait for Import to pop up.

Icon of the card on your desktop

FIG 13.04
Memory card
on desktop.

NEW

Figure 13.05 displays the *new in Lightroom 3* Import Dialog in expanded view.

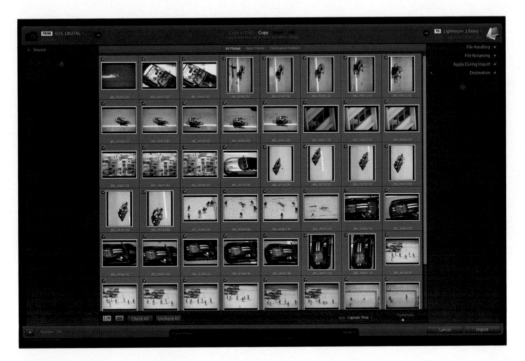

FIG 13.05
Import Dialog in Expanded View

FIG 13.06 displays the Dialog in Compact View. To change
between Expanded and Compact View, click on the arrow on
the bottom left-hand corner of Import. When the arrow points
up, you are in Expanded View. When the arrow points down, you
are in Compact View. D-65 prefers using the Expanded View in
our workflow.

FIG 13.06
Import Dialog in
Compact View

I SOURCE PANEL

NEW

Let's go through the Import window in Expanded View. **New in Lightroom 3** is the ability to browse in Import. The Source Panel allows you to browse your hard drives and devices that are available on your computer or network.

The top left corner, above the Source Panel displays your primary source, from which you have chosen to import. When you load a card into a card reader, *Lightroom* will automatically load that card as your source. (As long as the preference has been setup—refer to Chapter 5).

D-65 checks "Eject after import" in the Source panel, so that our card is automatically ejected from the desktop after the images have been imported.

FIG 13.07

2. In most cases, your source (card) will be selected automatically. If not, choose your source from the Source Panel.

Now, we will move across the top of Import. Once you have chosen what you'd like to import, you have four choices how to handle your files:

• **Copy as DNG:** Convert to DNG in a new location and add to catalog

• **Copy:** Copy photos to a new location and add to catalog

• **Move:** Move photos to a new location and add to catalog

• **Add:** Add photos to catalog without moving them

D-65 firmly believes that DNG will prevail and become the adopted universal RAW format, but it is not yet universal with all software manufacturers. For this reason, D-65 still believes in keeping the original proprietary RAW file from the camera manufacturer along with a DNG copy *after* the tweaks have been applied to the RAW files. We want our DNG to have the same information as our proprietary RAW files, which is why we create them after we are done working on them in *Lightroom*.

To accomplish this, D-65 chooses Copy, and this will copy our photos from the card to a new location, our *Lightroom*_Library hard drive, and add them to the catalog. Further down the line in our workflow we will make DNGs and save them in our archive.

3. Choose an option of how you would like to handle your import.

FIG 13.08

Copy as DNG **Copy** Move Add
Copy photos to a new location and add to catalog

All Photos | New Photos | Destination Folders

| DESTINATION PANEL

Now, from the Destination Panel in Import, we have to choose the destination, our 2010 folder within our *Lightroom_*Library hard drive.

4. Choose the location you are copying TO.

5. Go to the Destination Panel.

6. Check "Into Subfolder" and name your subfolder with your subject or job name, such as 20100506_bahamas.

TIP: You can see the year, month and day that the images were shot by hovering over the image with your mouse (Figure 13.09).

FIG 13.09
Hover the mouse over an image to see the year, month and day it was shot.

7. Organize: Choose "Into one folder."

8. Highlight or select your *Lightroom_*Library hard drive from the list of devices located in the Destination Panel.

9. Then select the 2010 folder, or whatever parent folder you wish to import into. If you do not use parent folders, then select the *Lightroom_*Library drive.

FIG 13.10

I FILE HANDLING PANEL

10. Open the File Handling Panel (**Figure 13.11**).

> ### File Handling ▼
>
> Render Previews [1:1] ⬍
>
> ☑ Don't Import Suspected Duplicates
>
> ☑ Make a Second Copy To : ▼
> / Volumes / Import_Backup

FIG 13.11

11. Render Previews: Choose 1:1 from the drop-down menu
(refer to Chapter 5 – Catalog Settings for more information
on Preview size).

12. Check "Don't Import Suspected Duplicates."

13. Check "Make a Second Copy To."

D-65 always recommends backing up to a secondary location.
We suggest an external hard drive or a second internal drive
(if you have one) for your backup. If you do have an external
drive to dedicate for this import backup, choose it now.
D-65 has a dedicated drive that we call Import_Backup
(**Figure 13.11**). This backup is a backup of all the changes
that are applied to your images on Import. This behavior is
new to Lightroom 3.

NEW

Import_Backup

FIG 13.12

I FILE RENAMING PANEL

D-65 renames our images on import with the same file naming convention that we use for the folders holding the images. *Lightroom* comes with a number of presets for renaming your images. To make the workflow really flow, we are going to create our own custom File Naming Preset. This preset will name our files with a naming convention consisting of *yyyymmdd_subject_sequence#(0001).the 3 letter file type extension*. This will allow you to batch-rename your files, giving them a meaningful name for easy retrieval from an archive. Our demonstration images are from a shoot in Miami that took place on June 5, 2010. Hence we are renaming the proprietary RAW files in the following way:

20100605_miami_0001.cr2

Creating a File Naming Preset

To create our File Naming preset, follow the steps listed below.

1. From the File Renaming panel, go to the drop- down menu next to Template and choose Edit.

FIG 13.13

2. The Filename Template Editor window will pop up. The default in the example window is Filename.

3. Delete the token Filename in the example window by clicking on it, and hitting the Delete key. Now you are starting with a clean template. (A token is the term for the field you are inserting or deleting in this window)

4. Go to the fourth window down, Additional, and choose YYYYMMDD from the drop-down menu and click on Insert. Your first token will contain the year, month and day the image was shot. *Lightroom* extracts this information from the metadata coming from the camera, so make sure your date/time is correct in the camera.

5. Your cursor should now be in the Example window after the newly inserted date token. Manually type in an underscore after the first token. This will separate the tokens we will be stringing together.

6. Go down to Custom, and click on Insert to the right of Custom Text. This will insert Custom Text as your next token.

7. Again, manually type in an underscore next to Custom Text to separate the tokens in the example window.

8. Go down to Numbering and from the third drop-down menu, Sequence, choose: Sequence #(0001) and click on Insert. This is your final token to insert, but do not click on Done yet.

Filename Template Editor

Preset: [Custom ⇕]

Example: **20100605_untitled_0001.cr2**

(Date (YYYYMMDD) ⌄) _ (Custom Text) _
(Sequence # (0001) ⌄)

Image Name

[Filename ⇕] (Insert)

Numbering

[Import # (1) ⇕] (Insert)

[Image # (1) ⇕] (Insert)

[Sequence # (0001) ⇕] (Insert)

Additional

[Date (YYYYMMDD) ⇕] (Insert)

Custom

Shoot Name (Insert)

Custom Text (Insert)

(Cancel) (Done)

FIG 13.14

9. Now we will save this as a Preset, so we can use it over and over again. To save the preset, go to the drop-down menu at the top of the window, under Preset, and choose Save Current Settings as New Preset.

Filename Template Editor

Prese ✓ **Custom**

Custom Name (x of y)
Custom Name – Original File Number
Custom Name – Sequence
Custom Name
Date – Filename
Filename – Sequence
Filename
Preserve Filename
Session Name – Sequence
Shoot Name – Original File Number
Shoot Name – Sequence

Save Current Settings as New Preset...

Example

Date
Sequ

Image Na

Numberi

Sequence # (0001) Insert

Additional

Date (YYYYMMDD) Insert

Custom

Shoot Name Insert

Custom Text Insert

Cancel Done

FIG 13.15

10. Name the preset yymmdd_subject_0001.ext (This describes how exactly your file will be named) and choose Create.

New Preset

Preset Name: yyyymmdd_subject_0001.ext

Cancel Create

FIG 13.16

11. Now choose Done in the Filename Template Editor window.

12. You will automatically be back in Import in the File Renaming Panel. You can apply this File Naming Preset to your images from the Template drop-down menu by choosing yyyymmdd_subject_0001.ext. Next to Custom Text, type in your subject or job name. In our example below, we typed in miami.

13. Our Start Number is 1, since this is the first image of our shoot.

File Renaming ▼

✓ Rename Files

Template yyyymmdd_...

Custom Text **miami**

Shoot Name

Start Number 1

Extensions Lowercase

Sample : 20100605_miami_0001.cr2

FIG 13.17

The cool part of saving a File Naming Preset is that it can be used over and over again every time you shoot. The only thing that will ever need to be edited is the actual subject name under Custom Text and possibly the Start Number.

FIG 13.18
File naming template
saved for use each time
there is an import

I APPLY DURING IMPORT PANEL

Develop Settings

You can further increase your workflow efficiency by applying
Develop Presets to images on import. *Lightroom* comes with
many Develop Presets and you can also create your own. D-65
has created a Develop Preset that we like to apply to all images
on import. The setting adjusts vibrance, saturation, black point,
clarity, and sharpening to simulate the look of Kodachrome film.
We created this Custom Preset in the Develop Module (see
Chapter 8). Depending upon your needs as a photographer, you
may or may not apply a Develop Setting on import from the drop
down menu.

14. Choose to apply a Develop Setting or not at this time.

Metadata

D-65 creates a basic Metadata Preset with our copyright and contact information. We apply this preset on import to all of our images (see Chapter 7 for steps on creating a Metadata Preset). We add further metadata using the Metadata Panel in the Library module to add specific information on each job.

What is Metadata?

Metadata is a set of standardized information about a photo, such as the author's name, resolution, color space, copyright, and keywords applied to it. For example, most digital cameras attach some basic information about a file, such as height, width, file format, and the time the image was taken.

Lightroom supports the information standard developed by the International Press Telecommunications Council (IPTC) to identify transmitted text and images. This standard includes entries for descriptions, keywords, categories, credits, and origins. You can use metadata to streamline your workflow and organize your files.

File information is stored using the Extensible Metadata Platform (XMP) standard. XMP is built on XML. In the case of camera RAW files that have a proprietary file format, XMP isn't written into the original files. To avoid file corruption, XMP metadata is stored in a separate file called a sidecar file. For all other file formats supported by *Lightroom* (JPEG, TIFF, PSD, and DNG), XMP metadata is written into the files in the location specified for that data. XMP facilitates the exchange of metadata between Adobe applications and across publishing workflows. For example, you can save metadata from one file as a template, and then import the metadata into other files.

Metadata that is stored in other formats, such as EXIF, IPTC (IIM), and TIFF is synchronized and described with XMP so that it can be more easily viewed and managed.

Applying Metadata Preset

In our workflow, we create a basic copyright preset that we apply to all our imported images. (refer to Chapter 7 for the steps on creating this Metadata Preset). If you already have a metadata

preset created, you can choose to apply it at this time from the drop-down menu, or choose New from the drop-down menu to create a new preset.

15. If you do create a new preset at this time, after you save it, you will automatically be placed back in Import in the Apply During Import Panel, and you can apply this new Metadata Preset to your images. From the Metadata drop-down menu, choose 2010_copyright.

FIG 13.19
The Apply During Import Panel allows you to apply a Develop Setting, Metadata preset and Keywords on Import.

Keywords

Lightroom gives you the ability to apply a set of keywords to your images upon import. Depending on the circumstances of your shoot, you may want to do this for all images, do it selectively at a later date, or both. We find it easier to use the Keyword Panel in the Library Module and add keywords after the images are imported. Keywording can be reviewed in Chapter 7.

16. Add keywords if you would like at this point.

Import Bottom Toolbar

On the bottom of Import, all the way to the left is the compact/expanded view arrow. The text to the right of the arrow illustrates the number of images you are importing and the size of the import.

There is also a button for Grid Mode or Loupe Mode, and a checkmark to check all images for import or uncheck all images for import. You can sort with different options in the drop-down menu, as well as set the size of the thumbnails with the Thumbnail Slider.

In the center of the screen at the bottom is an Import Preset tab where you can create or select import presets that you have setup.

D-65 always imports our images to a new folder specific for that subject/job, so we do not use Import Presets. On the bottom right are the Import and Cancel buttons.

17. Click Import to import your images or cancel if you don't want to go through with the Import.

FIG 13.20
Bottom area of Import

Import

After completing all of the above steps, you are now ready to import your files into *Lightroom*.

1. Click on import on the lower right of the Import Photos Dialog Box. The files will be imported into *Lightroom* and start to render one by one. We choose 1:1 previews as discussed in Chapter Five. You can monitor the import progress via the activity viewer in the top left-hand corner of the Library Module.

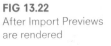

FIG 13.21
Images importing into the Library Module

FIG 13.22
After Import Previews are rendered

2. Now that you are in the Library Module, notice that your Previous Import is selected under the Catalog Panel (top left-hand side). Navigate to the Folders Panel. Make sure you select (highlight) the folder of images you are importing. This assures that you are working on the correct folder.

FIG 13.23
Images in designated folder in Library Module

I STEP 2: EDITING

The next step in our workflow is to edit. Editing and ranking works in much the same way that a film-based photographer works on a light table.

Checking Focus

First, we go to the Secondary Window button and take advantage of using multiple monitors. Then we click on an image and go to full screen. We then use the Tab key and Shift-Tab key combination to expand our view and collapse the panels. Using the arrow keys, we start moving through the images. We use the Navigator Tool with an appropriate zoom level to move through each image and check focus.

Rating Images

After checking focus, a photographer typically threw rejects in the trash, used a star or dot to mark a select, two stars to mark second tier selects and three stars to mark and cull "keepers." We can do exactly this within *Lightroom*.

We can add and remove stars from an image using the number keys 1 thru 5. We can also add color labels by using the numbers 6 through 9. We can rate and color label by using the Photo Menu and then choosing Set Rating, Set Color Label or Set Flag. Additionally, we can select an image in *Lightroom* and manually add or subtract stars by clicking on the dots immediately below the thumbnail. In essence, there are a number ways to rate and color label your images. These rankings and color labels will stay with the image, in its metadata, even after you process the files.

FIG 13.24
Using dual monitors and rating images

Rating Shortcuts

- You can use the] key to increase the rating and the [key to
 lower the rating; Command Z will undo a rating

- Having CAPS LOCK on while you are rating images
 automatically moves to the next image after you rate the first
 image

- You can also Set a Flag as a Pick, instead of rating and color
 labeling: for our workflow, we stick with ratings and color labels

Deleting Images

You can delete images in *Lightroom* in two ways:

- Hitting the delete key when an image is selected in the Grid
 View to delete images one by one

- Using the X key on an image to Flag as Rejected: after you are
 done editing the entire shoot and hitting the X key on all images
 you want to delete, go to the Photo Menu and choose Delete
 Rejected Photos

FIG 13.25
Delete Rejected
Photos Option.

FIG 13.26
After you choose to
Delete Rejected Photos,
the images marked as
rejected will be filtered
automatically, so you
can see what you are
deleting before you
do it.

D-65 suggests choosing "Delete from Disk," not "Remove from
Lightroom." We have no use for outtakes in our *Lightroom_*
Library hard drive. They just take up room, and can't be seen in
Lightroom once they are deleted from the catalog.

FIG 13.27
D-65 suggests Delete
from Disk

Lr	**Delete the 24 rejected master photos from disk, or just remove them from Lightroom?**
	Delete moves the files to Finder's Trash and removes them from Lightroom.

(Delete from Disk) (Cancel) (Remove)

1. Rank and edit your images.

2. Rotate images if needed.

3. Delete your outtakes.

| STEP 3: ADD KEYWORDS AND
ADDITIONAL METADATA

After we edit, we add keywords and additional metadata to all of
our images. We start by adding global keywords and metadata,
and then local keywords and metadata on smaller groups and
individual images (see Chapter 7).

*TIP: D-65 has created a keyword list of over 5500 keywords
 in a hierarchical order to allow you to easily keyword
 your images in Lightroom. To purchase the keyword list,
 go to http://www.D65.com.*

1. Keyword and add metadata to your images.

FIG 13.28
Use the Keywording, Keyword List and Metadata Panels to add information to your images

I STEP 4: RENAME YOUR IMAGES

Before we move into the Develop Module, we will rename our images since we have deleted some in our editing process. If you deleted any images in your edit, and like your images numbered sequentially, then you can rename (renumber) your images now.

1. Select all images.

2. Go to the Library Menu and choose Rename Photo in the drop-down (F2).

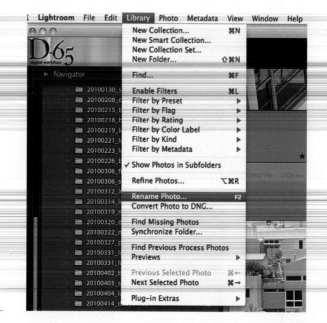

FIG 13.29
D-65 suggests renaming your images after editing so that they are in sequential order with gaps.

3. The Rename Photos Dialog Box pops up. Choose the template we just created (yyyymmdd_subject_0001.ext), put in your subject or job name next to Custom Text and make sure the Start Number is 1. Choose OK.

FIG 13.30
The Rename Photos window

| STEP 5: COLOR CORRECTING, "TWEAKING" YOUR FILES AND SYNCHRONIZING SETTINGS IN THE DEVELOP MODULE

1. Click on the Develop Module.

2. Move through all of your files in the Develop Module, tweaking and synching.

3. Any additional work that you need to do on a file in *Photoshop* would be done at this time by using Edit in *Photoshop*, and then saving the edited file back into *Lightroom*.

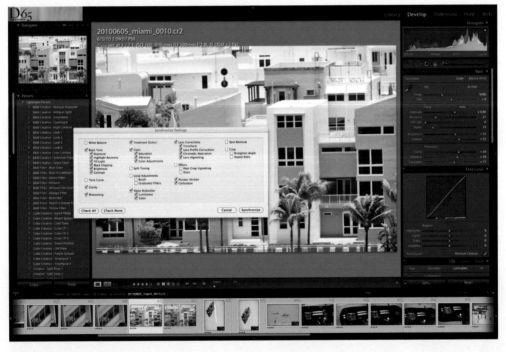

FIG 13.31
Work on your images in the Develop Module, either individually or by synching similar images.

| STEP 6: SAVING THE METADATA TO THE FILES

As mentioned in Chapter 5, there is no Save feature in *Lightroom*. Everything is always saved automatically to the catalog. However, if the catalog were to crash and you didn't have a backup, your data would be at risk. For this reason, just like an insurance plan, D-65 also takes the extra precaution to Save the Metadata to the files. This writes out a sidecar .XMP file for every proprietary RAW file and writes the date directly to the file for JPGS, PSD, TIFFS and DNGS.

1. Go back to the Library Module.

2. Select all your images.

3. Go to the Metadata Menu and choose "Save Metadata to Files."

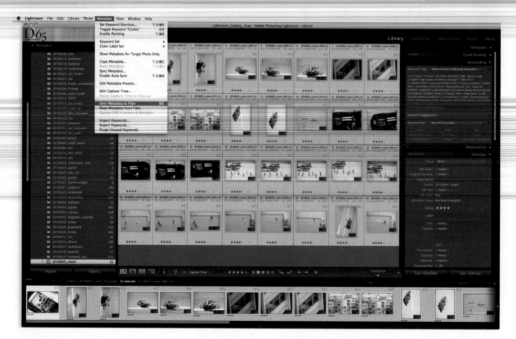

FIG 13.32
Save the metadata to your files

| STEP 7: CREATE A WEB GALLERY, SLIDESHOW OR PRINTS FOR YOUR FRIENDS, FAMILY OR CLIENT

D-65 would typically prepare a web gallery for the client to see the images and make their selects. D-65 does not send an entire shoot to a client. We prepare the client's selected files for their specific specifications depending upon usage and media. For personal work, we create web galleries to show our friends and family. Now, we also can upload directly to Flickr.

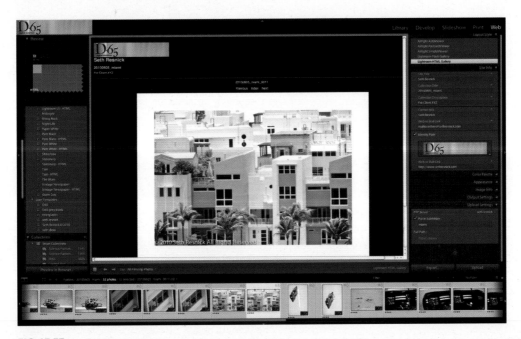

FIG 13.33

| STEP 8: EXPORTING YOUR FILES AND CREATING A JOB FOLDER

At this point, depending upon what type of photographer you are, and the workflow that you need, you may be done working in *Lightroom*. For example, if you're making exhibition prints using your own printer, then you're all done. Or if you are shooting for yourself, and don't need to deliver files to anyone, you are done too. Everything you need is already saved in *Lightroom*, and you

can move onto the next shoot. If you need to deliver files to a client, D-65 continues the workflow described below.

Lightroom is capable of exporting TIFF, PSD, JPEG, and DNG files. This is how *Lightroom* processes files. Whether you need any or all of these files will depend on your specific workflow and your needs as a photographer.

For D-65's workflow, we always create two types of files from our tweaked RAW files:

• DNG (Digital Negative format) for archiving

• JPG in sRGB color space at 72 ppi, and 600 pixels wide for copyright registration and submission to stock agents

Then, after our client reviews our images from our web gallery, we export the finals that they have selected. The third type of file that we export is:

• Any type of file our client requests on a per job basis. D-65 usually delivers client finals as TIFFs.

Creating a Job Folder

We export from the Library Module. On export, we will create a new job folder on our desktop, or on our hard drive(s) dedicated for our job folders. We use the job folder to organize files for archiving. This folder will be archived on multiple external hard drives, both on-site and off-site. The files are tweaked in *Lightroom*, then exported (processed) into the file type(s) you need for the job. All of these processed files go into a job folder for that specific job. This is all for organization and archiving. Let's explain this concept a bit more:

In the film world, when you returned to the lab to pick up your film, it was given to you in a nicely organized manner. The E-6 slides were in a box, the C-41 negatives were in sleeves and the prints were in glassine envelopes. You then took those chromes or negatives back to the office and filed them away.

We are going to simulate that same concept by creating a job folder for each and every job. The job folder will contain

subfolders for all of the different file types and information required for that job; such as DNG, JPG, TIFF, PSD, Invoice, Model Releases, Layouts, etc. The job folder and subfolders will use a naming convention similar to what you used for your image names. For example, for our job in Miami, we would create a job folder called 201000605_miami_job. The subfolders we create on Export within this job folder will be:

• 20100605_miami_dng

• 20100605_miami_jpg

We always use the year, month and first day of the job with an underscore and then job name for our file naming convention.

We choose to leave the proprietary RAW files from the camera on our hard drive named *Lightroom*_Library, not in our job folder. Any database will slow down as it accumulates information. *Lightroom* will currently slow down with more than 200,000 files. For this reason, we choose to only keep our RAW files in *Lightroom* and our processed files on external hard drives dedicated to holding just our job folders, outside of the *Lightroom*_Library hard drive.

Should we need to browse through these job folder hard drives, we would do so using *Lightroom* 3 or *Bridge*.

Let's export some files from our Miami shoot job into a job folder. For our workflow in this job, we are going to create a set of DNGs, a set of small JPGs for the copyright office, and four full size TIFFs of our client's selects chosen from the web gallery that we had already posted for their review.

I STEPS FOR EXPORT

1. Select all your images in the Library Grid Mode (you don't have to select them all unless you wanted to process them all—this all depends on your workflow).

2. Click on the Export Button (left of the Toolbar).

3. The Export dialog window will open.

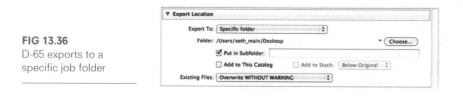

FIG 13.35
Export Dialog before
D-65 setup

4. **Export Location:** We are choosing to Export To: Specific
 Folder. Choose your hard drive where your job folders are
 located (we have a hard drive called 2010_job_folders already
 dedicated to holding all of our job folders for this year).

FIG 13.36
D-65 exports to a
specific job folder

▼ Export Location

Export To:	Specific folder
Folder:	/Users/seth_main/Desktop ▼ Choose...
☑ Put in Subfolder:	
☐ Add to This Catalog	☐ Add to Stack: Below Original
Existing Files:	Overwrite WITHOUT WARNING

5. Create a new job folder on that drive by clicking on
 New Folder.

FIG 13.37
Creating the job folder.

6. Name the folder with the file naming convention for the job. Our job folder name is 20100605_miami_job.

7. After you name the folder, choose Create.

8. Then click Choose back in the directory window. You will be brought back to the Export Dialog Box.

9. **Check Put in Subfolder:** give the subfolder the file naming convention for your job and file type you are creating. We will create DNGs for our first type of file for this job. Our subfolder is 20100605_miami_dng. For our workflow, we do not choose "Add to This Catalog" or "Stack with Original."

FIG 13.38
Export Location setup to D-65's workflow

10. **Existing Files:** Chose "Overwrite WITHOUT WARNING."

11. **File Naming:** If you wanted to rename your files to a different naming convention for your client's needs, this is where you could do it. D-65 does not check "Rename To:" because we have already renamed our files during our workflow in the Library Module.

FIG 13.39
Lightroom has the ability to Rename your files on Export.

▼ File Naming

☐ Rename To: Filename

Custom Text: Start Number:

Example: 20100605_miami_0001.dng Extensions: [Lowercase]

12. **File Settings:** This is where you choose what type of file you will be exporting. After choose the format, you will get different options for each type of Format. Under Format choose "DNG."

The DNG options that we choose are:

Compatibility: *Camera Raw* 5.4 and later (this depends on version of *Photoshop* you have and what version of *Camera Raw* you have installed)

JPEG Preview: Medium Size

▼ File Settings

Format: [DNG]

Compatibility: [Camera Raw 5.4 and later]
JPEG Preview: [Medium Size]

☐ Embed Original Raw File

☑ Include Video Files ▼ About Video File Support

Video files are always exported in their original file format, regardless of the file format selected above. Image sizing, output sharpening, metadata, and watermarking options are not applied to video files.

FIG 13.40

13. **Image Sizing:** This is where you can up-res/down-res and resize your files if needed. Since DNG files are RAW, we cannot check any of these options. We would choose our parameters in this section for any JPGS, PSDS or TIFFS.

14. **Output Sharpening:** *Lightroom* allows output sharpening for Screen or Print, using algorithms based on Pixel Genius's Photokit Sharpener. Since we are creating DNGs, there is no output sharpening, but we would use this feature for other processed files.

15. **Metadata:** There are two choices under Metadata. You can minimize the embedded Metadata (which only includes the copyright and which D-65 does not recommend), or you

can choose "Write Keywords as *Lightroom* Hierarchy." D-65 does not choose either of these options. If you have private metadata, it will be revealed in the Lightroom hierarchy.

16. **Watermarking:** We do not choose "Add Copyright Watermarks" on our files, but it is a great idea for proofs for wedding photographers, and works great in *Lightroom* 3.

17. **Post Processing:** We might or might not do any post processing from export depending upon the job. Refer to Chapter 14 for more information on Post Processing on Export.

18. **Click on Export.** Your RAW files will be converted to DNG and wind up in a DNG subfolder of the job folder in your job folder hard drive.

FIG 13.41

We will repeat this same Export step for JPGs (or whatever type of file you may need for the job). *Lightroom* can export more than one file type at the same time. You do not have to wait until one group is done to export another group; the export is being done in the background. If you wanted to cancel the Export, just click on the X key.

I EXPORTING JPEGs:

The following steps are for exporting JPEGs for the copyright office. We send small JPGs and not high-res files because since it is a public place, there have been cases of theft at the copyright office.

1. Select the images in the Library Grid Mode.

2. Choose Export. The Export dialog box will pop up.

3. Change the subfolder name to 20100605_miami_jpg.

4. Do not check "Rename To:" under File Naming.

5. Under File Settings: Format will be JPG, Quality is 80 and Color Space is sRGB.

6. Under Image Sizing: Check "Resize to Fit" and under Width and Height, set the width to 600, Height to 600 pixels and Resolution to 72 pixels per inch.

I UP-RESING ON EXPORT

Lightroom does an excellent job with up-resing as well. The up-res is done with a proprietary algorithm similar to the Bicubic Smoother in *Photoshop*. Above, we demonstrated going down in size to make smaller JPGs for the copyright office, but you can also create larger files very easily. Follow the same steps as above, and then under Image Sizing, put in the width and height either in inches, pixels or centimeters for your needs. If you wanted to make a 13-x19 print, put in those numbers. It's that easy!

7. Output Sharpening: Check "Sharpen For Screen, Amount Standard." Sharpening is not critical for the copyright office, but if we are going to this extent, we might as well sharpen them for screen use at the same time.

8. Metadata: Do not check either option.

9. Post Processing: Choose "After Export, Do Nothing."

10. Click on Export. Your RAW files will be converted to JPGs and wind up in a JPG subfolder of the job folder in your job folder hard drive.

FIG 13.42

I EXPORTING TIFFs FOR THE CLIENT

We are delivering these TIFFs in ColorMatch RGB. Ideally, we would deliver in CMYK for print use, but we only deliver in CMYK if we get complete cooperation from the client. When we deliver in RGB, we like to deliver in ColorMatch RGB because it is very close to CMYK. Delivering in Adobe 98 is sort of like saying "See all of this color? Well, you can't have it." When delivering in ColorMatch, the client can see and have all of the color they see.

1. Select the images the client chose in the Library Grid Mode.

2. Click on Export.

3. The Export dialog box will pop up. Change the subfolder name to 20100605_miami_tiff.

4. Do not check "Rename To:" under File Naming.

5. Under File Settings, select:

 Format: TIFF
 Compression: None
 Color Space: Choose Other

6. The Choose Profiles dialog box will appear. Check "Include Display Profiles" at the bottom left. Then check "ColorMatch RGB." Choose OK. Now you will have ColorMatch RGB as a choice in your Color Space drop-down menu.

FIG 13.43

7. **Under Image Sizing:** Do not check "Resize to Fit." We are sending full size files to the client. Resolution is 266 pixels per inch, which is two times the line screen of 133 for the press the client is using.

8. **Output Sharpening:** *Lightroom's* Output Sharpening is for screen and InkJet Printing. For web press printing, we would opt for the third party plug in Pixel Genius Photokit Sharpener, or leave output sharpening up to the client.

9. **Metadata:** Do not check either option

10. **Post Processing:** Choose "After Export, Do Nothing."

11. **Click on Export.** Our RAW files that the client selected will be converted to TIFFs and wind up in a TIFF subfolder of the job folder in your job folder hard drive.

FIG 13.44
Export options for ColorMatch TIFFs

12. Go to your job folder hard drive and you will see the job folder, with three subfolders of the images you just created.

FIG 13.45
Hard Drive dedicated to
holding your job folders

2010_job_folders

FIG 13.46
Miami Job Folder with
three subfolders of
different types of files
within them

I SUMMARY

D-65's workflow can be adapted to any type of
photographer. Our digital asset management system
will lead you thought the maze of technical problems
and challenges that stand between you and a seamless
digital workflow with *Lightroom* at the core.

CHAPTER 14
INTEGRATING *PHOTOSHOP* AND *LIGHTROOM*

What is advanced to some, is basic to others, but we are pretty sure that most of you will find that this chapter definitely takes it up a notch. Integrating *Photoshop* and *Lightroom* can even further enhance the power of *Lightroom*, and speed up your workflow. We are going to explore a few features such as Edit in *Photoshop* and Post Processing on Export.

I EDIT IN *PHOTOSHOP*

The first feature to examine is Edit in *Photoshop*, or keyboard shortcut Command-E. *Lightroom* provides the ability to go directly from a file in *Lightroom* into *Photoshop*, work on the file in *Photoshop*, and then to save the file with those changes back into *Lightroom*.

In **Figure 14.01**, we took a RAW file from *Lightroom* with *Lightroom* adjustments, 20100509_bimini_0101.cr2, and hit Command-E. This opens the file in *Photoshop* in a non-destructive fashion, recognizing all of the *Lightroom* adjustments.

We then applied some *Photoshop* adjustments, specifically, Content Aware Fill to remove the toy. The file is saved and closed and automatically saves an edited version of the file, as a TIF, next to the original RAW file in *Lightroom*'s Library. The new file from *Photoshop* has the name, 20100509_bimini_0101.cr2-Edit.tif. If the file is not saved next to the original, check the sort criteria. If you choose sort by Capture Time, the files will be next to each other.

FIG 14.01
Original RAW file with *Lightroom* adjustments

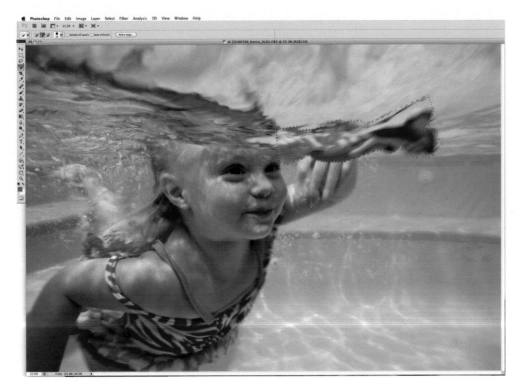

FIG 14.02
Command-E opens the file in *Photoshop* and we make a selection around the toy

Fill

Contents

Use: **Content-Aware**

Custom Pattern:

Blending

Mode: **Normal**

Opacity: **100** %

☐ Preserve Transparency

OK

Cancel

FIG 14.03
Using Content Aware
Fill to remove the toy in
Photoshop CS5

FIG 14.04
We choose Save and
the image will be saved
with the changes back
into *Lightroom*.

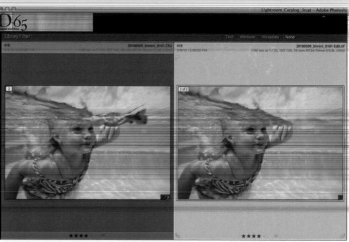

FIG 14.05
File saved next to
the original back
in *Lightroom*.

I EDIT IN *PHOTOSHOP:* MERGE TO PANORAMA

You can select multiple images in *Lightroom* and take advantage
of *Photoshop's* Merge to Panorama, or Merge to HDR. For this
demonstration, we are going to create a panorama of Miami
Beach with a rainbow which occurred Jan 1, 2010.

1. We select eight RAW files in the Library Module Grid Mode.

FIG 14.06
Eight RAW files are selected in *Lightroom*.

2. From the Library Module Photo menu, we select "Edit In"
 and drop down to "Merge to Panorama in *Photoshop*."

FIG 14.07
Edit In>Merge to
Panorama in *Photoshop*

3. The Photomerge dialog box opens and we select Auto for
 the layout, Blend Images Together, Vignette Removal and
 Geometric Distortion Correction.

FIG 14.08
Photomerge Dialog
box in CS5

429

4. The files are opened and the layers are blended together.

FIG 14.09
Align Selected Layers
Based On Content.

Progress

Align Selected Layers Based On Content

(Cancel)

FIG 14.10
All layers are aligned
in CS5

Progress

Aligning Layer 20100101_newyearsday_0028.CR2

(Cancel)

FIG 14.11
Blend Selected Layers
Based On Content

Progress

Blend Selected Layers Based On Content

(Cancel)

5. When the process is complete, we have a 200-plus
 degree panorama of Miami Beach. We choose Save and
 the composited panorama is saved back in *Lightroom*
 next to the eight original files with the name 20100101_
 newsyearsday_0031_Edit.Tif

FIG 14.12
Composited file saved
back into *Lightroom*.

FIG 14.13
New file is renamed
in *Lightroom* 201001_
newyearsday_0031.tif.

6. The file is rendered as an 803 MB TIF file. If we check the dimensions in *Photoshop,* we can see we now have a panorama which is over 92 inches wide. How cool is that?

Image Size

Pixel Dimensions: 803.0M

Width: 22080 pixels
Height: 6356 pixels

OK
Cancel
Auto...

Document Size:

Width: 92 inches
Height: 26.483 inches
Resolution: 240 pixels/inch

☑ Scale Styles
☑ Constrain Proportions
☑ Resample Image:
Bicubic Smoother (best for enlargement)

FIG 14.14
New file is
803 MB. Wow!

7. But wait—there's more! We could make non-destructive edits to this file in *Lightroom* and then if we choose Command-E or Open in *Photoshop* we could take advantage of those non-destructive edits and again open the file in *Photoshop.* If we choose Command-E we would get the following dialog.

Edit Photo with Adobe Photoshop CS5

What to Edit

⦿ **Edit a Copy with Lightroom Adjustments**
Apply the Lightroom adjustments to a copy of the file and edit that one.

◯ **Edit a Copy**
Edit a copy of the original file.
Lightroom adjustments will not be visible.

◯ **Edit Original**
Edit the original file.
Lightroom adjustments will not be visible.

☐ Stack with original Cancel Edit

FIG 14.15
The file could
now be edited back
in *Photoshop*

Edit A Copy With *Lightroom* Adjustments: Edits a copy of the original file with *Lightroom* adjustments visible.

Edit A Copy: Edits a copy of the original file without *Lightroom* adjustments. This is not for RAW files. It is for JPG, TIF and PSD only.

Edit Original: Edits the original file without *Lightroom* adjustments. This is not for RAW files. It is for JPG, TIF and PSD only.

It is you choice how far you want to go with this file, but it is important to understand the dialog box options nonetheless.

I POST PROCESSING ON EXPORT WITH ACTIONS FOR POWER PROCESSING

There are a number of options available under Post Processing in the Export Dialog Box. To really bump the workflow up a notch, we customize this feature for our workflow. We write *Photoshop* actions and have them execute on our images as we export them from *Lightroom* as Droplets. This truly integrates *Lightroom* and *Photoshop*, and speeds up workflow.

As a photographer, how often do you find yourself working in *Photoshop* performing repetitive tasks over and over again? If you are like most folks, the simple answer to this question is way too often.

Well, if you enjoy all that wasted time in *Photoshop* you have no problems, but if you want to reduce your time in *Photoshop* and get back to shooting, there is a solution. Actions automate repetitive tasks and are key to taming workflow. An action allows you to automate your workflow and batch process your files. An action is a recording of the steps needed to process one image, which can be played back and applied to a group of images. Learning how to write actions can help you get your life back or at least some of the precious time.

Consider this scenario, which was in fact a very real set of tasks we needed to accomplish this week. We had 400 RAW files that we worked on in *Lightroom* and wanted to prepare them for a

multimedia presentation. The requirements for the multimedia presentation were to have the images with a ¼ inch white frame and to have the images in sRGB at a resolution of 144. The verticals needed to be 768 tall and the horizontals needed to be 1024 wide.

If we were doing this one file at a time, we would likely still be working in *Photoshop* two days later. Instead, we were able to hit a keyboard shortcut, go to Starbucks and all the files were processed when we returned home, thanks to Post Processing on Export with Actions.

I ARE ACTIONS PART OF *PHOTOSHOP?*

Some actions come with *Photoshop* and those are known as the default actions. You can also write your own actions or gather them from other sources. Actions are located in *Photoshop's* main menu under Window>Actions.

Actions in the Actions palette are arranged in sets, each of which can contain one or more actions. To open an action set, click the right-pointing arrow to the left of the action set name. Now you'll see the list of actions in the set. This panel and Actions in general are not the most intuitive things in *Photoshop*. For example, after creating an action, you will find that you can't save an individual action. You can only save a set of actions. Sets are sort of like holding pens that hold individual actions. For example you might have a retouching set and a processing set and a sharpening set. In each of these sets you might have many actions to accomplish different tasks.

The actions included in *Photoshop* are only a small example of what can be done with actions. You can write your own actions and can record commands like open, close and save as part of the action. In fact just about everything you can do in *Photoshop* is actionable.

Before creating an action to perform a complex task (particularly if you're unsure exactly how to begin), search the web to see whether an action already exists to do the job. A good place to start looking is the Adobe Studio Exchange, which is a shared resource for many *Photoshop* tools.

If you find an action you like, you can load an action by opening the Actions palette menu, choosing Load Actions, navigate to where you saved the action and select the ATN file, and click Load to load it. You can then play the action by opening the actions set, selecting the action to play, and clicking the Play Selection button. **Big note:** you have to have an image open to play the action on.

I CREATING YOUR OWN ACTION

Once you're comfortable with finding the actions and using them, you can try creating your own custom actions.

We like to have our destinations designated by the action so we suggest that you create a folder on your desktop that is permanent destination for all your actions. We call ours "D-65 Lab." By having this permanent "lab" on the desktop, all of the actions run to the same destination eliminating any problems with folders no longer in existence or disappearing files.

One further problem is that *Lightroom* doesn't really play actions. The good news is that you can turn an action into a Droplet and have the Droplet executed by *Lightroom*. Following is a demonstration on Post Processing in *Lightroom* for our presentation scenario described earlier.

I BEFORE YOU BEGIN WRITING
THE FOLLOWING ACTION:

1. Edit and rank the images in the *Lightroom* (delete all outtakes).

2. Verify that the images have been properly named, keywords added and that metadata has been applied.

3. Make sure that all developing is finished and the images are pretty much the way you want them.

4. Make sure that you have a destination folder for your actions. Ideally, set up the folder with sub folders for all the processing you are going to do. For the action below I have a D-65 Lab folder and one sub folders inside, called Multimedia.

We will write a simple action that will access your processed full-size JPGs located in your job folder (these jpegs would have processed during export from *Lightroom*) and will size them to a resolution of 144 with a .25 inch white border and deposit the processed files into a folder called Multimedia. The horizontals will be 1024 wide and the verticals will be 768 tall. All the metadata applied from *Lightroom* will be embedded in this new set of JPEGs. Even your rankings will be there, too!

I LET'S WRITE THE ACTION

1. Make new folder on desktop called D-65 Lab or "white border for client x," or whatever you want to call it. We are creating a folder called D-65 Lab and inside that folder will be a folder called Multimedia Images.

FIG 14.16
Folder called D65_lab on Desktop.

FIG 14.17
D65_lab has folder inside called Multimedia Images

2. Process one RAW file in *Lightroom* into a JPG using the specifications below:

 • Color Space is sRGB

- Resolution at 144

- Check Resize to Fit Dimensions at 987x732

Because we are making a ¼ inch white border around the image, the image size is 987x732. When we add the border the final size will be 1024 x 768.

FIG 14.18
Export Dialog Box

3. Open the one JPG you just created in *Photoshop*.

4. Go to the Actions Palette in *Photoshop*, located under Window>Actions.

5. Using the flyout arrow, create new set called *Lightroom*
 Actions. You will put any action your write for *Lightroom*
 into this set.

6. Highlight that set and choose create new action within that set.

7. Name the action "xxx action (i.e., whatever action you
 are writing)"

New Action

Name: 1/4 inch white border

Set: Lightroom Actions

Function Key: None ☐ Shift ☐ Command

Color: ☐ None

Record

Cancel

FIG 14.23
New named in CS5.

8. Click Record.

9. Go to image that is already open and from the Image Menu, choose Canvas Size.

10. Type in .25 x .25 under width and height. Make sure Relative is checked, and that the Canvas Extension Color is white.

11. Choose OK.

Canvas Size

Current Size: 1.86M
Width: 6.854 inches
Height: 4.569 inches

OK
Cancel

New Size: 2.03M
Width: .25 inches
Height: .25 inches
☑ Relative
Anchor:

Canvas extension color: White

FIG 14.24
Canvas Size in CS5.

FIG 14.25
Image with ¼
white canvas

12. Go to the File Menu and choose Save As.

13. Save as a JPG to the new "multimedia" folder that you created in the D-65 Lab on your desktop.

FIG 14.26
Image saved to multimedia folder in D65_lab

14. The JPEG options dialog box will appear. Choose Quality 10, Maximum, Baseline Standard and choose OK.

FIG 14.27
Image saved as JPG.

15. Close the image that is open in *Photoshop*.

16. Stop the Action from the Actions Palette (blue button at the bottom).

FIG 14.28
The action is stopped.

17. Now you need to convert the Action into a droplet: select Action Called ¼ Inch White Border from the Actions Palette.

18. Go to File Menu>Automate>Create Droplet.

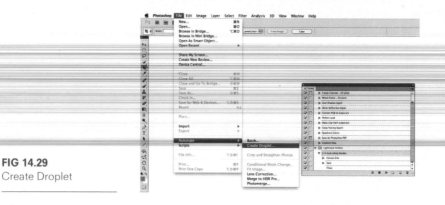

FIG 14.29
Create Droplet

19. Save the droplet in User>Library>Application Support>Adobe>*Lightroom*>Export Actions.

For a PC, the location is Documents and Settings>UserName >ApplicationData>Adobe>*Lightroom*>Export Actions.

20. Check "Suppress File Open Options Dialogs" and "Suppress Color Profile Warnings" And select Destination NONE.

21. Save Droplet and give it a name that makes sense, like quarterinchwhiteborder.

FIG 14.30
The droplet is created and save

To Run the Action/Droplet in *Lightroom*

1. Open *Lightroom*.

2. Select the images that you want to export and process with this new droplet in the Library Module.

3. Choose Export.

4. Go through the Export Dialog box choosing the correct parameters.

5. Under Post Processing—After Export, choose the droplet from the drop-down menu.

FIG 14.31
Post-Processing

FIG 14.32
Post-Processing
drop down menu—
choose droplet

6. Click on Export

7. Your selected images will export to the correct specs and the droplet will run on them.

I SUMMARY

Lightroom provides the ability to go directly from *Lightroom* into *Photoshop* and then to save those changes back to *Lightroom*. This means that you can take advantage of *Photoshop* features like Photomerge and Merge to HDR directly out of *Lightroom*. Further, you can use the power of non-destructive editing in *Lightroom* which would otherwise be destructive in *Photoshop*. You can even write actions in *Photoshop* and save them as Droplets and play those directly out of *Lightroom*.

The dilemma is:

"I use a Laptop in the field when shooting, and a desktop at the studio/home for processing and management in *Lightroom*. If the "main" Library and Catalog live on my "main" computer's external drive in the studio/home, how do I sync the Catalog on my laptop or other computers with the "main" Library and Catalog?"

There are several ways to do this and we will review them here. Most of them are rather confusing, but D-65 has found

work-around solutions that run effortlessly and flawlessly. Your methodology for accomplishing this needed task will be dependent upon what you need to do on your files in the field.

I D-65 CONCEPTS FOR SYNCING

Concept One:

You maintain your archive on your studio or home desktop computer. You have a shoot on location, so you will be bringing a laptop and external hard drive on location with you. You may do some work on the files you capture in the field, but your main goal is simply to take the images you captured in the field and bring them back to the studio, placing the images from the field onto the studio/home machine. In this scenario, you don't need to bring your entire archive of images with you on your shoot.

Solution for Concept One:

1. The easiest and most reliable way to accomplish this is to bring a laptop and a hard drive on location. For absolute protection, we like to bring two or three external drives on location, duplicating the contents to all three drives just to protect against drive failure or theft or any other unforeseen circumstance. The system below is what we use for 99% of our location shooting. Following the steps for Concept One will transfer all metadata and images from your laptop to your desktop successfully and easily.

 The only items that won't transfer are Collections, Smart Collections and Virtual Copies. We always suggest that you wait until you get home to make Smart Collections, Collections or Virtual Copies.

2. Ideally, reformat the hard drive before the trip. We usually take Lacie Rugged Drives or Lacie Little Big Disk 1 terabyte drives but any decent portable drive will do. The drive is named Lightroom_Library_Road

FIG 15.01
Drive for road formatted
and named Lightroom_
Library_Road

3. Before we leave home, we create a new *Lightroom* Catalog
 on the freshly reformatted drive for the portable computer.
 We name the catalog yyyymmdd_Lightroom_Catalog_Road.
 Refer to Chapter 6 for creating a new catalog.

FIG 15.02
Lightroom Catalog
named 20100604_
Lightroom_Catalog_
Road created on the
Lightroom_Library_
Road drive.

4. We go on location with the laptop computer and shoot the
 job(s) on location. We import from the card to the portable
 drive into a folder named yyyymmdd_jobname and back up
 to another drive called Import_Backup just for safety.

FIG 15.03
Import from card to
the portable drive
into a folder named
yyyymmdd_jobname
and back up to another
drive called Import_
Backup just for safety.

5. Our external drive (Lightroom_Library_Road) will then have
 a *Lightroom* Catalog (20100604_Lightroom_Catalog_Road)
 and a folder of images from that job.

FIG 15.04
20100604_Lightroom_
Catalog_Road with
Miami folder of images.

6. We tweak our files in the field and apply metadata and keywords, edit out ones we don't want, rank, and essentially accomplish as much as we can.

7. After we are done tweaking all our files, we select them all in the Library Module Grid Mode and choose Save Metadata to File (Command-S) or if you prefer, you could also have Automatically Write Changes into XMP selected in Catalog Preferences (although it does tax the system to automatically write XMP).

FIG 15.05
XMP has been saved
to the RAW file using
Command-S

8. We return from location and plug the external drive Lightroom_Library_Road into our main computer at the studio or at home.

Lightroom_Library

Lightroom_Library_
Road

FIG 15.06
Back home, external
drive named Lightroom_
Library_Road is plugged
into the main computer

9. We start *Lightroom* on the main computer and choose Import from the lower-left hand corner of the Library Module. We select the folder to import.

10. **The Import Photos Dialog Box will pop up:**

 • **File Handling:** Choose "Copy photos to a new location and add to catalog."

 • **Copy to:** the location that all of our image files reside, our Lightroom_Library hard drive on our main computer. In our case it would be /volumes/Lightroom_Library/2010

 • **Organize:** by original folders

 • Don't re-import suspected duplicates

 • **File Naming:** Template Filename—because we named the files in the field

 • **Information to Apply:** None, because we have applied Develop Settings, Metadata and Keywords in the field

 • Choose 1:1 Initial Previews because we always want 1:1 previews

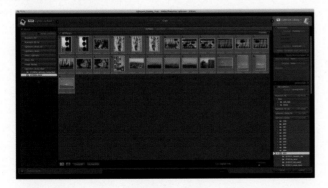

FIG 15.07
Import as outlined in
Step 10

447

11. The files are imported and all material is now on our main drive. The portable drive can be reformatted and readied for the next location shoot.

Concept Two:

You maintain your archive on your studio or home desktop. You are leaving for a location shoot and you want to bring your entire catalog and images from studio/home with you. You do not plan on working on any old images, but you do want the material with you just in case. You have a shoot on location so you will be bringing a laptop and external hard drive with you. You may do some work on the files you capture in the field and your goal is to add these images to your existing catalog that you took with you in the field. When you return to the home or office you want to update the catalog at home with the material you captured in the field.

Solution for Concept Two:

1. The easiest and most reliable way to accomplish this scenario is to bring a laptop and an external hard drive large enough to hold the entire *Lightroom* Catalog and image files and which can be reformatted on location. For absolute protection, we like to bring two or three drives on location, duplicating the contents to all three drives just to protect against drive failure, theft or any other unforeseen circumstance.

2. Ideally, reformat the hard drive you are bringing on location before the trip. We usually take a Lacie Little Big Disk 1 Terabyte external drive. The external drive plugged into the desktop computer and the external portable drive is named Lightroom_Library_Road exactly like Concept One.

FIG 15.08
Drive for road formatted and named Lightroom_Library_Road

Lightroom_Library_
Road

3. Before we leave for our trip we copy our Lightroom_Catalog
and folders of images from our main Lightroom_Library to
the external drive that we are taking on location.

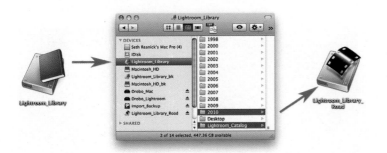

FIG 15.09
We copy the Lightroom_
Catalog from the
desktop computer
to the drive that we
will take on the road,
Lightroom_Library_
Road. We also copy any
folder of images that we
want to bring with us. In
this case, we are also
taking our entire folder
of 2010 images.

Copy

Copying 7,482 items to "Lightroom_Library_Road"

30.92 GB of 128.56 GB – About an hour

Copying 2 items to "Lightroom_Library_Road"

54.40 GB of 233.89 GB – About 2 hours

FIG 15.10
Copying catalog and
folder of images to
Lightroom_Library_Road
from the drive named
Lightroom_Library.

4. We go on location and plug in our Lightroom_Library_Road
hard drive into our Laptop and rename the drive
Lightroom_Library.

IMPORTANT: *Lightroom* is path specific, so we want to
change the name of the drive hooked up to the laptop
from Lightroom_Library_Road to Lightroom_Library before
we start *Lightroom* on the laptop. By keeping the name
Lightroom_Library, the path is the same and there won't be
any problem locating the catalog on the laptop.

 Drive is renamed
Lightroom_Library
on laptop before
opening Lightroom

Lightroom_Library_
Road → Lightroom_Library

FIG 15.11
Drive is renamed
Lightroom_Library
before starting
Lightroom on
the Laptop

5. We start *Lightroom* on the laptop and all of the files that we took with us will be available. We will still be able to see full size previews of the files we did not take. Their respective folders will be grayed out and have a question mark.

FIG 15.12
Lightroom is launched on Laptop.

6. We shoot on the road and import the files. We then tweak our files in the field and apply metadata and keywords, edit out ones we don't want, rank, and essentially accomplish as much as we can. We avoid making collections and avoid making virtual copies.

FIG 15.13
New images are imported and tweaked in *Lightroom* and metadata is applied.

7. As in Concept One, after you are done tweaking all your files, select them all in the Library Module Grid Mode and choose Save Metadata to File (Command-S) or if you prefer, you could also have Automatically Write Changes into XMP

selected in Catalog Preferences although it does tax the
system to automatically write XMP.

8. We return home and start *Lightroom* on the laptop to make
 sure that everything is working. We close *Lightroom* and
 change the name of the external drive back to Lightroom_
 Library_Road.

**Drive is renamed
back to Lightroom_
Library_Road**

Lightroom_Library_
Road

Lightroom_Library

Lightroom_Library

Lightroom_Library_
Road

FIG 15.14
The drive is renamed
back to Lightroom_
Library_Road

FIG 15.15
The Lightroom_Library_
Road drive is plugged
into the main computer
at home or office and
we choose import from
the lower left-hand
corner of the Library
Module. We select the
folder to import.

9. **The Import Photos Dialog Box will pop up:**

 • **File Handling:** Choose "Copy photos to a new location
 and add to catalog"

 • **Copy to:** the location that all of our image files reside, our
 Lightroom_Library Hard Drive on our main computer. In our
 case it would be /volumes/Lightroom_Library/2010

 • **Organize:** by original folders

 • Don't re-import suspected duplicates

 • **File Naming:** Template Filename—because we named the
 files in the field

 • **Information to Apply:** None, because we have applied
 Develop Settings, Metadata and Keywords in the field

 • Choose 1:1 Initial Previews because we always want
 1:1 previews

FIG 15.16
Import as outlined in
item 10

10. The files are imported and all material is now on our main drive. The portable drive can be reformatted and readied for the next location shoot.

Concept Three:

You maintain your archive on your studio or home desktop. You are leaving for a location shoot and you want to bring your entire catalog and some images from studio/home with you. You plan on *working on old images from the existing catalog but you also want to be adding new material.* You have a shoot on location so you will be bringing a laptop and external hard drive on location with you. When you return to the studio / home, you want to update the catalog on your main computer with the material you captured in the field, and with the material changed in the field. Now we must sync the field catalog and the studio/home catalog.

Solution for Concept Three:

1. The easiest and most reliable way to accomplish this scenario is to bring a laptop and an external hard large enough to hold the entire *Lightroom* Catalog and image files and which can be reformatted on location. For absolute protection we like to bring two or three drives on location duplicating the contents to all three drives just to protect against drive failure, theft or any other unforeseen circumstance.

2. Ideally, reformat the hard drive you are bringing on location before the trip. We usually take a Lacie Little Big Disk 1

Terabyte external drive. The external drive plugged into the desktop computer and the external portable drive is named Lightroom_Library_Road exactly like in Concept One.

Lightroom_Library_Road

FIG 15.17
Drive for road formatted and named Lightroom_ Library_Road.

3. Before we leave for our trip, we copy our Lightroom_Catalog and folders of images from our main Lightroom_Library to the external drive that we are taking on location.

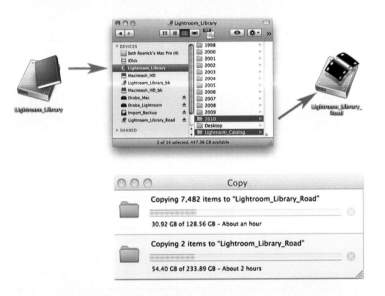

FIG 15.18
We copy the Lightroom_ Catalog from the Desktop Computer to the drive that we will take on the road, Lightroom_Library_ Road. We also copy any folder of images that we want to bring with us. In this case we are also taking our entire folder of 2010 images.

FIG 15.19
Copying catalog and folder of images to Lightroom_Library_Road from drive named Lightroom_Library.

4. We go on location and plug in our Lightroom_Library_Road hard drive into our Laptop and **rename** the drive Lightroom_Library.

IMPORTANT: *Lightroom* is path specific, so we want to change the name of the drive hooked up to the laptop from Lightroom_Library_Road to Lightroom_Library before we start *Lightroom* on the laptop. By keeping the name as Lightroom_Library, the path is the same and there won't be any problem locating the catalog on the laptop.

FIG 15.20
Drive is renamed
Lightroom_Library
before starting
Lightroom on
the Laptop.

Drive is renamed
Lightroom_Library
on laptop before
opening Lightroom

Lightroom_Library_
Road ──────────────▶ Lightroom_Library

5. We start *Lightroom* on the Laptop and all of the files that we took with us will be available. We will still be able to see full size previews of the files we did not take. Their respective folders will be grayed out and have a question mark.

FIG 15.21
Lightroom is launched
on Laptop.

6. We shoot on the road and import the files. We then tweak our files in the field and apply metadata and keywords, edit out ones we don't want, rank, and essentially accomplish as much as we can. We avoid making collections and avoid making virtual copies.

FIG 15.22
New images are
imported and tweaked
in *Lightroom* and
metadata is applied.

7. As in Concept One, after you are done tweaking all your files select them all in the Library Module Grid Mode and choose Save Metadata to File (Command-S) or if you prefer, you could also have Automatically Write Changes into XMP selected in Catalog Preferences although it does tax the system to automatically write XMP.

8. We have already imported a new job, but now you have decided to work on another folder of images. We always advise that you write down on a piece of paper what folder or folders you are going to do work on. In our example, we decide to do work on a folder of images called 20100528_boatsink.

FIG 15.23
We added our new folder called 20100604_ miami, but we also work on some images from a folder called 20100528_ boatsink. After we are done, we make sure we choose Command-S or save metadata to file.

9. As in Concept One, after you are done tweaking all your files, select them all in the Library Module Grid Mode and choose Save Metadata to File (Command-S) or if you prefer, you could also have Automatically Write Changes into XMP selected in Catalog Preferences although it does tax the system to automatically write XMP.

10. We return home and start *Lightroom* on the Laptop to make sure that everything is working. We close *Lightroom* and change the name of the external drive back to Lightroom_Library_Road.

Drive is renamed back to Lightroom_ Library_Road

Lightroom_Library_ Road

Lightroom_Library

FIG 15.24
The drive is renamed back to Lightroom_ Library_Road.

FIG 15.25
The Lightroom_Library_
Road drive is plugged
into the main computer
at home or office.

11. We open up *Lightroom* on our main computer and we
 navigate to the folder or folders that we worked on. In our
 case it is 20100528_boatsink. We select all the images on the
 desktop computer and we delete them from the hard disk
 and we delete the folder

FIG 15.26
The images and the
folder that we worked
on while we were on the
road is deleted from the
home computer.

14. Once the folder is deleted from the computer at home, we
 choose import from the lower left-hand corner of the Library
 module and we will now import the new folder created on
 the road 20100604_miami as well as the folder we worked
 on 20100528_boatsink. We will import from the Lightroom_
 Library_Road drive to our Lightroom_Library Drive.

15. We choose import and The Import Photos Dialog Box will
 pop up and we import both the 20100528_boatsink folder as
 well as the new folder 20100604_miami.

 • **File Handling:** Choose Copy photos to a new location and
 add to catalog.

 • **Copy to:** the location that all of our image files reside, our
 Lightroom_Library Hard Drive on our main computer. In our
 case it would be /volumes/Lightroom_Library/2010

 • **Organize:** by original folders

- Don't re-import suspected duplicates

- **File Naming:** Template Filename – because we named the files in the field

- **Information to Apply:** None because we have applied Develop Settings, Metadata and Keywords in the field.

- Choose 1:1 Initial Previews because we always want 1:1 previews.

FIG 15.27
We import both the new folder created on the road 20100604_miami and the folder that we worked on while on the road 20100528_ boatsink into our main Lightroom_Library.

16. The files are imported and all material is now on our main drive. The portable drive can be reformatted and readied for the next location shoot.

Concept Four:

You maintain your archive on your studio or home desktop computer. You have a shoot on location, so you will be bringing a laptop and external hard drive on location with you. You will do some work on the files you capture in the field and you are going to work on files that you bought from home. Now you are truly going to have to synch the laptop computer to the desktop computer.

Solution for Concept Four:

1. The easiest and most reliable way to accomplish this is to bring a laptop and an external hard large enough to hold the

entire *Lightroom* Catalog and image files and which can be reformatted on location. For absolute protection, we like to bring two or three drives on location duplicating the contents to all three drives just to protect against drive failure, theft or any other unforeseen circumstance.

2. Ideally, reformat the hard drive you are bringing on location before the trip. We usually take a Lacie Little Big Disk 1 Terabyte external drive. The External drive plugged into the desktop computer and the external portable drive is named Lightroom_Library_Road exactly like in Concept One.

FIG 15.28
Drive for road formatted and named Lightroom_Library_Road.

Lightroom_Library_ Road

3. Before we leave for our trip, we copy our Lightroom_Catalog and folders of images from our main Lightroom_Library to the external drive that we are taking on location.

FIG 15.29
We copy the Lightroom_Catalog from the Desktop Computer to the drive that we will take on the road, Lightroom_Library_Road. We also copy any folder of images that we want to bring with us. In this case we are also taking our entire folder of 2010 images.

FIG 15.30
Copying catalog and folder of images to Lightroom_Library_Road from drive named Lightroom_Library.

4. We go on location and plug in our Lightroom_Library_Road hard drive into our Laptop and rename it Lightroom_Library.

 IMPORTANT: *Lightroom* is path specific, so we want to change the name of the drive hooked up to the laptop from Lightroom_Library_Road to Lightroom_Library before we start *Lightroom* on the laptop. By keeping the name as Lightroom_Library, the path is the same and there won't be any problem locating the catalog on the laptop.

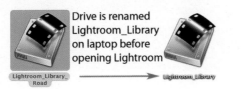

Drive is renamed Lightroom_Library on laptop before opening Lightroom

Lightroom_Library_Road → Lightroom_Library

FIG 15.31
Drive is renamed Lightroom_Library before starting *Lightroom* on t he Laptop.

5. We start *Lightroom* on the Laptop and all of the files that we took with us will be available. We will still be able to see full size previews of the files we did not take. Their respective folders will be grayed out and have a question mark.

FIG 15.32
Lightroom is launched on Laptop.

6. We shoot on the road and import the files. We then tweak our files in the field and apply metadata and keywords, edit out ones we don't want, rank, and essentially accomplish as much as we can. We may even make collections and smart collections and virtual copies. We also work on several other folders of images, so now we must sync the Laptop *Lightroom* Catalog to the desktop.

7. We truly try to avoid this method because it is complicated and it will take a long time and use a lot of space. For most of our work we use Concept One, but this is yet another way.

8. To process the entire catalog, you would select all the photographs in the catalog that you want to export from.

FIG 15.33
All photographs are selected from the catalog that you want to export from.

9. Because the process takes so long, we are going to select just one folder of images but you could do this with the entire catalog.

FIG 15.34
For demonstration purposes, we select only one folder of 100 files but conceivably this could be done with the entire catalog.

10. Choose Export as Catalog from *Lightroom's* Library File Menu.

FIG 15.35
Select Export as Catalog from *Lightroom* Library File menu

11. We chose Save As, name the file Demo_Catalog_for_Export and save it to the desktop of the Laptop computer or an external drive or any place that is large enough to hold all the information.

FIG 15.36
Catalog is exported

12. It takes quite a long time to export a catalog. The catalog contains all the images and XMP files, the previews of those images and the catalog of those images.

FIG 15.37
The exported catalog contains the images, the previews and a catalog file

13. Now the exported catalog is imported into the office or desktop Computer. We choose Import from Catalog from the *Lightroom* File Menu.

FIG 15.38
Import from Catalog

14. Now the exported catalog is imported into the office or desktop Computer. To do this, we choose Import from Catalog from *Lightroom* File Menu. The information from the exported catalog is merged into the master catalog on the desktop computer. While this method works and will preserve virtual copies, collections and smart collections, it can be a very tedious and time consuming process.

Concept Five: Only for Advanced or Power Users

We contemplated not putting this part in the book, but here goes. This concept can be used for several advanced scenarios. We are going to present a very advanced concept and if you understand this, you can extrapolate quite a few possibilities. *Lightroom* is not a network application yet, but you can force it to be a networked application with a little help.

FIG 15.39
Images are placed on server or network drive.

1. All of the images above are placed on a drive or on a server.

2. Each person in the office has a copy of *Lightroom* and builds their own *Lightroom* Catalog on their respective computers. **One person** is deemed to be the **Master** and no one touches that catalog except the Master. He or she imports all the images from the server, either by copying to a new location or by adding the images from the existing location.

3. Each person in the office does exactly the same thing. They each have a catalog with images.

4. Person A is going to be working on Captions and Person B is going to be working on Keywording and Person C is going to be working in the Develop Module. The key is that each person has a specific task that they work on.

5. At the end of the day, after the Master has made sure that each person (or slave if you will) has correctly done their task, the catalogs are exported but without negatives and without previews. This is totally cool. For this demonstration, we will export a catalog of over 42,000 files without negatives and without previews. This will take only minutes or less but it would take days to do this and include the previews and the negatives.

6. We select All Photographs from our Catalog.

FIG 15.40
All Photographs from
the catalog is selected.

7. We Choose Export as Catalog from the *Lightroom* Library
 File Menu

FIG 15.41
Each person working on
images chooses Export
as Catalog when they
are done working.

8. In this example, we have called the catalog Test Catalog. We
 uncheck "Export negative files" and we uncheck "Include
 available previews." In essence, we are exporting metadata
 only to import this metadata into the Master catalog.

FIG 15.42
Catalog is exported.

9. The catalog is exported from each "slave" computer.

FIG 15.43
Exporting the Catalog is very fast

10. The catalog contains only a catalog file and the export is very fast. This is imported into the Master Computer and effectively the Master computer is updated with all the changes from the slave computers.

FIG 15.44
Each person working on their catalog exports a catalog when they are done working and then the Master imports the file into the Master Catalog and everything on the Master computer is updated.

This process effectively turns *Lightroom* into a feasible network application.

I SUMMARY

You use *Lightroom* on a main computer and you take a laptop on location. How you go about synching the work done on your laptop on location to your main computer is a critical part of workflow.

There are several methods that will accomplish this task in *Lightroom*. The choice you make will be dependent on whether or not you are simply acquiring new information on location that you want to bring back to the main computer, or whether you are taking information from the main computer and working on that in the field and then syncing that information back to the main computer.

At a very advanced level, *Lightroom* can even be forced to become a network application synching multiple catalogs on different computers.

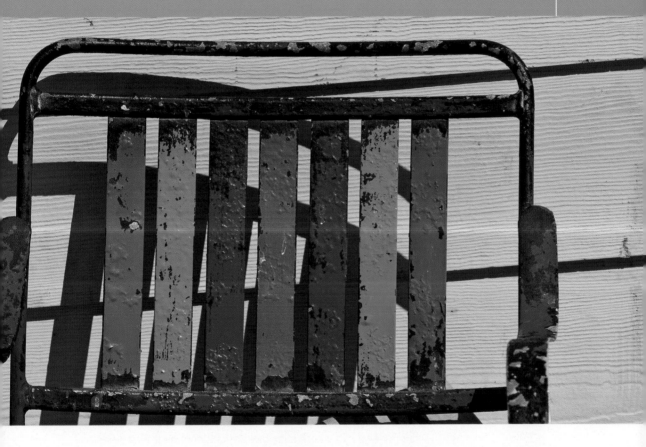

ARCHIVING YOUR IMAGES AND CATALOG

Back-up is important, but back-up is not preservation. The goal of D-65 is to have an EXACT DUPLICATE of our catalog and of all of our image files on multiple media in multiple locations.

An archive should be made regularly because computers are not 100% reliable. Hard disks malfunction, viruses and worms corrupt data, and people can make simple mistakes like inadvertently deleting files. Having an archive means you can recover from such faults, with little, if any, lost data.

As Hurricane Wilma passed over Miami Beach, we watched and took photographs from our 17th floor apartment, which faces the Atlantic Ocean on the front side and the Intercoastal Waterway on the backside. We live on a very narrow section of Miami Beach, which is roughly one foot above sea level. Our building flooded, our docks were destroyed, and as the storm intensified, we watched the roof come off of the building next door. As we looked out at the raging storm, we realized that our building was actually swaying a few degrees in this Class 3 Hurricane. We were lucky, but countless others weren't so lucky.

FIG 16.02
Hurricane Wilma ravages even the normally calm waters of the Intracoastal Waterway

FIG 16.01
Hurricane Wilma strikes Miami Beach as a Category 3 Hurricane

Hurricanes, typhoons, tornados, fires, volcanoes, blizzards and even tsunamis are a fact of life and they wreck lives and destroy property. After each of these events, you can usually always find a news clip where a reporter asks someone if they were able to save or salvage any of their belongings. You know the scenario because you have seen it hundreds of times. There is man or woman crying at the seen of what was once their house, devastated because they lost everything. When they can salvage items they typically grab the memories like wedding pictures, baby pictures or family pictures. While having little financial value, these items contain tremendous personal value and are irreplaceable. Did you ever stop to think what would happen to your image collection even if it were on multiple media but all stored in only one location?

If you are a digital photographer, your data is the heart of your business. Not having an archive strategy in place means that a single malfunction can leave your business without any data, thus placing the future of the business in jeopardy.

D-65 suggests having a place that is a safe place for the computer in the event that one has to evacuate. We wrap all of the hard drives and computers in garbage bags and put them in the bathtub at the approach of a hurricane. The bathtub will hopefully drain if there is water and most bathrooms have doors to offer extra protection. Ideally a bathroom on an upper floor would be a wiser choice than one in the basement.

I DUPLICATE BACKUPS IN MULTIPLE PLACES

While basic computer backups are a good start, a backup is not necessarily an archive and does little good if your home or offices are destroyed. Not only do you need backups, but it is critical to have multiple backups, both off-site and on-site in the case of an emergency. Redundancy, redundancy, redundancy: you simply can't have too much.

An archive should be made to separate media that you can pick up and take with you. This way, copies of your data can be kept off-site, such as in another building. This helps protect against disasters, which may obliterate the building where your computer is held.

I BACKUPS

Ideally, the copies made onto backup media should be performed with a system that verifies the data. This is fundamental difference between a backup and an archive. Most folks simply perform a Finder Copy better known as drag and drop. These are very unreliable and permissions, preferences and other needed files may or may not copy this way. We personally like to use *SuperDuper* from Shirt Pocket and *Retrospect* from Dantz but there are other products as well. These products perform a bit-for-bit duplication and then verify that the data has been duplicated correctly.

The frequency of your "backups" should be dictated by how much data you would like to lose if there is a problem on your machine. For example, if you enter a significant amount of data every day, you should be backing up every day. If you rarely enter new data, then backups once per week might be okay.

"Backups" should be tested. Make sure that you can read the backup you just wrote. Nothing is worse than having a disaster and discovering that your backups are unreadable for some reason or another. If you are burning CDs or DVDs, it is usually sufficient to have the burner program "verify" the disk after it is written.

Of course, if you don't have a computer or power, you won't be able to access the data, but just knowing your personal and business documents are safe is reassuring. A good battery backup system is always a wise idea, but if power is out for an extended period of time even this will fail.

EMERGENCY POWER

In case of an emergency, you may or may not have access to power, phone service, or the Internet, and the need for power is the foundation of maintaining communication. Power alternatives include extra batteries, conversion battery kits, power cords that hook up to a car cigarette lighter, solar packs, and manual power generators.

Preparation is the best defense against nature and other unforeseen disasters. While a personal bomb shelter might help you rest easily at night, there are more practical ways to protect your personal treasures. In the event of a catastrophe, take care of your family, friends, property, and community. Knowing that you're prepared will let you do just that. Personal safety is always first, of course. But after that, it's the insurance companies and state and federal agencies that bear the burden of helping families rebuild and replace material possessions.

ARCHIVING *LIGHTROOM*

Archiving is different than backing up during processing or in the field. An archive is duplicated bit-for-bit, verified for integrity, duplicated for both on- and off-site storage.

I IMPORT BACKUP

There are several backups available within *Lightroom* but it is important to understand exactly what they do, and more importantly, what they don't do. When we first import files into *Lightroom*, the import dialog box offers a backup. In *Lightroom* 2.0 this backup was a copy of the exact structure on the card. If a metadata template, naming template or develop preset was applied, this backup would not show that structure but *new in Lightroom 3* is the ability to import to a second destination with any and all changes applied at import.

NEW

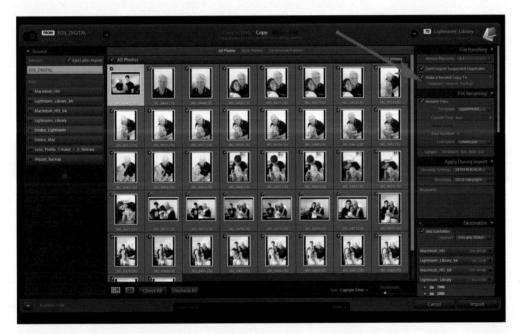

FIG 16.03
New in Lightroom 3 is the ability to import to a second location with any metadata, naming templates or develop preset intact.

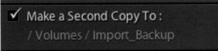

FIG 16.04
Backup to second location on import.

I THE CATALOG BACKUP

The Catalog Backup in *Lightroom's* Catalog Preferences is a backup of the Catalog only. While the preferences clearly state "Catalog Backup," most photographers fail to recognize exactly what this means.

It means exactly what it says. It is a backup of the Catalog. **It is not backing up any of the images associated with the catalog.** So if you have your catalog and your images on Drive A and you have chosen to backup to Drive B, the only backup occurring is a backup of the catalog, not the images. If Drive A fails, and this is the only place where you had your images, you would have just lost all your images.

Additionally, there are choices for when to perform this Catalog Backup. In *Lightroom* 2, all the choices were when starting *Lightroom*. The last thing we would have wanted was to have to wait for a complete backup of the catalog when starting *Lightroom*, which could take hours. The engineers listened and *New in Lightroom 3*, we now we have choices to back up the catalog when quitting *Lightroom*. It is important to note that this backup still only backs up the catalog and not the images associated with the catalog.

NEW

FIG 16.05
Options for *Lightroom*
Catalog Backup

In the Catalog Settings Preference we choose "Never" because we like to back up our catalog and our images twice a day.

FIG 16.06
Our choice for Catalog Backup is Never because we choose to use software that will back up our entire catalog and our images twice a day or more

I THE D-65 ARCHIVE

We want to duplicate and back up our images and our *Lightroom* Catalog. As we said earlier, the *Lightroom* Library and Catalog are held on an internal terabyte drive with nothing else on it. We duplicate the *Lightroom* Library and Catalog on a second internal terabyte drive as well as on two external drives, one of which goes off-site.

I MEDIA CHOICE FOR ARCHIVE

D-65 chooses hard drives as our main means of archiving for many reasons. Do you remember SyQuest drives? Eventually, they became obsolete. The same happened with the ZIP format, optical drives, and on and on. The only standard that has been around to stand the test of time is the hard drive.

When a newer and faster drive comes out, it is easy to simply duplicate an entire drive. Many people make their main archive on CD, but there are many problems with CDs. The average CD may only last for 3-10 years and that is a potential disaster for archiving. Further, if one has 20 GB of data per photo shoot, there could easily be 50 CDs or more per shoot.

I D-65 DRIVE STRUCTURE

As discussed in Chapter 4, D-65 chooses to have a large internal drive holding our images (*Lightroom* Library) and our Catalog. The structure of that drive looks like Figure 16.07.

Two Terabyte internal hard drive which holds images and the *Lightroom* Catalog. The Drive is named Lightroom_Library.

Folders of images and .XMP files are organized by yyyymmdd_ jobname in each calendar year.

The *Lightroom* Catalog and Previews are held in the catalog folder on the Lightroom_Library drive.

FIG 16.07

In each year folder are folders for each job named yyyymmdd_ jobname and in each job folder are the RAW files and corresponding .XMP files as in **Figure 16.08** below.

The folders are organized by yyyymmdd_jobname. These folders contain the RAW files and the .XMP sidecar files

FIG 16.08
Folders with RAW files and XM

The files themselves inside the folder structure.

The *Lightroom* Catalog folder contains two files, the Lightroom_ Catalog Previews.lrdata and the Lightroom_Catalog.lrcat.

The Catalog Folder has two files,
Lightroom_Catalog Previews.lrdata
and Lightroom_Catalog.lrcat

FIG 16.09
The Lightroom Catalog
showing the Lightroom_
Catalog Previews.lrdata
and the Lightroom_
Catalog.lrcat files.

| MAKING THE BACKUPS

The Lightroom_Library gets duplicated to a second internal drive
called Lightroom_Library_bk and that drive gets duplicated to
a Drobo. Even the Drobo gets duplicated to a second Drobo
that gets stored off-site. *For detailed information on Drobo, see:*
http://www.datarobotic.com.

FIG 16.10
 The Lightroom_Library
gets duplicated to a
second internal drive
called Lightroom_
Library_bk and that
drive gets duplicated
to a Drobo and to a
second Drobo. The
contents of the second
Drobo are stored offsite
and swapped out on a
regular basis.

As we said earlier, we do not use the drag and drop of Finder
copies as they are not very accurate. Instead, we use software
specifically designed for archiving. We currently use *SuperDuper*.
SuperDuper runs on a schedule in the background and does a
complete backup of all the drives multiple times a day.

FIG 16.11
SuperDuper makes a
complete bootable copy
of one drive to another.

FIG 16.12
SuperDuper can
schedule a backup to
work behind the scenes
several times or more
a day.

I SUMMARY

Backup is important, but backup is not preservation.
The goal of D-65 is to have an EXACT DUPLICATE of
our catalog and of all of our image files on multiple
media in multiple locations.

Archives should be made regularly because computers
are not 100% reliable. Hard disks malfunction, viruses
and worms corrupt data, and people can make simple
mistakes like deleting files inadvertently. Having an
archive means you can recover from such faults, with
little, if any, lost data.

If you are a digital photographer, your data is the heart
of your business. Not having an archive strategy in
place means that a single malfunction can leave your
business without any data, thus placing the future of
the business in jeopardy.